wheels

wheels

Christie's Presents the MagicalWorld of Automotive Toys

Mike and Sue Richardson

D.A.

CHRONICLE BOOKS San Francisco First paperback edition published in the United States in 1999 by Chronicle Books.

First published in Great Britain in 1998 by Pavilion Books, Ltd.

Text copyright $\mathbb C$ 1998 by Mike and Sue Richardson

Photographs © 1998 by Mike and Sue Richardson and © 1998 by Christie's South Kensington

All rights reserved. No part of this book may be reproduced in any form without written permission from the publisher.

Printed in Italy by Tipocolor.

ISBN 0-8118-2320-2

Library of Congress Cataloging-in-Publication Data available.

SPECIAL PHOTOGRAPHY: ed schneider

DESIGN: balley design associates

DESIGNERS: simon balley and joanna hill

COVER DESIGN: benjamin pham

Distributed in Canada by

Raincoast Books

8680 Cambie Street

Vancouver, B.C. V6P 6M9

10987654321

Chronicle Books

85 Second Street

San Francisco, California 94105

www.chroniclebooks.com

contents

INTRODUCTION 6

1890-1914

1 YARD TOYS AND PARLOR TOYS 10

1915-1933

2 SOPHISTICATION, DIVERSIFICATION, AND DEPRESSION 32

1934-1945

3 HIGH FIDELITY FOR ALL THE WORLD 58

1946-1964

4 THE FLOWERING OF DIECASTING AND THE RISE OF PLASTIC 90

1965-1980

5 THE BEGINNING OF THE END OF THE ROAD 136

1981 onwards

6 FROM TOY AUTO TO MODEL AUTO 162

COLLECTORS' INFORMATION 177

INDEX 187

From the moment the first internal combustion engine was fitted to a wheeled vehicle in the 1880s to create the "horseless carriage", it was only a matter of time before the toy makers followed suit. Sure enough, when Henry Ford made the first automobiles around the turn of the century and children started enjoying the sight of these noisy contraptions that began to appear everywhere, there was an immediate demand for toys cars.

It was a relatively straightforward matter for the toy manufacturers to add to their existing catalogues. After all, if you could make a cast-iron horse-drawn item with turning wheels, you could make a cast-iron automobile with turning wheels; if you could make a pressed-steel hansom cab, you could make a pressed-

steel doctor's coupé - and American toy manufacturers, led by the Dayton Group in Ohio, did

just that. German and French industries, already skilled in producing fine

mechanical toys, also had no difficulty adapting to the new demand. Cheaper toys were not neglected either, and Pennytoys (five- and tencent toys) from France and Germany quickly penetrated the markets on either side of the Atlantic.

Between 1890 and 1920, whether made of wood, cast iron, or tin, the toys were not recognizable as any particular make. By the time of World War I, some were powered. A flywheel system developed in America

produced effective forward momentum at the slightest push; in Germany clockwork vehicles were made by

UCTION

Lehmann, Bing, Günthermann and Hess, and steam-driven ones were made by Carette. After the war, American toy manufacture really came into its own, and the actual vehicles seen on the roads were reproduced with ever-greater fidelity, mostly using pressed steel and cast iron, by Buddy L, Arcade and Marx.

The range of toys had been wide from the start; children had always taken great pleasure in "commercials" – trucks, vans and buses with decals of names and adverts applied on to the sides – fire engines, diggers, earthmovers, and farm vehicles. These were joined by cars of all kinds, from Rolls and Cadillacs to sports and racing cars. Most popular of all were working models with moving parts, action features or gimmicks, such as the Elgin road-sweeper that actually swept and the motorcycle whose rider leapt in and out of the saddle, vehicles that anticipated the sophisticated radio-controlled models of today.

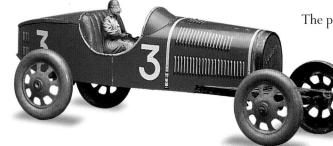

0

n p

0

c

The process of pressure diecasting in mazac, and later plastic, was used in America in the1930s by Tootsietoy and Hubley, and after World War II by Ertl and Marx, using aluminum and plastic respectively. In England the new process was adopted by Dinky; in Germany by Märklin. Now it

was possible to mass-produce high-quality toys cheaply and still achieve great accuracy of modelling, especially when the toys were sold under license from the manufacturers of the full-size versions. Thereafter, what had always been sold as toys for children began to appeal to adults as well.

Ironically, it was a time of relative prosperity that brought the greatest pressures to bear on the toy manufacturers. The emergence of the "teen culture" in the 1960s saw childhood effectively shortened as children, lured away by pop music, fashion and television, grew out of toy cars at an earlier age. Since then, the toy car market has been further squeezed by the end of the population bulge of the baby-boomer generation and by competition from rival attractions such as Action Man and, later, computer games.

The manufacturers have responded in a variety of ways: by amalgamating; by shifting production to the Far East to reduce costs; by specializing in sturdy toys for younger children; and, crucially, by moving away from the toy market and concentrating on producing models for collectors. It had become clear that there was a healthy adult market for miniature gems designed to be displayed rather than played with.

To the collector, however, by far the greatest interest – and value – lies in period items from the toymaking heyday. Remarkably high prices are now paid for good examples, especially scarcer items, at the numerous toy fairs and auctions. However, the higher the prices paid for antique toys and models, the greater the risk of making an expensive mistake. Owing to the frequency with which older models are reissued, often even using original moulds and dies, it is not always easy to verify a toy's authenticity. Even in the world of toy cars, chicanery exists, and collectors need to be on their guard against later versions or reproductions passed off as originals. As in all antique collecting, the best defence against deception is knowledge.

It is hoped that by outlining the history of toy-car making and by identifying some of the pitfalls awaiting

the unwary, Wheels will be of practical

help to the collector, and to anyone who has ever played with cars,

trucks and diggers on the floor or garden path. Such readers should be prepared to experience a pleasant wave of nostalgia, and some may even feel the urge to dust off those Dinkies and other old toys in the attic and give them another run – with a pleasure increased, if we have done our job, by knowing something about their place in the colorful history of automotive toys.

Y A R D T O Y S A N D P A R L O R T O Y S

In the mid-nineteenth century, before Karl Friedrich Benz invented the automobile, the toy industries in Europe and America were busy developing new manufacturing techniques and products. There were marked differences, however, between the two parts of the industrialized world. America was a vast, expanding country with an industrial belt between the Eastern Seaboard and the western Great Lakes, with parallel manufacturing regions in Canada. There were ports and cities along the Atlantic Coast to the south, and a huge interior of agricultural land, mountains, and deserts with isolated industrial and farming settlements. Europe was a congested jumble of states of different sizes, each of which was developing its own industry and devoting its time - when the armies were not fighting among themselves or with the rest of the world to competing economically by aggressively developing and exporting new products.

The sheer size of America, its vast spaces and relatively small population, meant that land was fairly cheap compared with Europe, and each farm or house in a rural town was larger than those of the crowded Old World. Machinery and vehicles had to be robust and large to work the American land and to stand up to the rough roads, and the materials from which things were made had to withstand much hard use for many years. American industry was thus used to making artifacts that did not break, or were easily repaired if they did: products farmers could mend themselves or have repaired by the local blacksmith, and which did not have to be sent hundreds of miles to the manufacturers for fixing.

Children's toys are frequently scaled-down versions of the things they are familiar with in the adult world, and even playthings need to be strong to withstand the roughness of the backyard, where children with access to the outside prefer to play. In America, the existing technologies of manufacturing in wood, pressed steel, and cast iron were perfectly fitted for producing suitable toys.

German industry meanwhile, particularly the firm of Lehmann, was perfecting attractive, cheap, light, mass-market tin toys, which they sold as far and wide as they could. The differences between these two production styles meant that European toys supplemented American-made ones, rather than competing with them directly.

For the first twenty-five years after the invention of the automobile in 1890 most of the transatlantic trade was going from Europe to America, as the growing population of America became more prosperous and imports augmented the products of the home industry. Around the turn of the century, the demand for toys of all sorts was so great that the value of imports from Germany alone roughly equalled the value of toys produced in America. As industry powered prosperity, there was a continual increase in the amount of money available. Henry Ford's ModelT – both the actual automobile and the toy versions – became a symbol of that prosperity, and firms in America as well as overseas developed rapidly to help people spend their new wealth.

WOODEN TOYS

Toys made of wood have existed for centuries. They were easy to make as the raw material was around everywhere. A sharp knife could carve a little animal out of a stick. But because wood breaks easily and burns well, few examples of early wooden toys have survived into the late twentieth century. Luckily, the long distances between town centers in America had led to the development of mail-order firms and their well illustrated catalogues, so at least we know what was available.

In 1878, one of these new mail-order firms, Montgomery Ward & Co., was advertising wheeled toys. Taylor of Chicago was making a boys' wagon, a small version of a horse-drawn wagon that could carry a load, and there was a whole range of US mail wagons, some of which were big enough to carry a child. These had to be pulled along by other children, but can be regarded as precursors of the pedal car. By 1894, it was advertising a Rescue Hook and Ladder Truck Co. No. 1 that was "made wholly of wood. Has four handsomely painted ladders, which are so made that they can be joined together, forming one long ladder. An interesting toy for any boy." This was a pull-along toy, but before long there were models of fire vehicles powered by internal combustion

engines. Of the manufacturers themselves, even where they are named in the catalogues,

virtually nothing else is known. The main exception

is Schoenhut, which is famed for its circus animals. In the years before World War I, Schoenhut featured a range of Modlwood toys that had four or five different automotive shapes: open and closed cars, racers, and a couple of trucks that "can be readily put together and taken apart...[giving] plenty of study and constructive amusement." Wooden vehicles from these early years rarely show up on the collectors' circuit, but examples in good condition with interesting paper stickers are worth collecting.

In Europe, wooden toy production flourished in Germany, especially in the Erzgebirge area of Saxony. After the collapse of the local mining industries, the villagers had taken to the cottage production of wooden items during the winter, and by the 1850s had organized themselves into guilds. They exhibited at the Nuremberg Toy Fair, and their products,

especially Noah's Arks and animals, came to be known by the name Erzgebirge. With the advent of the automobile, it was simple to add toy road vehicles to their range.

below: The first Tootsietoy car, no. 4528 (5cm/2in, 1911, USA) surrounded by European flat-lead vehicles.

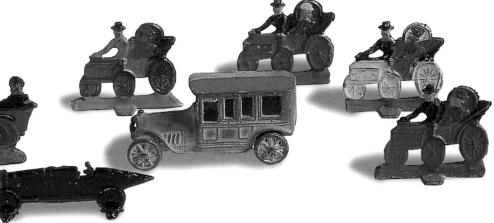

1

CAST-IRON TOYS

At the end of the nineteenth century, American toys were characteristically manufactured in cast iron. Not only was it used for a great variety of playthings, but its use was almost exclusive to America. Toy automobile collectors have hunted widely for European firms that specialized in cast iron and have come up with an insignificant handful. The technology of casting in iron was perfect for a country that had not yet completed its Industrial Revolution, a country that had to concentrate on developing the land and feeding the towns, rather than on making sophisticated machinery that could weave fine cloth, make

centre: Clockwork-motored Bing Open Tourer, missing its driver (tinplate, 27cm/10.5in, c.1914, Germany).

small intricate parts for watches for the luxury market, and produce repeat quantities of goods for export.

While the technology for cast iron was known to the ancient Chinese, it was developed to a high degree of sophistication during the Industrial Revolution in England – the materials needed to make cast iron are iron ore, fuel for smelting, and water for cooling. There are iron ore deposits around the Great Lakes, especially on the upper side of Lake Superior. The heartland of manufacturing was further south in Detroit and Cleveland on Lake Erie, and in Chicago on Lake Michigan – all areas with water transport for the raw materials. Not only was cast iron easy to make, these blocks of iron ore were transportable to factories, which made items such as locomotive wheels, girders and framing for skyscrapers, farm implements, steam engine cylinders, sewing machines stands, baby carriage wheels, domestic fire grates, decorative stands for kettles ... and toys.

The iron-casting process is also relatively simple. A tray of sand incorporating a gluing medium takes the impression of a full-size wooden model of the desired piece (say, a house name plate) as easily as wax takes that of a seal ring. Cast iron is added by gravity, allowed to cool, and broken out of the sand. Multipiece molds allow more complex pieces to be made in a similar way. Gravity filling of molds has its limitations, because air bubbles tend to collect in corners and undercuts are diffi-

14

cult, so large or complicated cast-iron items are often made in pieces and then fastened together. This generally results in products that are heavy and robust. The low technology of the foundry variety of toys made from cast iron. At the simple, cheap end is a twenty-four-piece set of solid menagerie animals one to three inches long, including elephants, giraffes and chickens, long. Toys on wheels manufactured by the Gong Bell company range from a simple pull-along bell, sounded by a cam on the axle to an elaborate Liberty Chime, which portrayed Liberty riding like Venus on a shell, waving the Stars and Stripes! A less fanciful method of transport is represented by an iron money-box in the form of a San Francisco-type cable car that was set in motion when a coin was dropped in the top. The catalogue also has a selection of "indestructible malleable iron toys" - a horse-drawn truck with driver and load 13 inches long and an even larger fire wagon at 18 inches. The cast-iron toy manufacturers were not going to have the slightest difficulty adapting production to models of vehicles powered

by the newly introduced internal combustion engine.

STEEL AND TINPLATE TOYS

In America, when steel was incorporated into toys, it was frequently used along with cast iron and made up only a small part of the toy, notably the bell for chime toys and perhaps a carriage seat or the body of a cart. Usually quite heavy-gauge, the steel was therefore difficult to make into complicated shapes; it is not really surprising that cast iron was so much more popular.

large, low-demand items like locomotive wheels, but if it were necessary to make enough sewing-machines stands to equip a garment factory, one could increase production just by adding another shed and employing more labor. It is also possible to make cast-iron articles with more intricate detail, but they are correspondingly more expensive, as better-quality iron, made with low-impurity coke, is needed, and more care has to be taken in the making and filling of the molds.

was ideal for short-run productions of

The 1886 Montgomery Ward catalogue advertised a wide

The European version of sheet steel used for toys was tinplate. This is a very thin sheet of steel coated with tin; its attractive shiny finish provided a good surface, if first etched, for paint or for colorful litho printing. Offset lithography had developed into a reliable and repeatable process by which a pattern was transferred from the original lithographic stone, via a flat plate or, later, rubber rollers, to the surface of the tin. This could then be cut and folded into a variety of shapes, from

below: A pressed-steel and cast-iron Hill Climber Two-seater Car with friction motor (30cm/12in, c.1903, USA).

a simple cracker box to the cleverest mechanical Lehmann toy. Most of the steel toys sold in America were these light tinplate ones imported from Germany. It was easier,

at this time, to ship consignments across the Atlantic than across America. The vast interiors were reached mainly by railroad. Whereas in Europe complex road networks were already in place before the automobile arrived, in America their development followed that of automotive transport.

MAKERS AND SELLERS

Once the processes for making the toys had developed and merchandise was available, it had to be sold. In America, unlike in Europe, specialist shops were few and far between, a notable example being the famous F.A.O. Schwartz of New York City, established in 1862 and still active today. Smaller toy outlets such as hardware stores were supplied by wholesale companies, among them Butler Bros and Marshall Field & Co, which had cohorts of travelling salesmen and sent out trade catalogues. But daily or even weekly town shopping was out of the question for many Americans, and they relied on mailorder companies such as Montgomery Ward & Co., which started in 1872, and Sears Roebuck, which began in the early 1890s. The illustrated catalogues of these middle men provided much of our knowledge about early American toys. We know the size, weight, mechanical action, packing quantity, and the price - but often not the name of the manufacturer. The distribution companies that were doing the advertising and selling were much more powerful than the makers, who would go to them hat-in-hand to demonstrate the superior qualities of their products.

Occasionally, a catalogue states that the toys were "imported from Germany", or were "quality European toys," but rarely was the source specified. Until toy collectors had the chance to commit time to research, we knew what was for sale but not who made it. This lack of information is not helped by the absence of identifying marks on many toys, whatever material they were made from. The name would have meant nothing to the original purchaser, and applying it might have damaged the look of the toy or just made the item cost more. Even the decorative as well as informative trademarks, which were so common on European toys, were not much used in America. Some collectors say that it should not matter who made a toy, that its desirability lies in its attractiveness, its working features, or its play value. Most people, however, are curious and want to know as much as possible, including the maker's name. Manufacturers who made desirable toys gained recognition, and today being able to name the maker nowadays usually enhances a toy's value.

THE DAYTON GROUP

The Dayton Group, as it was referred to, was a loose association of Ohio toy companies. Patient research by several collectors has revealed that D. P. Clark first set up business in 1897. In 1904, he was joined by Schieble, but four years later, Schieble left to set up the Schieble Toy and Novelty Co. with John C. Turner, who later departed from Schieble to set up business on his own. Clark meanwhile renamed his firm the Dayton Friction Toy Works. While this history led to the companies being labelled the Dayton Group, the interactions and disagreements between the individuals and their companies resulted in many differences in their products.

The toys that the Dayton Friction Toy Works produced are known as Hill Climber Friction Power Toys, a type that

remained in production until the Great Depression took its toll on the nation's toy industry. The Toy Works' significant era was before World War I, because it was the first manufacturer to develop a particularly American mechanism with which to fight off the inroads of European clockwork toys.

In 1897, Clark patented a rotating flywheel system that gave the toys great momentum across uncarpeted wooden floors. As the 1903 Montgomery Ward catalogue tells us:

All Hill Climber toys are now equipped with a new patent "Self

Adjustable Friction Distributing Idler" which presses together the

working parts and causes the power axle to bite and grip at

every touch. The slightest touch starts the toy, and by pressing

down and giving two or three hard pushes, sufficient momentum

will be given to the power to travel a long distance. It runs

backward and forward, up hill or down hill and over small

obstructions with ease. It may be used outdoors as well as in

and furnishes unlimited amusement to children of all ages.

Clark's early toys – for instance an automobile in the style of "the latest and most fashionable," complete with a chauffeur and two lady passengers in big hats; a fire engine with moving piston rod, pump wheel and gong "giving an air of hustle and bustle to the toy so necessary to imitate a real fire engine"; a circus menagerie wagon that "contains five animals each of which moves cleverly around in the cage as it runs on the floor" – were made of hand-soldered tin painted

in bright colors with gilt striping. The chassis, flywheel, and large wheels, positioned so close together that they were almost touching, were made of cast iron.

Other Dayton Group manufacturers made clockworkpowered trucks with a more conventional wheelbase – one at each corner – and some had rubber-tired wheels. All of these were generic toys, however, not particular models. As the years passed, more realistic models joined the lines, and "early" and "late" items are featured in the same catalogue. A 1915 ad had the above-mentioned fire engine and menagerie wagon, but also current phaetons and tourers, along with panel vans, trucks, and tanks that look as strange as the original vehicles. The toys have increased in length from 8 to 10 inches up to 16 to 20 inches, and they have details pressed into the tin rather than being painted on. Many have separate wings-cum-running-boards attached to the sides.

RIVALS

The Dayton Group did not have a clear field for long. Acme Toy Works, whose trademark was a stencilled A monogram, made an excellent representation of a 1900 Curved Dash Oldsmobile. This is perhaps the earliest *model* car made in America. Other pressed-steel toy manufacturers stayed in business for longer. Ives made toys of the old-fashioned horseless carriage sort from 1907, before concentrating on trains.

Hafner similarly

was the ancestor of American Flyer trains. The Wilkins Toy Company, which made in steel and cast iron, was acquired by the famous firm, the Kingsbury Manufacturing Company.

There was also the challenge of toys imported from Europe, particularly from Germany. Lehmann products are often named as such in the American catalogues, and other manufacturers are clearly recognizable from the good illustrations of the toys. Bassett-Lowke steam cars are oddly priced in British sterling in 1903/4, as are the more expensive clockwork versions of those toys. A wide variety of Bing vehicles was also imported. Hess, with its distinctive smaller models, is easy to recognize. Top-of-the-range Carette limousines, with a chauffeur and trunks on the roof, are in the catalogues too. Indeed, in 1914 about half of all toys sold in America were of German origin.

Increasingly, American toys were advertised as American: "guaranteed domestic mechanical toys," which were powered by clockwork, just like German toys. One manufacturer claimed that the toys "Run on entirely new principles, guaranteed" Increasingly, American toys were advertised as American: "advectional toys," which centre: A J National Au Pedal Car (

spiral springs on steel shaft adjusted to series of cogs, run 150ft with 1 winding. Fine enamel and each with chauffeur, front wheels turn."This last feature allowed the toys to run in circles. There was also a Flying Racer and a Flying Limousine, both finished in lavender and red with gilt stripes. While it sounds as if these were painted tin, at least one manufacturer was making automotive toys from lithographed tin.

centre: A fully restored American National Automobiles No. 7 Child's Pedal Car (107cm/42in, c.1910, USA). motor and leather seat cushions (tinplate, 25cm/10in, c.1902, Germany).

above: Bing Brake with clockwork

d

Ρ

At the turn of the century, Ferdinand Strauss, regarded by many writers to be the founder

of the mechanical toy industry in America,

was an importer of German toys. As the realization grew that America was losing out to Europe, Strauss began to make clockwork, litho tin toys, of light weight and good quality, to compete head to head and to supply his own toy shops. By 1914, he was producing beautifully made toys to fill the shelves of his four New York shops. The toys were fragile and few have survived, making them much sought-after by collectors.

American catalogues also offered pedal cars made of pressed steel. A 1914 Butler Bros catalogue features "Juvenile Steel Automobiles: All up-to-date models, handsomely finished, sheet steel bodies, auto steering system, open bottoms, strong double spoke wheels."These range in size from 30 to 50 inches long and sport names such as Scorcher, National, Wizard, and Speedwell. If you found the remains of one in a junk shop, you would have no trouble dating it to before World War I, for they catch the high-perched, open-box look of the runabouts of the time. Surprisingly, none of this group looks very like a model of the full size. The Ford Model T was selling so well that many children would have given anything for a pedal version.

CAST IRON PREDOMINATES

Today, the most visible production from this era is in cast iron, partly because a lot of it was made and partly because of its indestructibility. This feature, which has always been valued highly by parents, was heavily promoted in advertising, and it is true that a cast-iron toy would survive rough treatment in an unpaved back yard. You can often tell the "play value" of a toy (how much it has been played with) by how much of the original paint is left, and it is not unusual to find that it has disappeared from almost all of the outer surfaces. To determine the factory color you will need to inspect the inside of the toy in a good light or with a small flashlight. If the model, say an excavator, has spent much time buried in a sand tray, however, whatever paint is left may be badly faded.

The material is not just heavy but brittle, and thin wings and other small unsupported pieces can break off if the toy is dropped on a paved sidewalk or a hard surface. It is fairly common now to find that a damaged chassis replaced by a new one, perhaps made from lead or even from cast iron. One giveaway is that the toy is now held together with screws instead of the original rivets. But there are some very skilled restorers around, who can do an excellent job of replacing parts so that they look original. Though the work can take a long time, the reward is the large difference in price between a broken toy and one that looks factory-fresh. Unfortunately, a meaningless phrase has crept into sales lists – "restored to original." A toy can be original, or restored, but not both. A restored or repainted toy is never worth as much as an original.

For the first twenty or so years of toy vehicle production, cast-iron toys tended to be big, but during the next twenty years, as many as four, six or even more sizes of the same type were made. The toys reflected the transport of the time, and as body styles changed in the full-size world, the models changed as well. Once an item appeared in a catalogue, however, it was often kept there long after the style had been superseded. This makes dating difficult. It is often possible to say that an item with a particular cab shape

cannot be earlier than X, but unless there is evidence in a manufacturer's catalogue, it is not possible to attribute a not-later-than-X date. The earliest manufacturers of cast-iron toyautos, Dent and Williams, did not trademark their products either, though Kenton sometimes did. During this period, the toys were occasionally fitted with clockwork motors and could wreak terrible damage on furniture if they got out of control. These motors were often "bought out," as were wheels, and may be little help in identifying the manufacturer of a toy.

AMERICAN MANUFACTURERS

A. C. Williams, a family firm in Ravena, Ohio, turned to toy making in 1893. Kenton Hardware Company of Kenton, Ohio, and the Dent Hardware Co. of Fullerton,
Pennsylvania, were set up in 1894 and
1895 respectively. Which company made
the first automotive toy is a matter for

below: A Märklin Motor Fire Engine with clockwork motor and steering (tinplate, 28cm/11in, c.1910, Germany).

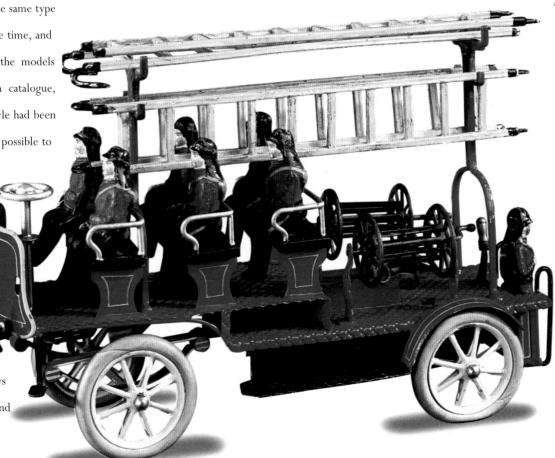

speculation. Williams is well known for its line of horse-drawn fire appliances modelled with horses racing to put out the flames. It made coin banks and smaller cast-iron pieces as well as some automotive items. Williams's trucks, sedans, and tourers are unmarked, but feature turned-steel wheel hubs. These are prevented from slipping off the axles by the spreading effect of the iron axle rod being hit on the end with a starred peen. The firm survived the 1930s by making dime-store toys.

Dent and his partners expanded their hardware business into toys around the turn of the century, producing very fine castings. Their vehicles are crisply detailed and fitted with wheels much smaller than those of their competitors. Even as early as 1909, two Dent products – a car and a fire pumper – featured wings and running boards, and the vehicles, at about 14 inches long, are large for the time. Sadly, when times got hard they were unable to maintain sales of such a quality product, and the firm faded away early in the Depression.

Kenton started making cast-iron automotive toys in 1903. It painted them red and coined the catchy name Red Devils for them. How devilish one of the early items looked, a clockwork automobile with tiller steering and a driver in a top hat, is open to question. Another early toy, dating from 1905, is a runabout 5 inches long. Dating from 1910 is an open touring car, a model of an air-cooled Franklin, 8½ inches long, complete with a driver and a lady passenger sitting in the back. Also from 1910 is a boat-tailed speedster 7 inches long. Quite a few of Kenton toys, including fire pumpers, are fitted with a driver. As the decades passed, the toys got larger, but they were still relatively simple coarse castings (compared with those of Dent) and, perhaps because of this, Kenton was still producing cast-iron vehicles into the late 1930s.

A number of other manufacturers made toys in the early days. Most fall into the "unknown" category since they are not identified in the catalogues, but Grey Iron, of Mount Joy, Pennsylvania, is known to have made a selection of very small toys, a mere 1½inches long, alongside the soldiers which were their principal line.

Diecast toys made their first appearance in around 1910, though the technique of pressure diecasting was not to be fully exploited until the post-Depression 1930s. Dowst Manufactuing Company, which had developed the very latest in linotype printing machines, turned the skill of casting lead type to making small toys, novelties that they made by the gross. It was only later that the business adopted the famous brand name Tootsietoy. Parallel development was going on in France, where several firms made small intricate pieces from lead hardened with antimony and tin, often with a bronzed finish. Most of the vehicles - usually made up of only one or two castings fitted with axles and tiny spoked wheels - are unmarked. However, SR (Simon & Rivollet) often did mark its toys. It is likely that there was cross-fertilization between Dowst and SR, perhaps with SR dies exported to America. The French products were often referred to as Pennytoys, as they were sold for a penny (or a few cents) on the streets of Europe.

EUROPEAN MANUFACTURERS:

LEHMANN

The easiest European toys to recognize from the end of the nineteenth century and the beginning of the twentieth were made by Lehmann. In addition to being brightly colored and prominently marked – with a tinplate press that looks like a bell or with the initials EPL – they all have a clever and

amusing action. Ernst Paul Lehmann, the genius behind these toys, became a partner in the failing firm of G. L. Eichner & Sons of Nuremberg in 1881. When Eichner died three years later, Lehmann changed the name of the business and continued alone, building up one of the pre-eminent and most prolific firms in his field. The toys were aimed at a mass market. With their bright colors, they had instant eye-appeal. Prices were kept low by the use of a newly developed, thin, cheap tinplate, some of which was actually manufactured in Wales. The clockwork action that propelled the toy along also captured the attention with one or another amusing gimmicks, such as a mule bucking between the traces of a cart or a sedan chair being pushed by a walking man. The calls of street traders would attract passers-by to watch these toys in action, and the comic effect would often produce a sale.

When automobiles appeared on the streets, Lehmann, who disliked this modern invention,

nevertheless took advantage of the new type of moving prototype. As early as 1897, he introduced to the mass market the Motor Car, a short horseless carriage with a driver out in front. The clockwork mechanism is concealed in the back of the carriage, and when the steering rod held in the driver's hand is pushed down one of the holes in the underframe, the steering can be set to go straight forward or describe left- or right-hand circles. This may not sound very

above: The Bing 'Platform' Fire Escape, aimed at the American market (tinplate, 25cm/10in, c.1910, Germany). exciting today, but in the late 1890s it had considerable novelty appeal.

Lehmann sold eighty-five percent of his product through wholesalers spread across the world. Indeed, the box for the Motor Car has two sets of instructions on the lid, one in German and one in English. Lehmann was very conscious that the world's markets differed, so in 1904 he set out on a trip to promote his toys at the Louisiana Purchase Exposition at St. Louis, Missouri. He and his party then went by rail to San Francisco.

He had just made an automotive toy that he might have targeted at the American market, which had fallen in a big way for comic strips and was eagerly buying toys based on comic-strip

center: A restored early example of the Günthermann Vis-à-Vis Motor Car (tinplate, c.1898, Germany).

w example of shaped hood, driven by an oversized driver s Motor Car who raised a horn to his lips and tooted down it, was not inspired by a comic strip, but it was such a caricature of a well-fed, self-aggrandizing

characters. Tut-Tut, a car with a coalbucket-

capitalist that it could have been. Several Lehmann vehicles were available with logos of different business and some were obviously targeted at overseas markets; the Aut Lala delivery van of 1907, for example, was decorated in Royal Mail livery and aimed at the British market. There was an open-top doubledecker bus, as well as a variety of cars and vans with odd but memorable names that transcended frontiers – Uhu, Aha, Lolo, Oho – all derived from ritual greetings and toasts made at a humorous club of which Lehmann was a member.

Once a toy was put into manufacture, it stayed in for many

24

years, and from 1910 Lehmann paid attention to covering his mechanisms with patents, first in Europe and then in America.

One late-production taxi decorated in yellowand-black Yellow Cab livery is marked PATD 2 DEC 1913 and USA 25 JAN 1927 on the chassis side. The 1912 Sears Roebuck catalogue made a feature of "Lehmann's Reliable Mechanical Toys" and illustrated the Tut-Tut, the Naughty Boy, a truck, and a pre-eminence of bus. The Lehmann over other manufacturers Bing, Hess, and Carette - also featured in the Sears catalogue is indicated by the fact that Lehmann is usually named, unlike the others. Lehmann must have contributed

most of the German tinplate wind-ups that by this time had secured forty percent of the American market.

BING

The year 1881 was a good one for the German toy industry, as Bing also turned to toy making. It covered all types of toys: stationary steam engines, trains, boats, optical and electrical toys with automotive subjects making up but a small part of the line. However, Bing commanded the quality end of the market, and it made many of the better-looking larger toys in the Sears Roebuck catalogues from 1910. Bing sold only to retailers. Its 1906 catalogue gives an indication of the large size of the firm, which had about 3,000 employees and showrooms not only in Hamburg and Berlin, but also in London, Paris, Milan, and Amsterdam. By 1914, Bing had no fewer than 5,000 workers.

No doubt Arthur Walter Gamage, who had started a shop in 1878 in Holborn, visited the Bing showroom in London to choose products to feature in his wonderful emporium and mail-order catalogues. His 1906 catalogue has three pages of mainly German motor cars, open-top buses, and fire engines. Most of the lithographed illustrations are not labelled with the manufacturer, but some small ones have the Günthermann shield in one corner. The pride of the group, however, is from Bing and is described thus:

Model of Modern Motor Car. Very elegantly finished with extra

strong, best quality clockwork, pneumatic rubber tyres, plastic

seats (imitation cushions), cooling box in fine brass finish, and

brake. Front axle adjustable to run straight or in a circle, with

lanterns. Very elegant finish, with finely nickelled headlight for

real burning.

featured advertisements for those quintessential English foods, Bovril and Grape Nuts. A slightly later French catalogue has the same two buses, but here they are operated by a German company, Grosse Omnibus Gesellschaft, advertising Suchard chocolate.

Bing also catered to American market, and soon available, among other products, was an "American 'Platform' Fire-Escape with Motor Car." This complex toy was described as being "finely japanned, with strong clockwork, with winch to raise or lower the platforms, with hooter sounding 'Tuff Tuff' pneumatic rubber tires, front axle to adjust for straight or circular run, with

above: A Günthermann Open Tourer with its driver and three passengers (tinplate, 20cm/8in, c.1910, Germany).

The accompanying illustration has, in the corner, the initials GBN, standing for Gebrüder Bing *n Tourer* Nürnberg (Bing Brothers, Nuremberg). *ssengers* The plates for the illustrations were *supplied* by the manufacturers and the Bing

toys appear identically in its own 1906 catalogue. Gamage must have been an extremely important customer, buying in bulk, because the price he quoted was about a third less than Bing's list price! The importance of the British market is acknowledged by the manufacture of two "Clockwork Omnibuses (London Street Car) Original English Model."They were both run by the General Omnibus Company Limited and Bing's automotive toys were often fitted with figures, especially drivers, and the firm sold separately three sizes of composition Motor Car Figures, all dressed with cloth. The cars often had brass lamps, some of which could be lit. There were doors that opened on some toys, and glass windscreens were common. Handbrakes operated on a rear wheel. On some of the toys, the clockwork could be set to steer the car through more interesting patterns than the usual circles. These "Running Figures" varied from triangular and figure-eight shapes to a much more complex six-petal daisy pattern.

two firemen."

GÜNTHERMANN

The trademark AWSG in an encircled shield was lithographed onto many of the toys produced by Günthermann, which released its first horseless carriage, complete with driver, in 1898. The initials SG were those of the founder of the company, who had died some time before, and AW those of his factory manager, who had married the former's widow. After the latter's death in 1919, his initials were removed. One of the most photographed of Günthermann's early toys suggests an 1890s Peugeot vis-à-vis: a small open vehicle with a wheel at each corner, a high seat for the driver between the rear wheels and a passenger seat facing him. The driver grasps the wheel fixed to a column that projects vertically upwards between his knees, so the conveyance is conveniently neither left- nor right-hand drive. The driver would have had to peer around the passenger to see where he was going! The bodywork is nicely lithographed in bright colors on the exterior, with detail of the seat padding and kick panels in shades of fawn and brown. The large spoked wheels are fitted with solid white rubber tires and there are lamps at the front. The driver is a particularly rounded model in painted tinplate. The commonness

of this sturdy toy can be partly accounted for by Günthermann's practice of making the same vehicle in a variety of sizes, with the largest of this type being almost 12 inches long.

Automobile racing began almost as soon as there were two vehicles available to compete, and before long specialist cars were designed to take part in a series of races sponsored by Gordon Bennett. Günthermann produced one toy in two different sizes; lithographed in white with gold detail with

"Coupe Gordon Bennett" up the sides of the long raked hood, it was driven by a leather-clad driver while a mechanic crouched sinisterly behind the scuttle. This

below: Bub Four-Light Limousine with chauffeur and opening rear doors (tinplate, 26cm/10in, c.1912, Germany).

is an early example of a manufacturer identifying a popular craze and then producing several color variations to maximize sales. Günthermann was a prolific manufacturer, and it made small, cheaper vehicles in a variety of sizes $-4\frac{3}{4}$, $5\frac{1}{2}$, and $6\frac{1}{2}$ inches long for instance – the cheapest having solid tin wheels and costing only a few cents.

HESS

An automotive toy by Hess is very easy to recognize, even from the black-and-white line illustrations in mail-order catalogues, because of the presence of a starting handle. These toys are often of generic racing cars with half-rounded drivers and left- and right-hand pieces of lithographed tin clipped together with tabs, then tabbed into the neatly decorated vehicle. There is an economy in the pieces that gives an air of solidity to the figure. Toy production at Hess started just before the turn of the century with a horseless carriage, and continued through trucks fitted with plaster drivers to the overall lithographed decoration of the cheap popular racers. The distinguishing feature of Hess - the over-sized, sleeved starting handle - juts out of the center of the radiator, just below the word Hessmobil. This patented feature is the mechanism for winding up the flywheel of the friction drive. As time passed, the colors of the toys that remained in production became more garish and the quality declined, which meant that once the world depression began, the firm was not in a good enough condition to survive.

CARETTE

"This Trade Mark is a guarantee of superior workmanship." So states the 1910 Carette catalogue. The trademark is a cog wheel with a steam regulator superimposed and initialled G C Co. N. It shows that the Frenchman Georges Carette had set himself up in Nuremberg in 1886 primarily to make steam models: trains, ships, stationary engines, and so on. Automobile production was but a very small part of his whole enterprise. What set his product apart, however, were the quality, flair, and finesse that make the toys so desirable now. In common with other manufacturers, his vehicles were often made in a variety of sizes: a 1905 clockwork motor car came in three sizes $-7\frac{1}{2}$, $10\frac{1}{2}$, and 13 inches long – and with minute attention to detail, the passengers were available in three sizes, too. These early products were painted and varnished, or "highly japanned," as the catalogue terms the finish.

A small proportion of Hess's automotive toys were steamdriven, as were the vehicles on which they were modelled; and these went on being manufactured after the internal combustion engine had ousted steam. In 1910, a steampowered 12-inch-long Motor Bus was available, and the same pressings were also fitted with a clockwork motor. One version was called an "Exact model of the London Motor Bus," the side advertisements being for those non-British products Heinz 57 Varieties Sauces and Relishes and Van Houten's Cocoa. An accessory for the bus was a set of twenty-four figures: twentytwo ladies and gentlemen in a variety of outfits and hats, with

above: A rare Open Tourer with folding fabric hood made by Pinard. Unfortunately, the windshield is missing (tinplate, 28cm/11in, c.1905, France). d

Ъ

a driver and a conductor. There were other, papier-mâché figures for the cars, the best-quality lady having a motor veil. The cheaper toys – and Carette did make simple spring- or

flywheel-driven small toys that could compete in price with Lehmann and others – and the smaller versions of their other

> vehicles were lithographed to a very high standard of finish, which was most resistant to scratches and did not fade. The larger doluce tors were hand pointed and

Tourer. All were made in Germany. larger, deluxe toys were hand-painted and lined and then japanned. These "parlour toys" represent the classiest examples of pre-World War I production, and just as many children would have given anything for one then, so

would many collectors now.

below left: A Carette Tourer. centre: A

Carette Limousine. right: A Bing Open

The most exquisite 40cm (16in) -long Carette limousine could only be afforded by the wealthy. It was painted in aristocratic colors, such as rich maroon or opulent cream, with the roof and carriage lining in complementary colors. The spoked wheels were fitted with white rubber tires and the roof sported a wire-framed luggage rack. The barrel-shaped headlamps and the squared carriage lamps on either side of the windscreen were of brass or nickel plate. The driver looked through a bevelled glass windscreen, and the passenger compartment, with its opening doors, was likewise fully glazed. The loving care with which these scarce toys were treated is clear from the survival of several in very fine condition. Roof luggage racks, folding leather hoods, steering and fine detail occur further down the line too, but the Carette limousines can usually be distinguished from similar competing products by their distinctive lamps and bevelled glass.

In 1914 the Frenchman Carette had to flee Germany and the firm closed in 1917. The pressings were taken over by Karl Bub, who had been in business for many years but probably only began making toy automobiles in about 1912. Because of the lack of catalogues, it is difficult to know exactly what the firm made, but the pieces were similar to those of the other German manufacturers and of good quality. Other famous European names were in business but were more significant in subsequent years.

The biggest type of toy car has always been the pedal car. It did not catch on very quickly in Europe, though there are simple home-made or exquisite one-off coach-built examples. But by 1911, Bon Marché in Paris was selling varying sizes of a racing car based on the current Grand Prix Peugeot. At the other end of the scale, tinplate Pennytoys, designed to be sold for one penny (sterling) or an equivalent small sum in other currencies, were available in great proliferation. Rossignol in France began by making simple spirit-painted vehicles, while Johann Phillip Meier, Johann Distler, and H. Fischer & Co., along with some of the other German manufacturers, utilized lithographed tin. Horseless carriages, automobiles, buses, fire engines and ambulances were made in abundance over the years, many of which are difficult to attribute because of the lack of a trademark. Despite the prodigious numbers that were made, their fragility has meant that few have survived.

During the early years of the twentieth century, American manufacturers' associations, such as the Toy Manufacturers of the USA (whose logo was Uncle Sam's top hat filled with toys), attempted to keep European product out and promote

American product. Despite their efforts, by 1914 Germany was supplying about one-third of the goods on the market. Then a dramatically effective brake was applied to the importation of toys from Germany, at the outbreak of World War I and an embargo was placed on all German goods.

In 1910, Henry Ford announced that automobile production would be standardized. The new Model T was to be the only model that his factories would produce, though it would be available in several body styles: car, truck, pick-up, and so on. A total of fifteen million Model Ts were made, so it is safe to say that a considerable number of the seven million cars that were on the American roads in 1918 were Model Ts. Although toys are supposed to mirror reality, you would not think so to look at the pages of the 1919 Sears Roebuck catalogue.

below: The Märklin Road Engineer's Steam Roller and Trailer (48cm/19in, c.1929, Germany).

There was a page headed "Strauss Reliable *d Engineer's mechanical Toys,*" which illustrated toys *and Trailer c, Germany*). Mechanical Toys," which illustrated toys that are obviously derived from the ideas and techniques of Lehmann. Few of the toys are automotive, but there is a Trick Auto that goes forward, backward and in circles – not much of a trick – a

Dandy Roadster with a driver and mechanism, and a Boy-on-a-Delivery Mechanical Motorcyle. The various members of the Dayton Group were still active and producing their new distinctive friction toys, "an American invention." There is an open-cab, Buick-style limousine 13 inches long and a similar delivery wagon 10½ inches long, but the former was available in 1914 and the latter probably was too. A group of three sheetsteel, friction-powered commercials - a truck with barrels, a fire engine and a hook-and-ladder truck - range in size from 13 to 191/2 inches and are of a familiar design. Light-gauge sheet steel has been used for several smaller vehicles, some of which look prewar. Others have very simplified, but more up-to-date features, including doors that opened and keys that were fastened to the clockwork spring. Two little tin vans made by A. C. Gilbert (of later Erector Set fame) feature U.S. Mail and Ambulance lithography. They are pretty but primitive, and

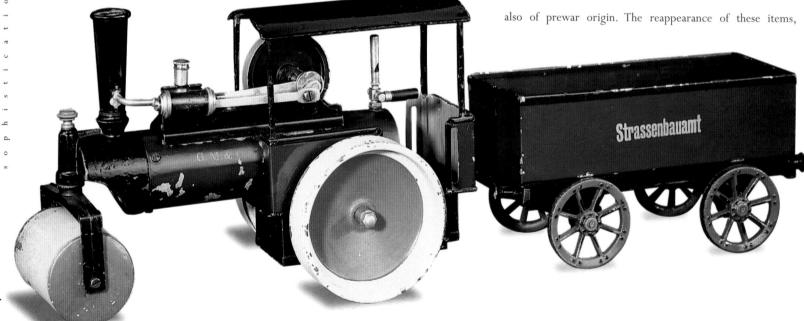

however, means that the industry was beginning to get back to normal production.

LUXURY TOYS

The Sears catalogue has new product, too. An attractive-looking but generic friction-steel roadster complete with driver provides the basis for a war-inspired Armored Auto, with a dummy gun and side fenders! There is also a 12-inch long Armored Tank with friction motor. Heralding a line of toys that were, and still are, particularly popular in America with its vast agricultural areas, the catalogue features:

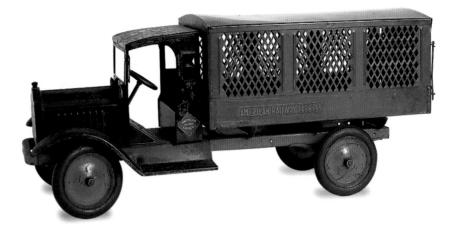

0

-

above: A pull-along American Railway Express Truck for sale in the 1928 Butler Bros catalogue (pressed steel, 66cm/26in, c.1928, USA).

A Dandy Miniature Farm Tractor Outfit. A mechanical miniature tractor which resembles

a real farm tractor. Rear wheels are 5 inches in diameter and the front are 21/8 inches.

Made of sheet steel and iron, nicely painted. A good clockwork motor with lever

attached to start and stop it at will. Complete with three miniature farm implements -

wooden roller, 4¾ inches long, with two metal strips for attaching to tractor; a 5-inch

metal disc harrow, and a double plow, size over all 10 x 4¼ inches including metal

strips for attaching. Size of tractor by itself, over all, 9½ inches long, 5¼ inches wide,

5¹/₃ inches high. Shpg wt, 4¹/₄ pounds \$4.67.

The high cost of the entire outfit indicates that the American economy was picking up and that there was a sale for luxury toys. The same 1919 Sears Roebuck catalogue advertises an even more expensive toy, the Auto Builder by the Structo Manufacturing Company:

Boys, build your own mechanical auto. A valuable educational

toy for the boy. A mechanically accurate toy automobile can be

made from this outfit. Outfit consists of necessary parts to build

a real toy mechanical automobile. Body made of medium grade

sheet steel. Nicely finished. All other parts are made of metal

and fit perfectly when they are assembled. Strong wheels $2\frac{1}{2}$

inches in diameter and a strong clockwork motor to run auto.

Fender and running board for each side about 1 inch wide.

Instructive and very interesting for boys. Something new in the line of construction toys. Complete with small wrench,

screwdriver and booklet of instructions for building. \$5.98.

This model is 15 inches long and bears a remarkable resemblance to the contemporary Stutz Bearcat Roadster, which was itself one of the many two-seat, long, round-tailed roadsters of the period. A further likeness is that the fully detailed gearbox is integral with the rear axle. Structo, whose slogan was "Make Men of Boys," went on to produce many ready-made toys – trucks, vans, a Whippet Tank, fire engines, and so on. Many did not include clockwork or the expensive gear and transmission train, so they were much cheaper. A 1929 advertisement claimed that "Heavier gauge steel is used than in any similar toy of comparable size," a claim that was probably true, because most steel toys of the same or heavier gauge were larger.

PRESSED-STEEL TOYS

The development of pressed-steel toys – sturdy and indestructible, as so many of the names suggest – was the major American manufacturing story of the 1920s. The technology was there in abundance. The materials and techniques that were used on the real auto only needed scaling down to large toy size, and an auto pressings subcontractor could even out the peaks and troughs in his mainstream production by making toys. The machinery was readily available, so firms that had been in the toy business could adapt to the popular new lines. The country was also embracing protectionism, and in 1922 import duties were increased to their highest ever level, giving the new industries an important price cushion.

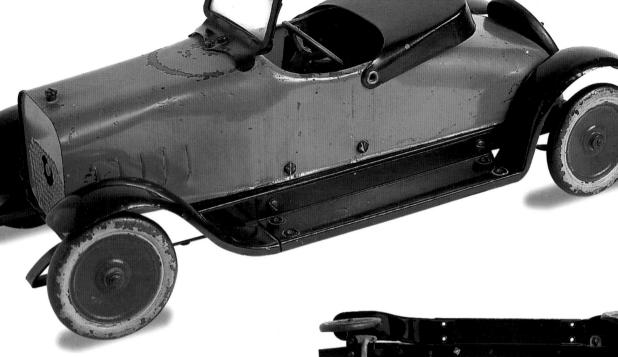

Black of Dayton Toys, one of the existing firms, and Miller set up Republic Floor Toys in the early 1920s. Building on their long experience, they sought a patent for a cover to protect friction motors from dirt and moisture, which meant that their line of smallish, 12- to 12^{3/2}-inch-long steel cars and trucks could be played with outside in the yard. Still distinctly toylike, their all-in-one running boards, shaped like a flat-bottomed V, show their Dayton heritage. A large bus at 28 inches and a slightly smaller ladder truck were closer to reality, but did not give the firm enough market penetration to survive beyond the graveyard year of 1932.

Making beautiful and action-packed toys assured of good sales to the rich, white sector of society while the economy was booming. Sturditoy, made by the Sturdy Corporation of

Pawtucket, Rhode Island, conveniently located near its rich customers, flourished during the 1920s, only to disappear about 1933. Its advert in *Playthings* for 1927

above: A Structo Roadster with a clockwork motor with a winding handle (pressed steel, 38cm/15in, c.1921, USA).

0

claims: "There's no substitute for Sturditoy. The final word in sheet steel toys. Oversize, overstrong & overwhelming favorites in the fine toy field." The fifteen or so models were large, at 26 to 28 inches, and beautiful: open coal and dairy trucks, an armored car, police patrol, steam shovel, U.S. Mail truck, chemical pumper and even a travelling store, with cartons of nationally known products. The most spectacular pair was an American La France Water Tower with working pump action and a companion Fire Engine with hosereel. It must have been fun driving those round the yard, filling them with water and racing to put out a cardboard-box fire.

Kelmet, Keystone, and Kingsbury sound like a firm of

below: A Kingsbury Sunbeam
World Land Speed Record Car (pressed steel, c.1927, USA).
Kelmet was short-lived, but it was significant in that some of its toys were models of actual trucks – White trucks in this case. Keystone, "Toys That Last," secured the rights to Packard and, at the end of the 1920s, made a 24inch tipping truck from hefty 18-gauge steel that could hold 300 pounds – and the factory paid the postage! The 1928 Butler Bros catalogue gives a

> full page to its large-size, pullalong toys, with a drawing of a portly gent, watch

chain across his waistcoat, standing in the back of a truck, accompanied by the slogan "trucks will support 200 pounds." The Butler line consists of vans, police patrols, tankers, wreckers, and so on. One truck, claimed to be able to lift 200lb, is a "Hydraulic dump truck 27 x 10¼ x 8, black, balloon type rubber tires, steering front wheels, brass compress air tank (pressure produced by turning front crank), body automatically lowered by pressing lever." But their Big Three, top-of-the-range, are a Water Pumper Fire Engine, an Aerial Ladder Truck and a Water Pumper Tower, which – to outdo competitors – not only has a klaxon horn, but "shoots water 25 to 35 ft." Handy if you had accidentally set fire to the chicken house! Keystone survived until 1958 by changing its manufacturing material to wood during World War II and to plastic thereafter.

KINGSBURY

Kingsbury, whose most important manufacturing decade was the 1930s, made many vehicles that were models of the real thing and not just generic examples. The firm's antecedents go back to before the turn of the century. Its strong toys, some made out of medium-gauge steel, were frequently powered by clockwork. Kingsbury's product during the 1920s was the usual stuff – trucks, vans, dump trucks – with a considerable emphasis on fire engines of several sorts, including ones that were a match for the top of the Sturditoy and Keystone lines. Their good clockwork, and their insight into what would

capture public's imagination, put a new type of automobile into the line.

the

Speed-record mania hit the world in the late 1920s and the United States, with its good supply of long beaches, salt flats and other suitable stretches of firm ground became the host for many attempts on the record. This came at a good time for Kingsbury. Its production stocks were building up as the post-World War boom lost momentum and the toy market decreased across the country. What was needed was a new product to boost the sales, and the company found it in toys representing the high-speed automobiles. The big red Sunbeam "slug" of 1927, powered by a clockwork motor to race across the dirt in the yard (just like the full-size one at Daytona), and fitted with rubber tires vulcanized directly onto the

hubs for straighter running, was a brand-new idea. It was not a racing car, but a large, satisfying, brilliantly colored record car. This was just the thing to create envy among schoolmates

and an upsurge in sales. Bluebird II, with its square radiators located prominently on each side above the rear wheels, followed in

1928. The Sunbeam Golden Arrow of 1929 - long, low, corrugated, and golden - looked like no other vehicle made before and could

hardly have been more different from the high-axle Model T. Kingsbury made its model 20 inches long and gained fame among collectors by creating one of the most recognizable of toy vehicles. The company survived the Depression on the back of such an innovative product.

RHDD V 8.

There is one name from the 1920s that has done more than merely survive until today. The Buddy L Manufacturing Company is flourishing in the 1990s, with the latest steel and plastic scale-model, electronically controlled, light and sound vehicles. The current fire pumpers sound earsplittingly like the real thing. The name Buddy L (which has been styled with quotes or a hyphen over the years) came from that of

left: A Kingsbury Bluebird World Land Speed record car (pressed steel,

c.1930, USA).

below: Kingsbury Golden Arrow World Land Speed Record Car (pressed steel, c.1930, USA).

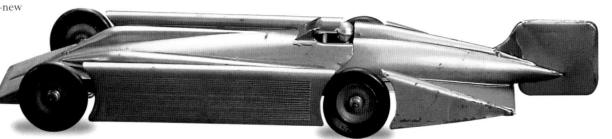

Buddy, the son of Fred Lundahl, who was called "Buddy L" to distinguish him from the other Buddys in the neighborhood.

The Moline Pressed Steel Company had been in business since before World War I, and in 1921 the firm contracted to make parts for International trucks for International Harvester, which, suffering a hiatus in its business, suspended the deal. Lundahl, who had already made sturdy automotive toys for his son, turned his inventive mind to them as an alternative product. He took a sample to F. A. O. Schwartz, who was mightily impressed by Lundahl's toys and salesmanship and ordered 500 of them. The factory turned out 4,000 pieces in the first year. At the 1922 New York Toy Fair, Lundahl exhibited an Express Truck, a Dump Truck, a Steam Shovel, and Ford Model Ts – at last a pressed-steel group of Model Ts. There was an impressive increase in production up to 1925, when 200,000 items left the factory.

These toys were in a class of their own. They were made of thicker steel (22-gauge to the others' 28-gauge), with the cowl and body riveted together and spot-welded on to the chassis and with a fully working steering wheel. These realistic indestructible toys worked very well. They were big, 24 to 36 inches long, and strong enough to be sat on and scooted along with the feet. You could kneel on the open-truck body, with one hand on the hood or fender and the other on the steering wheel, pushing with your free foot. It became common to supply them fitted with a removable bicycle or tractor-like seat. Their prices were high – in the same line as Structo sets – but they were cheaper than pedal cars; there was nothing else like them, and the economy was booming. Lundahl did not lose his ties with International Harvester when he went into toy production; indeed, he made the Red Baby truck for them to sell as a "part" from their catalogue.

The Buddy L factory was expanded, and in 1926 it made a non-automotive concrete mixer that could actually mix concrete "Just like the Big Ones."The pride of the early line was undoubtedly a 1927 model of an International Coach, 30 inches long and weighing 16½ pounds. The same year, a color advertising leaflet devised by Lundahl, *The Story of Buddy L*, promoted the line; 1928 saw the production of a Trench Digger that could dig scale trenches. The 1930 retail price list featured ten trucks, four fire vehicles, eight pieces of construction

above: The excellent International Coach manufactured by Buddy L

(74cm/29in, c.1927, USA).

equipment, a cheaper Junior Line, a selection of Fords, and a similar quantity of railroad items. The firm was going from strength to strength. Meanwhile, disastrously, the Wall Street market crash in late 1929 precipitated the world economy into a major recession. By 1933, fourteen million people were out of work, industrial production was half that of 1929, and only twenty Buddy L toys, a quarter of the 1930 list, were in production.

OTHER AMERICAN

MANUFACTURERS

The heavier gauges of pressed steel that toy makers used were equally suitable for the larger, child-carrying pedal cars. The Sears Roebuck 1919 catalogue shows a selection, from "Low Priced" (\$6, exactly the price of the Structo set) steel and wood toys that were small and basic (frame, seat, hood, steering wheel, wheels and pedals), through "Medium Priced" (similar, but with windshield and a trunk on the rear) to "Crackerjack Value" (similar-looking but mainly steel). Unfortunately most of these and an all-steel type were unmailable; unless you lived near a railroad station, they were very difficult to obtain.

American National Automobiles of Toledo, Ohio, and Steelcraft of Murray, Ohio, both made steel toys and pedal cars during the 1920s and early 1930s. American National Automobiles made a great line of pedal cars – "The premier line...exactly modelled after the real cars...lustrous enamel finishes in flashy color combinations. Each with adjustable pedals" – from a very cheap basic Whippet to a Marmon and a Studebaker. The listed equipment improved as you went up the line, from "cast steering wheel, gas lever, motor meter and pedals," through "composition steering wheel, gas lever, horn, instrument board, adjustable windshield, nickeled motormeter, metal headlights, license plate, gear shift, rubber pedals, oil can, oil," to "composition steering rod, gas lever, French horn, instrument board, nickeled adjustable windshield, spotlight, nickeled motor-meter, metal lamps, license plate, gear shift, stationary hood, round bumper, 'die-form' fenders, rubber pedals, motor buzzer, oil can, oil."

In their general line, Steelcraft made GMC trucks in the mid-1920s and added the distinctive Mack bulldog cab later. They made a Mack pedal dump truck, suitable for three- to sixyear-olds; a Model T Roadster, for two- to five-year-olds; and a Dodge Runabout, for three- to seven-year-olds. Big brothers, or rich kids, could have a Chrysler Roadster: "Very sporty, isn't it? Bullet-shaped headlights, spotlight, real rubber tires and all the fancy trim. A real car for you. Length, 50½ inches overall. \$31.50." Surviving the Depression, Steelcraft made up-to-date models, including an Airflow Dump Truck. Their later production included a Pedal Racer and a Lincoln Zephyr pedal car in 1941.

After 1914 there was a gap in the market brought on by the embargo on the import of German toys. Apart from Strauss and A. C. Gilbert, there were virtually no experienced American manufacturers of cheap, bright, attractive, lithographed tinplate toys - and even Strauss does not seem to have been in operation around 1920. J. Chein (pronounced Chain) & Co. had been in business in Harrison, New Jersey, since the turn of the century, and in 1925 began producing a series of a Mack bulldog trucks, many decorated with excellent lithography in clear, bright colors. There were fourteen different versions, ranging in size from 17 to 30 inches long. A number of these were simple dump trucks or wreckers others, such as the orange Hercules Ready-Mixed Concrete barrel truck, have a very high "desirability factor" among collectors. They are fitted with lithographed wheels, with the white tires marked "Hercules USA Chein T. M.," so for once there is no difficulty in identifying the maker. They also made generic square-hooded trucks and buses, including a beautiful Royal Blue Lines Pullman Bus. The line continued until the mid-1930s, and the firm remained in business making toys until 1979.

Girard is a name that keeps cropping up as a manufacturer of a wide variety of tinplate mechanical toys, but little is known about the history of this firm. Not all of its toys were marked with a name, and they do not seem to have survived well. Other litho tinplate manufacturers, such as Wolverine and Lindstrom, appeared at the tail end of this postwar period; toys from the latter company became important as advertising vehicles, carrying ads for LifeSavers, varieties of biscuits, and so on. But the main story at this time is that of the prodigious rise of Marx.

MARX

Louis Marx was employed by Ferdinand Strauss around the beginning of World War I and was soon running the factory. After they fell out, Marx set up his own business, Louis Marx & Co., and bought an existing toy plant in Erie, Pennsylvania. At some time he also acquired dies from Strauss and Girard. These are the bare bones of the moves Marx made for strategic or tactical reasons. This genius, who had an instinct for what would be popular, created new product with aplomb, borrowed ideas without too obviously plagiarizing (where borrowing was appropriate), ruthlessly broke into markets, kept his firm going through Depression and war, and established factories worldwide, becoming in the 1950s the world's biggest toy maker. He sold out in 1972 at the age of seventy-six.

"Mechanical Toys That Are Durable and Mechanically Perfect" was the Marx slogan, but what drove him was the conviction that he needed to make better toys for less money. He was not above investigating competitors' products, pricing structures and manufacturing sources, both in America and Europe, in his attempt to do just that. A successful product was not one that was merely cheaper than the competition, but one that appealed to the purchaser — both adult and child. Six qualities were needed, Marx stated: familiarity, surprise, skill, play value, comprehensibility and sturdiness. Given the appeal novelty action toys had in America, this might seem to be a fairly obvious set of criteria, but the important thing is that they were laid down and on the whole adhered to, keeping the firm on a consistently successful track. The name was kept in the public eye by printing – on the outside of the toy, not hidden underneath – the distinctive trademark. Even at a quick glance, the X of Marx inside a circle stands out.

The most distinctive and memorable group of Marx toys were the Crazy (or Funny) Cars. The Funny Flivver of 1926, with its pivoting front wheels and rotating driver's head, was the simple beginning of a style that lasted up to 1941. These cars were lithographed tin wind-ups fitted with integral drivers, with larger wheels at the rear and an eccentric action that caused the front wheels to turn in apparently random directions and the driver's head to rotate.

As the years passed, the action became more complicated, so that the vehicles bucked about, "causing" the figures to jump and shake. Such novelties were also applied to commercial vehicles. A fire engine with a fireman up a ladder worked on the same principle as the Funny Flivver. The best-known example from this era is the Joy Rider type, which came in many variations over subsequent years: "Joy Riders Elope," says a 1930 advertisement, complete with speed swirl drawings. "His head's in a whirl – and his 'girl friend' holds on for dear life! Backwards, forwards, around and around. They're getting nowhere fast." The diminutive girl sits back-to-back with the driver on the trunk, which actually looks like the piece of luggage and is the back-stop to prevent the vehicle from overbalancing backward as it bucks and scoots around. All this you got for just 49 cents, including postage.

The college boy Old Jalopy type began with the Leaping Lizzie in about 1927. These Ford Model A-type "old bangers" were run around campuses, their dents and rust patches covered with amusing remarks: "Four wheels, no brakes; My Lizzie of the Valley; Hop Inn..."There was no limit to the variety of action toys. There

below: The Tri-ang Ford Royal Mail Van, made by Lines Bros, is marked with the early 'Triangtois' trademark (46cm/18in, c.1933, UK).

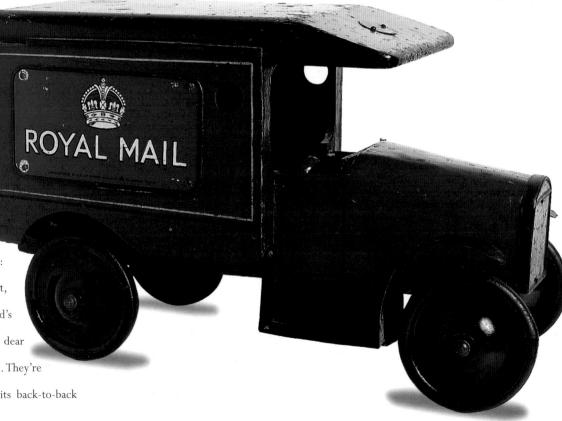

was a four-piece tractor set with a guaranteed unbreakable Marx spring; an aluminium Tractor that climbed over books or sand; Mack trucks made out of many pieces of tabbed and folded, prettily lithographed tin; a similar Fire Chief's Car with siren and bright and dim electric lights. The advert for the "Motor Cycle Cop, Entirely new and different motor action in a modern looking motorcycle! Upsets to either right or left...rights itself...and then another upset! Surprising action!" has the explanation that the motor is geared to large side keys to make the toy automatically right itself. Then there were racing cars, bus stations, gas stations and many non-automotive toys as well, all at competitive prices. That Marx was in really good shape to survive the Depression is indicated by the date of introduction of the Motor Cycle Cop – 1933. lettering, for example: "Junior Supply Co. New York 1923 Philadelphia" cast on a Mack parcel truck. Kenton became known for its commercial vehicles, many of which have their names cast on the side: there is an OIL GAS tank truck; a CONTRACTORS' dump truck, a JAEGER cement mixer. Apart from the PICKWICK NITE COACH, a distinctive longdistance coach with its upper deck shorter than the lower, Dent's good lines of double-decker buses, coaches, and fire engines often have no markings. Over the years, the wheels varied from heavy-spoked wheels through solid discs to wooden hubs with white balloon tires. The styles of the truck cabs kept up with those of full-size manufacturers, so rough introduction dates can be worked out.

CAST IRON

right: This Arcade Yellow Cab with painted finish (18cm/7in, c.1932, USA).

great, but the new style of toy by no means ousted the old. *1932, USA*). Williams continued producing a small Model T doctor's coupé and a good

The contrast between lithographed tin and cast iron was

Fordson tractor. Meanwhile, Dent went on making its fine castings, few of which were marked with the name but had clear, raised

ARCADE

Arcade became the most prolific American manufacturer, and most of its toys are marked inside the casting. The company had been in business since 1868 and changed its name to Arcade in 1884, though it did not make its mark in the production of automotive toys until the 1920s. Then it set about making deals with the full-size manufacturers, so that most of its products are models of actual vehicles, including Fords, Chevrolets, Mack trucks, Fordson tractors, and Fageol coaches. Moreover, it made exclusive deals with firms like Yellow Cab and produced special items for promotional giveaways, including a truck for Brinks and, later, a milk-bottle-shaped vehicle for Borden. "Perfect pocket size reproductions of the 'real ones' sturdily built - no clockwork to get out of order." Character merchandising, popular since the turn of the century, was exploited, too, with a good representation of the Andy Gump "348" car. The vehicles often came in two sizes, referred to in advertising simply as large or small, the sizes varying mainly between 5 and 13 inches. Commonly the finish was one single color – often red, blue, or grey – with the name Arcade applied to a door with a black and gold sticker. However, the Yellow Cab could be bought in yellow with a black top, or in yellow and red, brown and white, black and white, or blue and white. The castings are well detailed and very neat, but they are usually not intricate, with only simple working parts such as tipping mechanisms.

Arcade does not fit too well the end-of-1933 chapter

division that is used in this book, because of a very happy circumstance. In 1933, to combat the sense of desperation about the economic situation, Chicago mounted a grand exposition, the Chicago Century of Progress. Visitors were to be transported around by specially designed GMC articulated buses that were operated by Greyhound Lines. The dark blue, long-hooded cabs pulled white trailers, and their windows were edged like scalloped blinds. They were decorated with the dark blue Greyhound trademark and the roofs carried an appropriate legend. Arcade made the official replicas for sale as souvenirs. They came in five sizes, ranging from 5½ to 15 inches, and were a raging success. So was the fair. It was held again in 1934, and once again Arcade produced the souvenirs. What a way to bridge the problem years! Many examples of these toys have survived.

Arcade continued to produce realistic models: the Ford Sedan of 1934 replaced the one that was produced in 1930, which had in turn replaced that of 1924; the wreckers and other trucks were updated with the new cab styles; white rubber tires replaced the chromed cast wheels. Promotional and souvenir items remained a large part of Arcade's production, and they made even more groups of buses, including two sizes of Greyhound bus for the Great Lakes Exposition of 1936, three sizes of the 1939 New York World's Fair Bus and two versions of the same fair's Tractor-Train. A recent publication lists the 263 different Arcade toys in their variety of lengths.

HUBLEY AND KILGORE

Hubley Manufacturing Company, a cast iron maker of very long standing, came to be Arcade's main direct competitor. It usually marked its toys, but many are in any case distinguishable by their complexity. Some consider that Hubley's 11-inch-long 1927 Packard Straight 8 is the finest cast-iron toy ever produced. The long-hooded, elegant model has front doors that open, a driver sitting on detailed seats and hood sides that open to reveal the engine. The scarcity of this toy is occasioned partly by its original high price, which caused it to be dropped from the catalogue as the recession began to bite, and partly because it was much more likely than other cast-iron toys to get damaged in play. Hubley's five-ton truck came complete with tools. The General steam shovels could be used to dig sand or dirt, which the Huber Road Roller -- its complexity increasing through the five sizes - could then roll flat. There was also the Elgin roadsweeper, an excellent working model, which could sweep the road clean.

Produced, as was the real thing, after the economy began to recover, three sizes of Hubley's Chrysler Airflow toys had take-apart bodies, while a larger fourth size even had electric headlamps. Hubley had one area virtually to itself – motorcycles. Many of the toys authorized by the manufacturers are finely detailed, and the name Indian, Harley Davidson, or whatever can be seen clearly written on the gas tanks. The very accurate solo motorcycles, with sidecar or tricycle-type bikes, are all fitted with riders – some integral, others detachable –

0

portraying policemen, postmen, or civilians. Hubley proved to be among the most desirable of American toy makers.

One of several other smaller manufacturers that produced cast-iron toys and should not be forgotten is Kilgore. In business from 1920 to 1978, Kilgore Manufacturing Company made low-priced quality toys, but excelled in the late 1920s with a multipiece Roadster - now considered to be a Pontiac similar in size to Hubley's Packard. The body is separate from the chassis, and the radiator, bumpers, sidelight-cum-cowlband, windshield surround, and wheels are all chromed. Kilgore survived the recession by making small ten-cent toys with rubber wheels that challenged the up-and-coming diecasts of Tootsietoy. It also went up against Hubley with a small group of motorcycles. This most flexible company was arguably the first, in 1937, to use plastic (Bakelite) for small 4-inch auto toys. When the firm closed, two much-photographed, nickelplated showroom examples of a 1934 Ford V-8 Coupé and a Sedan were sold to a collector (the original toys were painted).

GERMAN MANUFACTURERS

When World War I ended in defeat for Germany, the country was in a sorry state: the government was weak; the reparations demanded drove it close to bankruptcy; and inflation raged. But Lehmann's production continued apace. Although part of Germany's market, America, in the main refused to buy their toys, though the rest of the world still wanted them. Lehmann had had the foresight to bill in the most stable currency, the American dollar, and thus it had no difficulty defying inflation, because it was able to purchase raw materials at a competitive price. The bulk of the production was still novelty toys, but the style of the clockwork, lithographed tinplate automobiles was brought up to date, starting immediately with a curvaceous Terra town car. This was later released, as usual, in other named liveries, including a yellow and black taxi. The rest of the saloons were squarish and ranged from a thin tinplate Sedan at 5½ inches to the quality electric-lighted Luxus at 13 inches, resplendent in cream and red, and its non-lighted companion, the Gala. There were garages suitable for the Sedan and the Galop racer. Very scarce now is the Deutsche Reichspost mail van, as is the delightful group of four motorbikes, which remain stable on two wheels by means of a gyroscope hidden within the frame cladding. These toys remained in the catalogue variably up to 1935 and 1940, neither Lehmann's death nor the rise of Hitler to power in the early 1930s affected their popularity.

The roll call of German toy makers – Hans Eberl, Bing, Karl Bub, Distler, Doll & Cie., Fischer, Günthermann, Hess, George G. Kellermann, Märklin, Tipp & Co., Oro (Orobr) – shows that although they did not find the going as smooth as Lehmann did, economic and political difficulties could be overcome by strong export products. Bing found that its output had to change, from exclusive toys for the rich child to a cheaper product that more people could afford. Tinplate became thinner and the pressings were simplified, though opening rear doors remained a feature. Cheaper clockwork motors were used and steering was also simplified. The earlier complex patterns could no longer be created, but Bing dabbled with a remote steering system. Separate brass or nickel lamps were not fitted, though the top of the line had large, battery-powered electric light bulbs. Hand enamelling was no longer used, and even large, flat areas of color were lithographed. Many of these changes paralleled the

move to greater standardization in the fullsize vehicles, typified by four versions, all 7 inches long, of the Model T – all in black, of course. After Bing was bought by Bub in 1933, some of

below: A Ford Model A Truck with the details of Arcade on the castings (cast iron, 15cm/6in, c.1932, USA).

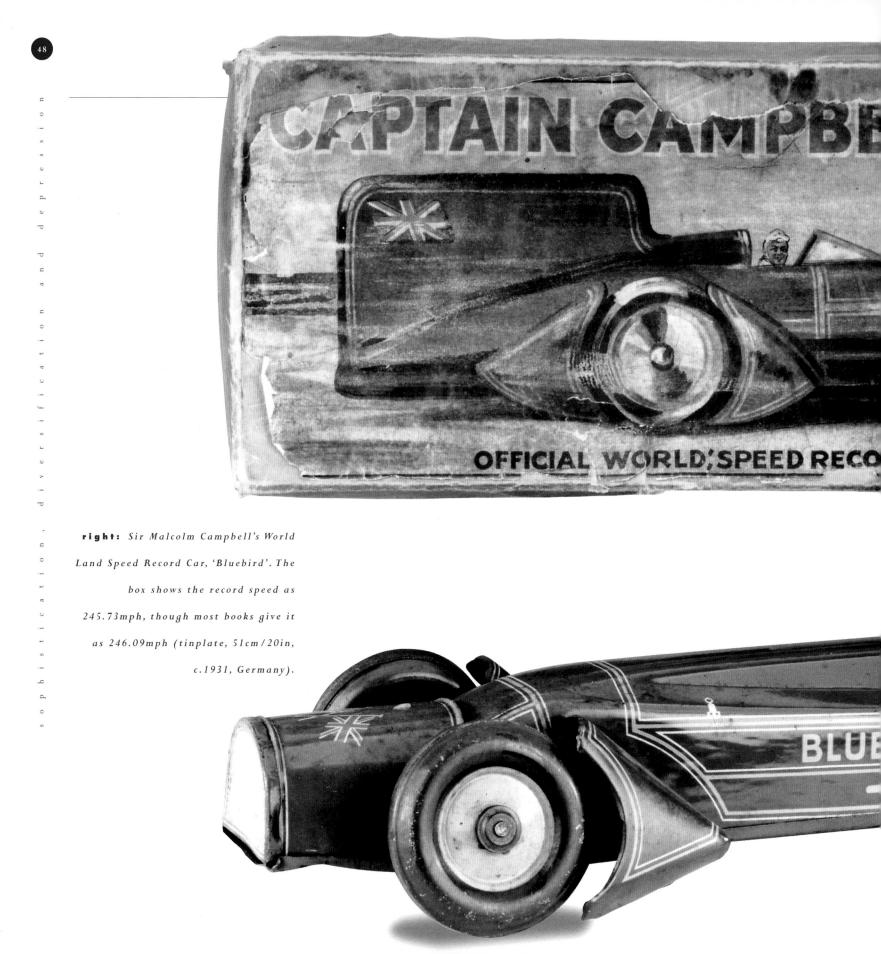

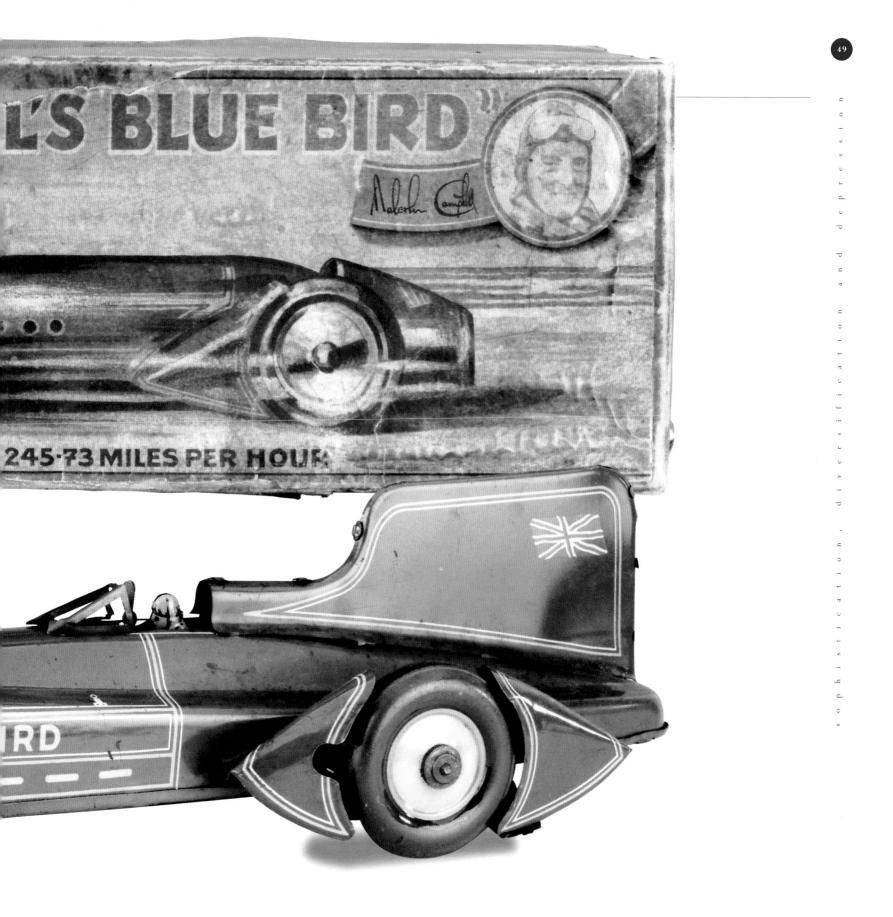

above: The Doll & Cie Open Steam Wagon, no. 802, is driven by a singlecylinder steam engine found under the hood (51cm/20in, c.1929, Germany). its models were still made under the original trademark.

Bub had already acquired Carette, and by the 1920s it was ready to go into mass production. With so much input from

takeovers, Bub did not develop a strong house style, and it is mainly identifiable from the K. B. N. trademark and the relatively inexpensive, but classy-looking, lithographed tinplate wheels. A smart 12-inch-long boxy saloon has wooden spoked wheels nicely represented on a solid disc of tin. In their extensive line, there was also a taxi that had been given a more up-market treatment than usual: a yellow cab complete with electric lights, steering and a driver. Günthermann also thrived in this era, making clockwork-powered saloon cars and tourers running on wheels with rubber tires, but its most spectacular toys were speed-record cars. In common with Kingsbury, it made a Golden Arrow. Its Bluebird III has lithographed rivet detail. Kay Don's Silver Bullet was the longest of the group at 22 inches. All of these Kingsbury and Günthermann toys were individually boxed, and the illustrations, some of which included pictures of the drivers, look as if they were officially approved. Another German firm, Tipp & Co. (Tippco) made toys, some of them on quite a large scale, in well-printed but much thinner-gauge tin. Around 1930, in an unaccustomed outburst of European frivolity, it made an open tourer for the Christmas market. Decorated with pictures of toys, it carried in the trunk a pine tree fitted with electric lights and was driven by an rather unhappylooking Father Christmas.

FRENCH PRODUCTS

France suffered from its lack of an industrial center. There were many small factories scattered in village locations, which made raw materials difficult to source and the finished product hard to distribute. Nevertheless, two toy firms – typically and patriotically making recognizable models of French vehicles – had been in business since before 1900. Charles Rossignol used his initials C. R. as his trademark and made his first model, a steam tram, in 1880. The first car, a Renault Taxi 7 inches long, was produced in 1905, but the firm is famous for a line of buses made between 1923 and 1929. The single-decker Paris bus, with its distinctive cream windows and roof and the lower part in green, was made by both De Dion and Renault, becoming more modern over the years (as the driver's cab was enclosed, and so on). Rossignol faithfully mirrored the changes, producing accurate models in several sizes finished with lovely lithography. Vans also featured in the catalogue, as did cars. In 1930 the company made a group of Renaults - sports, coupés and cabriolets - all with electric lights, opening doors and trunk. The company even supplied a lithographed tin garage in which to park them. The firm was notable for making a much wider range of sizes than was usual, from Pennytoys to large floor toys.

JEP (Jouets en Paris) began life as SIF, then traded as J de P between 1928 and 1932, and it remained in business until 1965. Early product was poor and cheap, but as J de P the business became a quality toy maker, it produced Renault, Hotchkiss and Rochet Schneider cars about 11 inches long. These were followed by even more impressive Renaults and some Bugattis. JEP also made larger-scale tinplate cars with accurate radiators – Hispano Suiza, Rolls-Royce, and so on. In those days of coachbuilding (apart from Renault, whose early cars had the distinctive "coalscuttle" hood), it was mainly the radiator that distinguished the make. JEP also reproduced a typical body and mechanism, including prop shaft and differential, with studied realism, to complement the grilles.

Accuracy was epitomized by the legendary Alfa P2, manufactured by CIJ (Companie International du Jouets). This distinctive 21-inch racing car, with its high, long hood and pointed tail, was made in thick tinplate and fitted with wire wheels with rubber tires. The pressings are well shaped and fit together neatly. The

below: The Märklin Tractor uses a two-speed pulley mechanism (27cm/10.5in, c.1929, Germany).

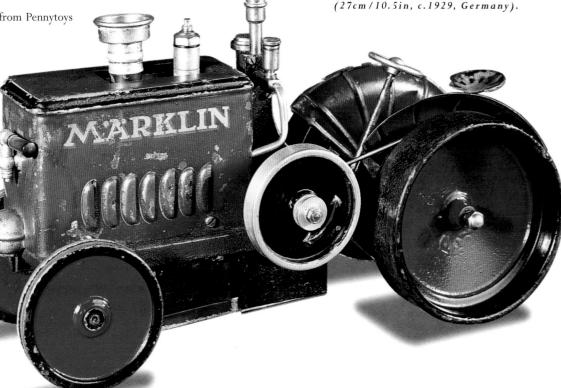

steering worked and had a powerful clockwork motor. Made for several years, it featured leaf-spring suspension, hinged filler caps, leather hood straps and a single-color painted finish (red, blue, or green). This was a very popular toy in many European countries, and it is puzzling that CIJ did not make anything else like it. Neither, mind you, did anyone else.

The range of scale cars is Jouets Citroën. The models were

below: A Bub Four-light Limousine equipped with its own toolbox (tinplate, 30cm/12in, c.1922, Germany). 15,000 10cv Torpedoes were sold during the first year,

conceived as a marketing tool for the promotion of Citroën's full-size vehicles, but they were a phenomenal success as toys. They were first released in 1923, and

prompting the release of a 5cv C3 cloverleaf in 1924, a delivery van and a B2 taxi in 1925, the new 10cv Torpedo in 1926 and the flat-bed lorry and coupé in 1927. André Citroën is quoted as saying: "The child is our future

client. His first

three words must be Papa, Mama and...Citroën."The pressings, with their realistically scaled roof, hood and trunk curves, have a no-nonsense solidity that characterizes the full size and makes them the best model cars of the era. The enamelled finish mirrors the rich colors of the full-size vehicles. The C6 chassis, the most desirable of kits, comes complete with the correct dashboard, carburetor and electric lights, as well as the usual steering, suspension and transmission.

ITALIAN COMPANIES

The turmoil of a recently unified Italy led, in 1921, to the rise to power of Mussolini, and the resulting period of stability enabled a small toy industry to develop. Metalgraph, in industrial Milan, made its first car in 1920 and its last at the end of the 1930s, although it concentrated mainly on its industrial tinplate lithographed packaging, cracker boxes and the like. Its mid-1920s production - a coupé de ville, racers, and a delivery van – were of average quality and no competition for the German toys. From about 1920, Ingap (Industria Nazionale Giocattoli Automatici Padoua) of Padua used tin to make a very wide line of toys. The business thrived, expanding from just twenty employees in 1920 to around 600 by the beginning of World War II. E. Cardini's line included only five vehicles during the 1920s, but its all-metal, stoveenamelled, clockwork Fiat 18BL lorry is of excellent quality.

BRITISH MAKERS

Britain's lithographed tinplate manufacturers owe their skill to the industry that churned out well-printed and sometimes ingenious cracker boxes and chocolate tins – some in the shape of the firm's delivery vans. Other manufacturers owe the inspiration for their product to Bing and the other German firms. The tinplate was usually thin but well printed, and the clockwork was commonly a cheap coil spring. Whitanco is reputed to have made the first toy car in 1915, and by 1919 had illustrates vans with two types of cab – an early open style and a subsequent closed one – with a series of different decorations: ambulance, Royal Mail and Carter Paterson Express Carriers, and the Stop Me and Buy One ice-cream van with a driver. Burnett made some delivery vans and a couple of Ubilda kits suitable for even the most ham-fisted child.

One of the most significant developments in British toy making took place in 1919. Three brothers broke away from their family company, which had been making toys and baby

made 1½ million toys, though not all were vehicles. Despite their use of German tooling, competition from Europe forced the firm out of business by 1923. The survival rate of their fragile product is low. Brimtoy began production during the same period and may have been directly inspired by German product. They were taken over by A. Wells & Co., whose trademark consisted of country-style, roofed water wells, romantically labelled Wells o' London. Its 1931 catalogue carriages, to set up Lines Bros Ltd, whose witty trademark is a triangle (a device made up of three lines). By 1925, their Merton factory on the outskirts of London was the most up-to-date, and they were producing pull-along wooden toys, some featuring molded plywood, as well as making steel and wooden pedal cars and three-wheeled Fairycycles for younger children. There is also a shiny aluminium caterpillar

above: These André Peugeot 201 Vans may have been promotional containers (tinplate, 15cm/6in, c.1932, France).

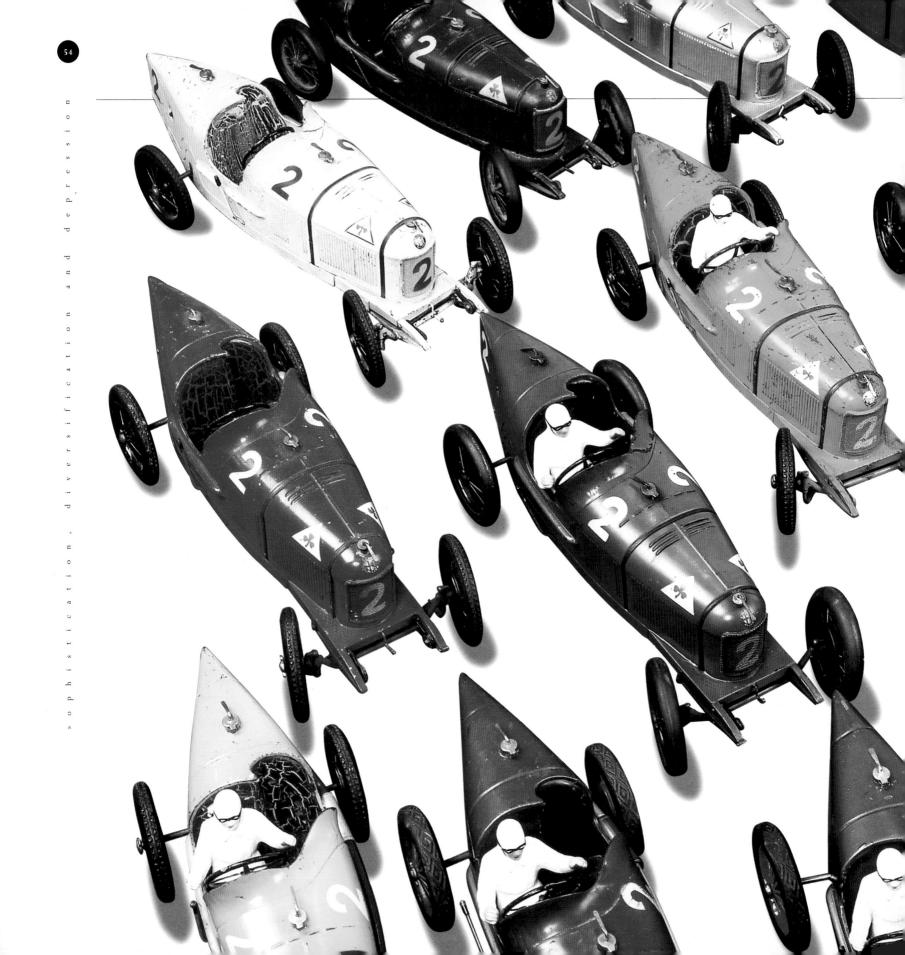

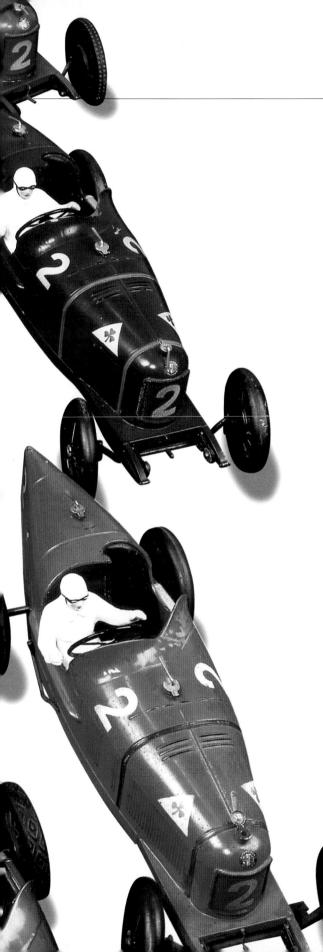

tractor that can climb over a pile of books that is similar to one made by Marx and makes one wonder which of these inventive firms conceived it and which "borrowed" the idea.

At the beginning of the 1930s, Meccano Ltd – a company renowned for making constructional sets, with which a child could make anything from wheelbarrows to cranes and bridges – adopted the idea of making sets to create cars. Enough pieces were supplied to make a racing car with long

tail and separate wings or a sports car with short tail and integral wings-cum-runningboards, and so on. There was not a great deal of flexibility, but the colors were vibrant and two sizes were made. If you could not build them yourself, you could buy the

made. If you could not build them yourself, you could buy the larger size already put together and one similar to the smaller size in a non-constructional version. They were all produced up to the end of the decade.

There was a number of accurate vehicles in unusual materials. Wallwork made two large cast-iron buses – a singleand a double-decker. Ranlite (Automobiles Geographical Ltd) experimented with Bakelite, one of the early plastics, producing two saloons and a Golden Arrow record car in 1931. These were expensive toys, but they did not cost as much as the most desirable European vehicles of all: accurate, large-scale pedal cars represented by the Citroën Clover Leaf and the Bugatti Grand Prix Type 52, both made by the makers of the full-size vehicle; the one-off Le Mans Bentley; or Lines Bros' more representational fluted-hood Vauxhall.

far left: These Alfa Romeo P2 racing cars by CIJ were made in many colours (pressed steel, 53cm/21in, 1933, France).

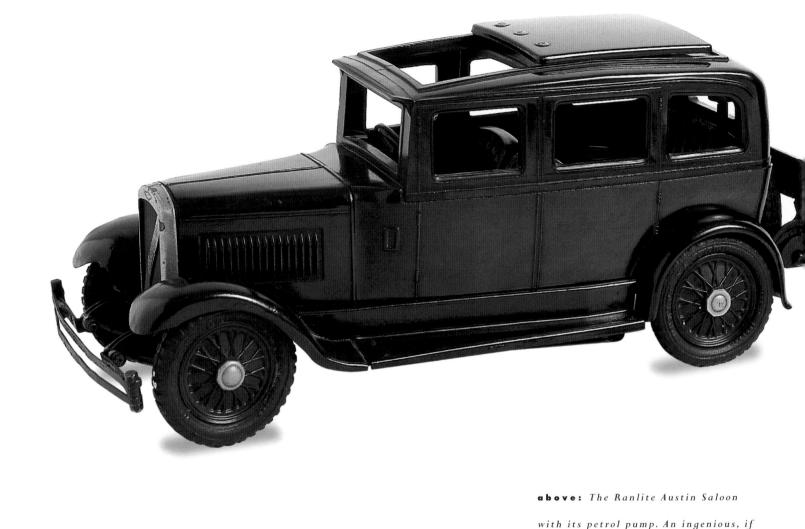

above: The Ranlite Austin Saloon with its petrol pump. An ingenious, if cumbersome, steering mechanism was available as an extra that allowed the child to guide the model while standing (bakelite/pressed steel, 26cm/10in, 1931, UK).

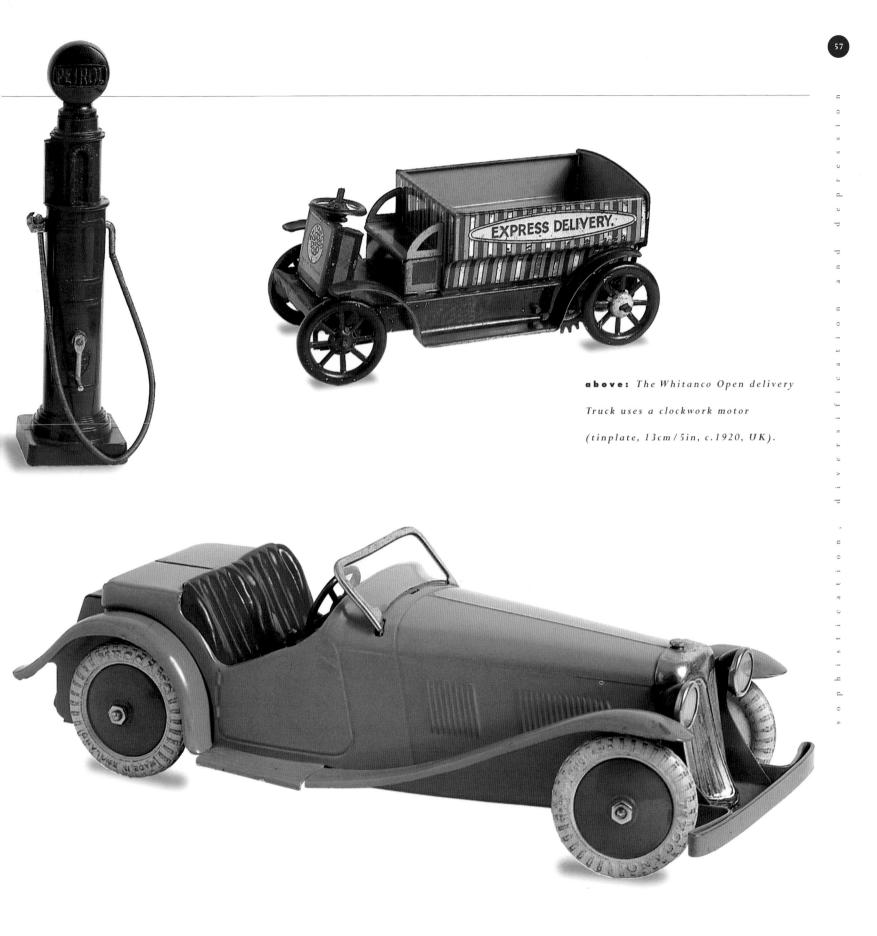

HIGH FIDELITY FOR ALL

In America, the toy car production era of the 1930s did not start properly until 1933, when the newly elected President Roosevelt announced his New Deal programmes to rescue the country from the Depression. By then, many toy firms had gone out of business, and those that remained were running with a much-reduced volume at the cheaper end of theirlongrunning production. The more complicated working cast-iron models with a multiplicity of pieces disappeared from the catalogues, and tinplate manufacturers used up scrap tin from a toy by lithographing the plain side with decoration for a different one.

below: The Tippco Double Deck Bus with adverts showing real products (tinplate, 26cm/10in, c.1934, Germany). Wyandotte All Metal Products had made a line of steel and wood trucks in several sizes during the 1920s, and in the 1930s it simplified its manufacture by exploiting the new American craze for streamlining. Depending on your taste, these pressed-steel toys look "crude," "somewhat unfinished" or have a "1930s charm." The automobiles and trucks were manufactured from as

few pieces of material as possible, with as few machine and finishing operations as was feasible. Just as a soldier's steel helmet can be punched out of a sheet of metal between two shaped platens in a heavy press because all the elements spread out from the center and there are no undercuts, so too can a toy auto or truck body. One tool might punch out the windows from a flat sheet, create the louvres, and cut the metal to size; a second would draw the steel down from the roof to the swelling streamlined fenders. Then the truck's back could be cut and folded, the two pieces welded together and painted, and the wheels fixed on. Wyandotte was very good at producing the streamlined spatted S fenders that distinguish its later toys, which were made very cheaply in vast quantities. A few of these toys are highly collectible. Wyandotte's circus trucks have a

igh fidelity for

lovely lithographed

tinplate back, and it is famed for its coffin-nosed Cord and its La Salle and Trailer set. Wyandotte survived World War II by making wooden toys and was bought by Marx in 1950.

Streamlined fairings over the wheels were not exclusive to one manufacturer, and Metalcraft used the style to update its line of solidly oblong, unsophisticated pressings. The original basic body, with a long hood, square-peaked driver's compartment, and mudguards-cum-running-boards, was based on the White truck, and the backs were used for advertising. A Coca-Cola truck had its rear shaped like a bottle carrier fitted with bottles, the H. J. Heinz Co. truck back advertised Rice Flakes, spaghetti and tomato ketchup. The decoration compensated for the heavy metal, the thick paint, and crude electric light fittings. The replacement streamlined body, though it did not have electric lights, is visually a great improvement. The firm did manage to stay solvent from 1927 through the Depression, undergoing a product revamp in 1933, but it eventually failed in 1937.

WEATHERING THE

DEPRESSION

Structo and Steelcraft were still in business throughout this period, as was Buddy L, but the latter was finding survival hard going. It held its prices so low in 1935 that it almost seemed as though it was having

above: An assortment of tinplate motorcycles by Tippco, Arnold and Mettoy.

a going-out-of-business sale. Indeed, in 1936 it announced that "No more will be made." Paradoxically, the car design that rescued Buddy L was a disaster at full size. The four-light streamlined Scarab failed miserably in the market, but the

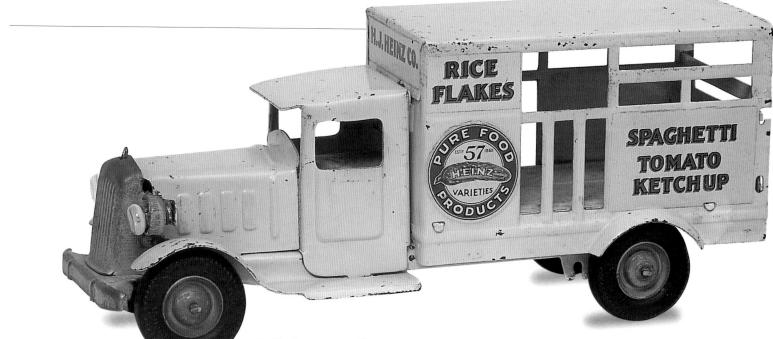

above: A Metalcraft Heinz Delivery Truck with electric lights (pressed steel, 30cm/12in, c.1934, USA). Buddy L toy, a small, squashed-looking single-piece body, available with or without clockwork motor, looking as little like the rest of the line as possible, sold thousands and thousands. Buddy L's heavy trucks had

been updated in about 1933 with peaked cab roofs. Small changes to radiators and other parts were made each year. Later, a prototypical International cab was introduced, and this was altered to follow the upgrades on the full-size vehicle. To make the line stand out on the toy-store shelf, the trucks were given distinctive, bright color schemes. To start with the cab was yellow and the back of the truck red. In 1936, Buddy L had the idea of partially dipping the yellow cab in red paint so that a diagonal split was created, the line running from the top of the radiator to the bottom behind the doors. In 1941, when the cab pressings had been changed to a more modern rounded nose, the color split became horizontal. All these trucks were intended to be sat on and ridden or pulled along with a wire attached at the radiator cap.

In the late 1930s, Buddy L began issuing smaller models, including a clockwork Greyhound bus, at 16½ inches. With the outbreak of hostilities, Buddy L had to change to a material that was not required for the war effort and used wood to good effect. The 1943 catalogue listed four large vehicles – a semi-trailer moving van, a Shell oil truck, a lumber truck, and a hook-and-ladder truck – as well as half a dozen small ones.

Kingsbury's progress during this period is something of a success story. As the automotive styles developed, so did its skill at producing the curved pressings that enabled it to make large models of the new streamline cars, most famously the Chrysler Airflow. These 14-inch-long beauties had enamelled finishes and were available fitted with a horn or electric headlights, as well as with their patented clockwork motor. They were initially produced in 1934 and 1935, the years when the full-size car was in production, and the toys sold far better and for far longer then the originals. The Airflow is *the* example of a car that did not sell to adults, but that, as a toy made by many manufacturers, sold in thousands to children. Kingsbury's winner of 1936 was a Coupé 'n Trailer, a neatly turned-out Lincoln Zephyr with a teardrop-styled trunk line, towing a curtained camper trailer. As an extra, you could buy the trailer fitted with a "radio," actually a musical box. The following year the car was available with further trailers; one with a tent roof, another with a rowing dinghy. A good model of the Divco step van, a vehicle that was designed for door-todoor deliveries and could be driven while standing up, also appeared. The decade was rounded off with a lovely model of the Sky Roof Sedan, a De Soto with a clear rear roof section that could be slid forward in fine weather.

MARX

Marx made such a variety of attractively priced toys that the firm appeared to be weathering the Depression without difficulty, but this impression stemmed from very clever product design and creation. For example, the 1933/4 Fire Chief car, which was eventually made in four versions, all fitted with sirens, was very similar to a 1933 creation sold by Girard under the Marx name. This in turn is thought to be less than accidentally like a 1931 toy made by Kingsbury. Untangling this "which came first: the chicken or the egg?" situation is virtually impossible, but it shows that Marx employed every device to keep costs down: using existing designs, employing preexisting tooling to contain origination costs, and modifying the action or finish of the toy to make it appear different. As a sales aid, the boxes for the toys often had simple but attractive graphics, as did the advertising. There is no doubt about the origin of a later product, however: the Tricky Taxi was originally patented by Heinrich Muller of Nuremberg and presumably sourced by Marx on one of his trips to Germany.

Small simple pressings, such as pointed-tail racers – constructed basically out of one sheet of tinplate, lithographed with all the details of multibranch exhaust pipes and a racing number, and bent and folded to shape with a radiator cowl

fixed on the front and a driver's head in the cockpit — were made in a variety of sizes during the lifetime of the Marx company and are very difficult for the nonexpert to date. The lithography did get brighter and the colors deeper as the years passed, and this can give a clue to the era. Sometimes one can say only

below: A Marx Amos 'n' Andy Fresh Air Taxi Cab (tinplate, 20cm/8in, c.1933, USA).

CHECI

DOUBLE

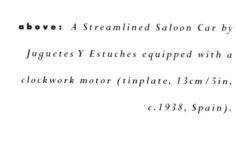

Da

0

right: The Märklin Streamlined Tourer came with suspension, steering, clockwork motor and drive train, with electric lighting available as an extra (tinplate, 38cm/15in, c.1935, Germany).

_

4

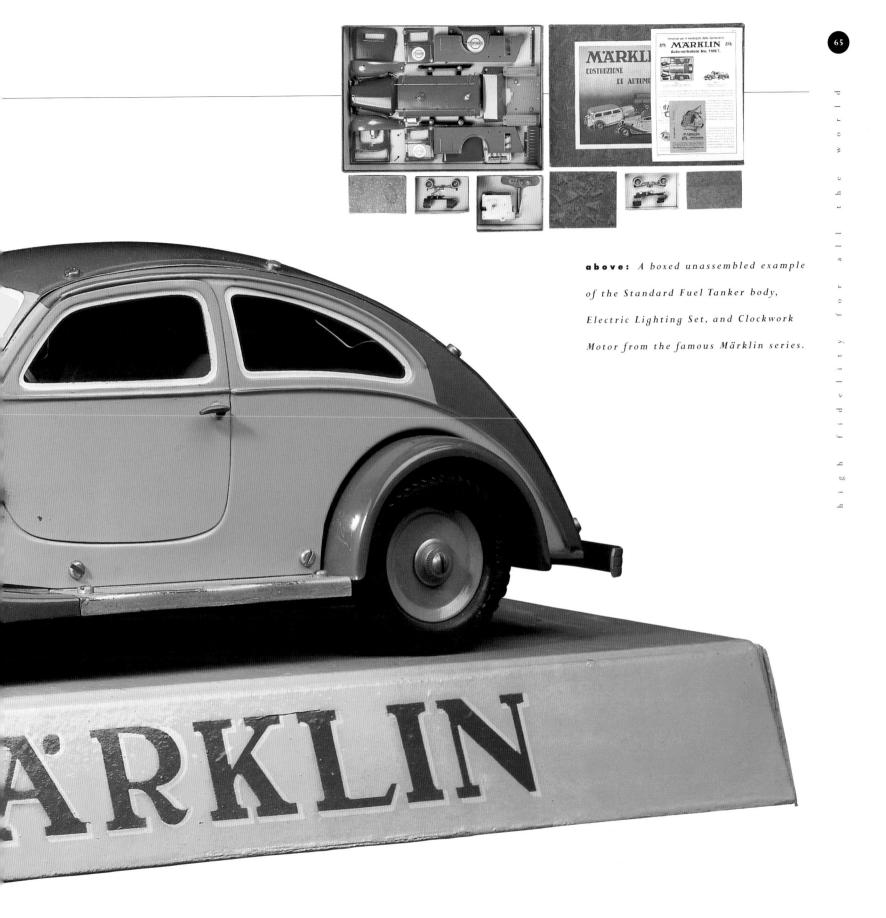

that a toy is prewar (between 1920 and 1939), because the logo is simply MAR superimposed on X TOYS in a circle, or immediately postwar (between 1939 and 1950), when the circle has an outer band reading "Made in the United States of America" – unless it was made in Europe! Luckily, if you want to specialize in collecting the full line, there are publications that go into copious detail.

below: A Marx Funny Car with

Charlie McCarthy in his Benzine Buggy

Th-Carth

PATS PEN

(tinplate, 19cm / 7¹/2in, c.1938, USA).

Marx made trucks by the billion. The distinctive Mack Bulldog was a favorite subject, but its shape was rather complicated to make out of one, or even

two, pieces of tinplate. The deep-sided chassis contained the motor, if there was one, and all the rest of the parts – cab, hood, back, and wheels – were attached to it. The backs ranged from a simple dump-truck box or a tow-truck crane to the much more decorative Coal and Coke dump

truck, oil tanker, US Mail van and a variety of other vans. The basic shape, despite its anachronistic open cab, continued to be made at least until the mid-1930s, even when more modern long-hood trucks, some sharing the earlier backs, came into the catalogue. Toward the outbreak of war, a new shape (streamlined or blobby, depending on how attractive you find it) was introduced. It has a familiar look, since exactly the same principles of manufacture had been utilized by Wyandotte: a wheel-spatted shape was bashed out of a flat piece of metal in only a couple of operations. Trucks with separate backs, buses, vans, and even cars were all made in the same way.

One of the larger products Marx advertised in 1935 was the 14¹/-inch G-Man Pursuit Car. A dark blue and bright red coupé, it was driven by a G-Man – a Federal Bureau of Investigation officer – who fired a noisy, sparking gun. This bright idea was patented, and other clever sales ideas proliferated. You could buy a garage or fire station that automatically released the vehicles to career across the floor when the doors were opened. The Brightlight Filling Station had battery-powered light bulbs on top of the pumps. Particularly attractive bus stations, a Busy Street and a Busy Parking Lot were all made from tinplate printed with highly detailed street scenes. Funny Cars (or Crazy Cars) were available with ever-greater variations of action and slogans: "Is Zat So," "Don't Bring Lulu,""Hotsie Totsie." One of the most famous, Charlie McCarthy, was based on the ventriloquist's

dummy operated by Edgar Bergen. Introduced in 1938, it has become a classic piece, partly because of the care with which the toy was designed, partly because its black and white color gives it a classy look not usually associated with Marx products.

By the late 1930s, cast iron, heavy and lacking plasticity, was becoming a material of the past. While it still suited the shapes of some types of vehicle, it often made the more modern shapes of monocoque road cars and the newest curved-hood trucks look lumpy and unattractive. Arcade used it for its buses, for several lines of tractors — Allis-Chalmers, McCormick-Deering Farmall, Oliver — with a selection of trailers, for fire engines in a variety of sizes, and for car carriers (with cars). This type of vehicle was still attractive in cast iron, because it remained

"bitty"-looking and complicated. The more modern shapes

worked reasonably well in cast iron for a small 4-inch-long

Chevrolet panel van and its ambulance version, but a 1937 Ford Sedan and "Covered Wagon" house trailer, $5\frac{1}{2}$ and $6\frac{1}{2}$ inches

long respectively, failed to inspire, despite their treaded white-

rubber tires and chromed grille/bumper unit.

HUBLEY

By 1936, Hubley had realized that the future lay in a different kind of material, despite its excellent representation of an 8inch-long late 1930s Yellow Cab, which featured a fold-down luggage rack. And so the company began to move toward pressure diecasting in mazac. It used the name Hubley Kiddie line from the original one, which it was still making. The first road vehicle, a generic sedan, was only 3½ inches long. Cast in one piece, it was fitted with white, solid rubber

AST SERVICE

COAST TO COAS

Toy to distinguish the new

wheels. From this unprepossessing start they made a couple of attractive art deco futuristic racers — one in a similar size and one bigger — that would have looked just as good in cast iron! But the lovely, single-piece Futuristic Lincoln, with its vertical tail fin, shows just how fast Hubley was learning about the new material and process. The rest of its prewar mazac production of trucks and fire engines was similarly a curious mixture of shapes, with some that could have been made as well in cast iron, and others that demonstrated competent diecasting.

TOOTSIETOY

The market was not lacking examples of what could be done by the expert pressure diecaster, for Tootsietoy was now in full production. According to sales figures it publicized in a trade catalogue, by mid-1933 production was back to the levels of

above: This Chein Royal Blue Line Motor Coach was not motorized (tinplate, 46cm/18in, c.1932, USA). 1930. Tootsietoy had been diecasting vehicles in a lead alloy since 1921, when it made a one-piece limousine, less than 2 inches long, with open-spoked turning wheels, soon to be

right: This Lincoln is an example of the largest type of model, the child's pedal car (115cm/45in, 1935, USA).

followed by a group of 3-inch-long Model T tourers and the like. Six popular vans – all the same basic casting lettered Grocery,

Milk, etc. - followed three years later. The 1933 catalogue featured, on its first page, Mack artics, a dairy van, a wrecker, and a motorcycle delivery outfit. The next page had Funnies, Andy Gump, Uncle Walt and Smitty and friends in a variety of vehicles. Unusual for diecast toys, the figures bobbed up and down or moved back and forth, but this attempt to compete with Marx failed disastrously, and the toys were withdrawn. They are therefore very scarce, and since the popularity of comic character toys is so great, they fetch very high prices on the collectors' market. The catalogue has a further page and a half of small (2½ inch) and medium (3½ inch) sedans, coupés, roadsters, delivery trucks (including a Mack US Mail), flat-bed trucks, tankers, tractors, racers, military trucks, fire engines, and an attractive Overland Bus. Some were available with or without rubber tires, and most were featured in mixed sets.

Though Tootsietoy did not say so, there was something particularly significant about the models (and they were good models) on the first page. An ad in *Playthings* revealed what that was: "New Hard Metal...500% stronger and

0

33% lighter than our old metal – This metal is practically unbreakable with even rough usage." It was mazac (zamac), a zinc-based alloy. Among its alleged "Seven points of superiority," it was "The first toy automobile with the new type of slanting radiator, beautifully nickeled," and had white rubber tires. The vehicle illustrated was a Graham-Paige, as were the Dairy Van and wrecker. Graham was initially reluctant to have its name used, which was strange since chassis, grille) castings of the high-quality La Salles. Fine castings and interesting vehicles also marked some of the subsequent single-piece issues, in particular the Ford Camel back vans – many of which, decorated with store names, were used as promotionals. The Ford Woody station wagon and some other 1940 issues, including some good Greyhound buses, were reissued after the war, but the previous quality was not maintained.

> With its casting skill and the market penetration of these good, durable and realistically painted representations of a wide range of vehicle types, Tootsietoy swept the board. In 1940, its production was sixty percent higher than in 1933. No other manufacturers attempted to compete on any scale, though some, like Hubley, eventually realized that diecasting in mazac was *the* way to produce high-

quality, cheap, mass-produced toy autos.

Ó

A few other companies found their own niches. Jack and Maurice Manoil had been making lead soldiers, figures, and military vehicles when they broke into diecasting with four large (approximately 4½ inches), good-quality two-piece castings of futuristic vehicles: an aerodynamic car with a fin, a

Tootsietoy had made a

promotional the previous year, and the castings and replication were excellent. A good selection of Grahams, finished in quality colors, was followed by the other three-piece (body,

SLUSH MOLDING AND

POT METAL

Slush molding was a technique that was eventually to fall into disuse because of the superior characteristics of pressure diecasting. Its result was called pot metal because the lead alloy was simply melted in a pot and poured into an open mold, then allowed to cool sufficiently to produce a thick lining; at that point, the surplus was poured off, leaving a rough inner surface. After further cooling, the object was removed from the mold. This method could be employed at home - by melting bits of lead roofing or other broken lead toys - in small workshops, or at fully functioning factories, with accompanying variations in quality. Unless vans, cars, buses, and so on made with this process were identified in some way on the outside, their origin can often only be guessed at, though avid collector/researchers are gradually finding out more information. The Kansas Toy & Novelty Co.-cum-Best Toy production is best documented, because many of their 11/2- to 4-inch toys carry model numbers embossed on the outside, no doubt as an aid to travelling salesmen. In the late 1920s before Christmas, the firm is reputed to have employed fifteen people in two shifts and to have been selling to department stores such as Krees, Kresge, and Sears Roebuck.

Lincoln Toys of Nebraska was run by Stevenson, who previously worked for Kansas Toy. In his heyday in the early 1930s, the improved slush molds had patterned underpans, and

coupé, a saloon, and a wrecker. These toys were soon followed by a few single-piece items, including a larger aerodynamic tail-finned bus that could almost double

above: A Tippco Fire Brigade Turntable Ladder (tinplate, 59cm/23in, c.1938, Germany). for a World War II bomb. The line was small, but the futuristic look appealed very much to the American child who was familiar with the strange shapes of the

Buck Rogers and Flash Gordon space vehicles. The production of these toys continued into 1942 and recommenced for a short time after the war. Erie toys were made by the Parker White Metal Co., based in Erie, Pennsylvania, famous as the home of Louis Marx's company. These nicely detailed, fine single castings, in two sizes – 1936 Lincoln Zephyrs and Packard Roadsters, Ford Pickup trucks and, just before the war, a couple of futuristic vehicles – are now very difficult to find. he claimed to have made 80,000 toys in a three-month period in 1931. He, too, sold to chain stores, including Woolworth, and eventually employed nearly thirty people, producing 30,000 pieces a day. With quantities as vast as this, you would think such toys should be found everywhere, but the soft metal meant that they distorted easily if dropped or run into a wall. In any case, there was no incentive for people to care for what was the cheap plastic toy of its era. Some of these toys are referred to as "hobos," because molds wandered around from company to company. It can be almost impossible to identify them, especially since wheels and tires were often bought from common sources. Many of the toys are crude, but some are nice castings with quite an appeal, including a charming 4inch-long Air Drive Coach, a futuristic vehicle with a rear fin and a propeller on the tail. Its maker has only recently been identified as C.A.W. (Charles A. Wood), who manufactured from 1925 to 1940.

One firm, Barclay, managed the transition from slush molding to diecasting, survived World War II, and stayed in business until 1971 – no mean feat. Like Manoil, they made toy soldiers, and, in about 1930, it added road vehicles to its line. It was the largest producer of pot-metal toys, making more than 150 different items across a range of sizes: army and farm vehicles, ambulances, sedans, coupés, fire vehicles, trucks with loads, racing cars, car transporters with cars, and so on. Many of these were of the same size as potmetal toys from other manufacturers, and some were a little large, but on the whole are of a superior quality. When Barclay went into diecasting, the casting was quite fine, and some toys were even two-piece. An amusement for collectors is to put a slush-mold toy and its diecast version next to each other on the shelf and to challenge others to see if they can tell which is which without picking them up.

Rubber now seems an odd material to use for toys, but it has all the advantages of modern plastic. Indeed, when Auburn Rubber returned to production after World War I, the material that was soon adopted was vinyl. After tires

:	T h	e Tippco Merco	edes Benz
Fü	h r	erwagen," or H	litler's Car
ite,	, 2	3cm/9in, c.19.	39, Germany).

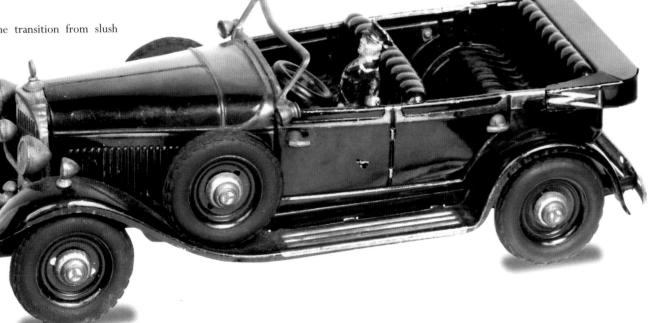

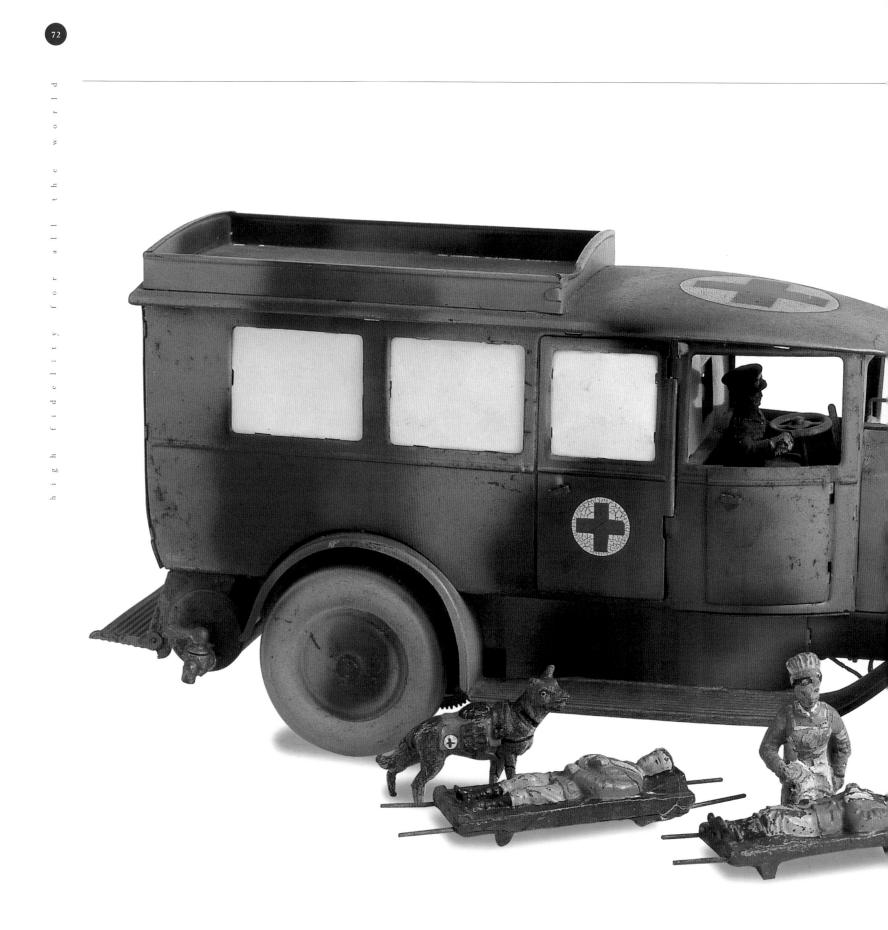

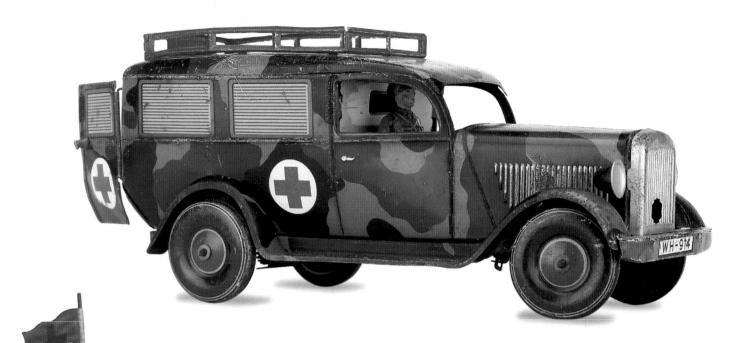

above: A lithographed Tippco Army Ambulance with a composition driver (tinplate, 23cm/9in, c.1939, Germany). ____

4

left: A Lineol Army Ambulance with nurse, wounded soldiers and a Red Cross dog. It also includes a water tank and stretcher racks (tinplate, 28cm/11in, c.1939, Germany).

and stick-on-soles, Auburn came to be used for soldiers and, in 1936, automobiles, producing a most collectible coffin-nose Cord sedan, as well as Fords, Oldsmobiles, Plymouths, and a tractor that sold in vast quantities. In all, Auburn produced ninety different rubber vehicles and twenty vinyl ones. In the same field were Sun Rubber, Rainbow Rubber and other small, unknown manufacturers.

GERMAN EXPANSION

Germany's economy revived as Hitler, who had come to power in 1933, put the unemployed to work building the autobahns that were to link the major German cities and industrial areas. Their long, straight stretches were ideal for the large, power-

above: A typical Tippco Army Troop Transport with soldier figures (tinplate, 30cm/12in, c.1937, Germany).

fully engined, coach-built limousines of the era. This was truly the era of "big tin" toys – 12, 16, and even 20 inches long – and Tipp & Co. made many of them. Tippco had been making a range of quality toys (mail vans, buses, and trucks among them), but it really came into its own after its founder, Philip Ullmann, fled the Nazis, arrived in England and set up the firm of Mettoy. Identifiable by its trademark TCO number plates, Tippco created imposing saloons and coupés, both with and without electric lights. They often had doors that opened and uniformed drivers, and their elegance was enhanced by the discreet, classy colors applied to the large areas of bodywork and roof. Usually the radiators are generic, but Tippco is famed for two Mercedes: their Hitler Mercedes is small at 9 inches, but complete with correct radiator with three-pointed star mascot, rubber tires, steering, and uniformed driver and passengers; the Autobahn-Kurier, at 14 inches has a long elegance created by the teardrop styling of the mudguards and the rakish tail, a beautiful model of a streamlined vehicle. Bub, Distler, and Günthermann were also making large saloons, but a couple of their toys stand out. Bub created a good model of a 1938 Horch 830BL Convertible, with electric lights and rubber tires. Not only do the doors open, but the windows go up and down as well. Günthermann's "Roll-back" roof coupé came in two large sizes – 45 and 38cm (18 and 15in). Its fabric top rolls all the way back to be secured on top of the cabin trunk at the rear. Finished in orange with cream carriage striping, it has the expected technical features of lights, opening doors, and so on.

Gebrüder Märklin had been in business at Göppingen since 1840. Its main production was railway trains and accessories, stations, and lamp standards, though it did produce a few grand automobiles. The 1934/5 catalogue shows the latest line, a group of constructional vehicles that may well have owed its inspiration to Meccano in England. The 1101 series shared a 14-inch-long chassis, and there were six bodies: a streamlined coupé, a pullman limousine, an open truck, a racing car, an armored car, and a fabulous "Standard" gasoline tanker, the last to be introduced and now the scarcest. With a highquality, richly colored finish, their attraction is hardly diminished by the chromed screwheads holding them together.

Though it was difficult for many of the other European

governments to accept, Germany was gearing up for war by expanding its armed forces and developing modern, purposebuilt military vehicles. Other countries may have thought that, along with tanks and artillery, a canvas canopy on a fairly standard, heavy-duty open truck would do as troop transport, but Germany did not. It designed specific vehicles, even though it had to pretend they were for civilian purposes; tracked, armored fighting vehicles were called "tractors," for example. Strict specifications were laid down. Armored fighting vehicles, for instance, were to have at least six wheels, with multiple-wheel drive, to be capable of reaching a minimum speed of forty miles per hour on good roads, have a crew of five men (commander, driver, two gunners and a radio operator), and so on.

Once pretence was no longer needed, certain toy manufacturers were officially encouraged to produce accurate models of these distinctive vehicles. Lineol, Hausser, and Tippco all made large tinplate vehicles in compatible size. Their products ranged from motorbikes 4 inches long, through 7inch Kübelwagens, staff cars and prime movers to ambulances 12 inches long. Most impressive of all at 34 inches combined, was Hausser's Prime Mover and Field Gun, sold finished in green/brown/sand camouflage and fitted with twelve soldiers dressed in field grey. With great attention to detail, many of the pieces had authentic grey or camouflaged paint and were sold with military personnel in the correct uniforms, and ran on treaded rubber tires. Since the government considered that the

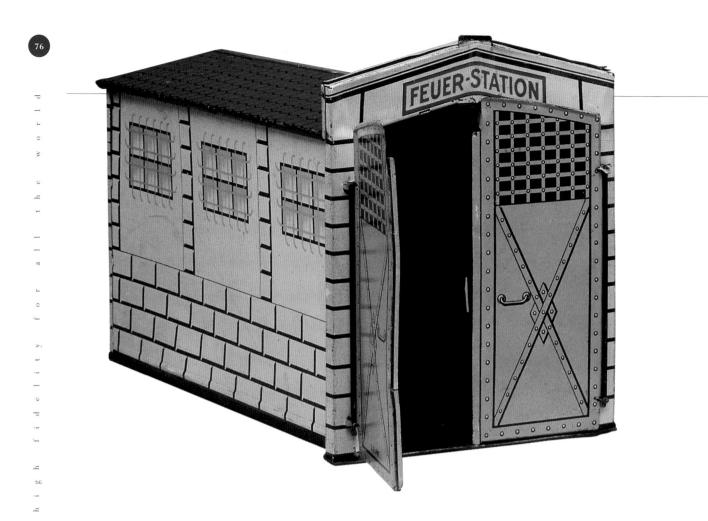

above: A Distler Fire Engine and its Fire Station with five of its six firemen (tinplate, 28cm/11in, c.1928, Germany).

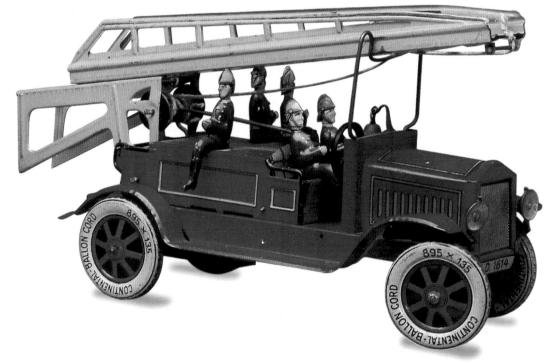

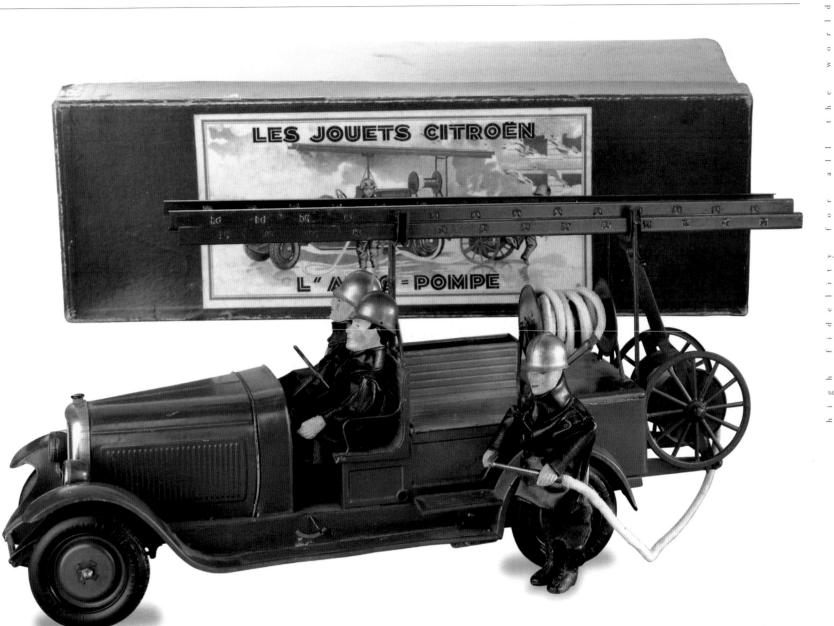

above: A Citroën Fire Engine. The firemen have moving arms and legs. It is very rare to find models of this age with their original box (tinplate, 46cm/18in, c.1928, France). availability of non-essential items was a good morale booster, production of German toys carried on well into the war, with some tooling even being moved to toy producers in Occupied France. Dux tooling, for instance, was sent to the JEP factory and was left behind during the retreat, to be reused by JEP after the war.

FRENCH INNOVATION

In France in the mid-1930s, C. R. (Rossignol) was in full production, making anything from cheap, small, cheerfully printed clockwork vehicles, which were the Pennytoys of their day, through a group of racing cars, to a series of Peugeot

below: Wells Ambulances with drivers (tinplate, 20cm/8in, c.1933 and 12.5cm/5in, c.1929, UK).

0

3

50

Ч

inch red and yellow racing car was made with neatly folded seams and sported a representation of a Peugeot grille, but the

301/401/601 models. A middle-sized, 15-

more important Coupés are good models of their prototypes.

There was even a garage, with an electric light, in which to house them. A 20-inch Transports Routiers van, also a Peugeot, is resplendent in red, yellow, black, and cream lithography; it has a short side ladder to enable the driver to reach the roofrack. The height of JEP's line is represented by superb models of a Renault 40hp and a Talbot Lago 6, which featured, along with electric lights, steering, a well-modelled radiator, and a working six-cylinder engine. Production then tailed off in the late 1930s into simple pressed-steel models. Neither Rossignol or JEP made much of importance after the war.

Les Jouets JRD was producing a variety of items, from small, cheap composition Peugeots to larger tinplate. Just before the war, these included a painted Renault Nervasport with driver, passenger, and a pig ensconced in the dickey seat! Not to be outdone, CIJ, which concentrated its tinplate production on Renaults, made a Viva Grandsport in 1937 with three figures on a bench seat. This was updated after the war

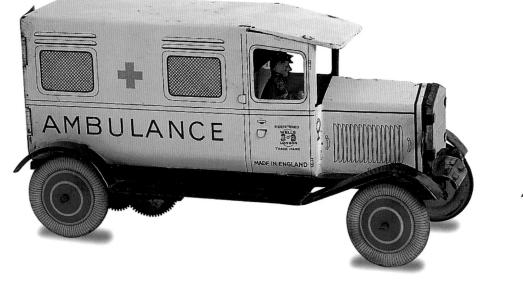

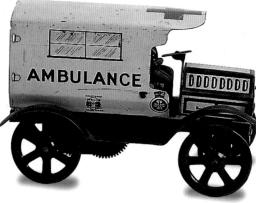

with the replacement of one of the passengers by a poodle!

EUROPEAN AND JAPANESE

COMPETITION

Ingap was the most active Italian firm, making simple but cleanly printed racers and tourers. The Spanish firms Paya and Rico, which had been in business since 1906 and 1920 respectively, had a vast output of cheap tinplate toys, brightly colored, simple, thin pressings with sharp edges and corners. Much of their production, from pennytoy size up, was copied from Italian and German toys. Rico's buses, taxis, and Silver Bullet record cars in two sizes, 11 and 22 inches, have a flimsy charm. Paya's best era, when it made trucks and fire engines 4 to 5 inches long, and saloons and buses up to 14 inches long, was between 1935 and 1940. They also made produced some high-quality bolt-together cars, which have more than a passing resemblance to Märklin Constructors. In the 1930s, Japan was a newcomer on the automotive tinplate toy scene. Its manufacturers gained inspiration mainly

from America, the closest industrialized country. Japan had not developed much of an indigenous car industry and had been similarly affected by the world Depression, but those who could afford it tended to run American automobiles. Kosuge, Modern Toy (MT), Nomura, and several smaller and unknown companies made elegant printed tinplate saloons (Airflows, Lincolns, and Cadillacs among them), American outline buses, racing cars, motorcycle combinations, and so on, in sizes ranging from 8 to 16 inches; a presage of things to come.

English lithographed tinplate could not match the quality of the German product. Wells and Brimtoy, which traded later in the period from the same address, made some attractive vans – Royal Mail, Carter Paterson – and

above: A Minic Tourer, a Rolls-Royce Sunshine Saloon and a Learner's Car (tinplate, 13cm/5in, c.1938, UK). ambulances 7 and 8½ inches long. Their buses and trolley bus were emblazoned with a "Buy British" message, which reinforced the trend already set by the government's

below: A Taylor & Barrett Trolley Bus with a Bus Stop sign by Johillco (cast lead, 13cm/5in, c.1938, UK). imposition in 1932 of a ten percent duty on imports, other than those from the Empire. Wells-Brimtoy racing cars, fire engines and camouflaged military items

have a somewhat cheap and flimsy appearance. On the whole, Mettoy's tin toys were larger, typically 10 to 17 inches long, and the line contained some nice, if plain, saloons. Utilizing the Union Jack and the slogan "Britain delivers the goods," Mettoy's major market was the United States, which was now reopening to imports. Ullmann, Mettoy's founder, had known the value of American market from his experience of running Tippco in Germany.

TRI-ANG

It was the Tri-ang trademark that dominated English tinplate production in the second half of the 1930s. The heavyweight end of its line was represented by the painted British Racing Green finish of the 16-inch MG Magic Midget record car, and by the similar-length Tourer and Saloon; meanwhile it was

making old-fashioned-looking printed tinplate steam-powered trucks. Its major innovation, however, was a series of brightly painted, tinplate, clockwork vehicles – *all to scale with each other* –

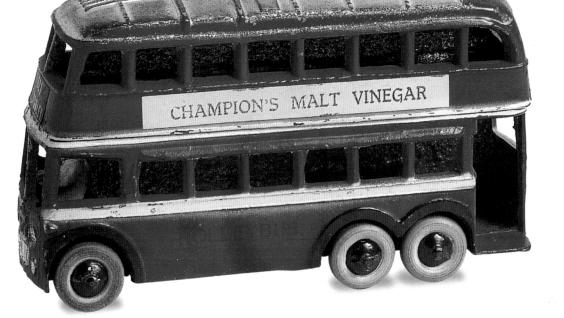

that was christened Minic. These varied in size from the little FordY type, 3½ inches long, through a London taxi at 4¼ inches to the double-decker London Bus at 7½ inches. Most of Triang's toys were generic, and its long-hooded trailer trucks with Minic or Carter Paterson advertisements have a similarity to the American Wolverine line, with its authentic ads.

Though French manufacturers – Eureka in particular – were producing stylish pedal cars with Renault and Peugeot radiators, as well as an attractive representation of a Citroën Rosalie, Tri-ang's pedal cars are the best documented. Lines Bros' 1937/8 catalogue lists no fewer than thirty pedal cars and lorries, ranging from the Prince, a simple steel pressing for two- to four-year-olds, to the sumptuous Electric Rolls:

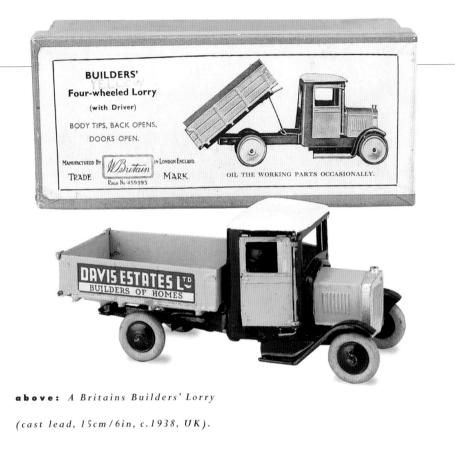

A wonderful luxury model with coach-built wooden body. Driven by 12-volt electric motor on rear axle.

Accumulators concealed under lift-up bonnet. Gear box with forward, neutral and reverse. Band brake to rear

axle. Electric headlamps, side lamps and tail lamp operated by switch on dashboard. Adjustable direction

indicator. Wheels fitted 21/4" Dunlop pneumatic tyres with chromium-plated rims and Schrader valves. Spare

wheel and tyre. Dummy hood. Adjustable upholstered seat. Motor switch operated by foot pedal. For children

up to 12 years. 12-15 miles on one charge at an average speed of 5 miles per hour. All fittings chromium

plated. Now fitted with electric buzzer horn, also electric Stop and Go. Length 83".

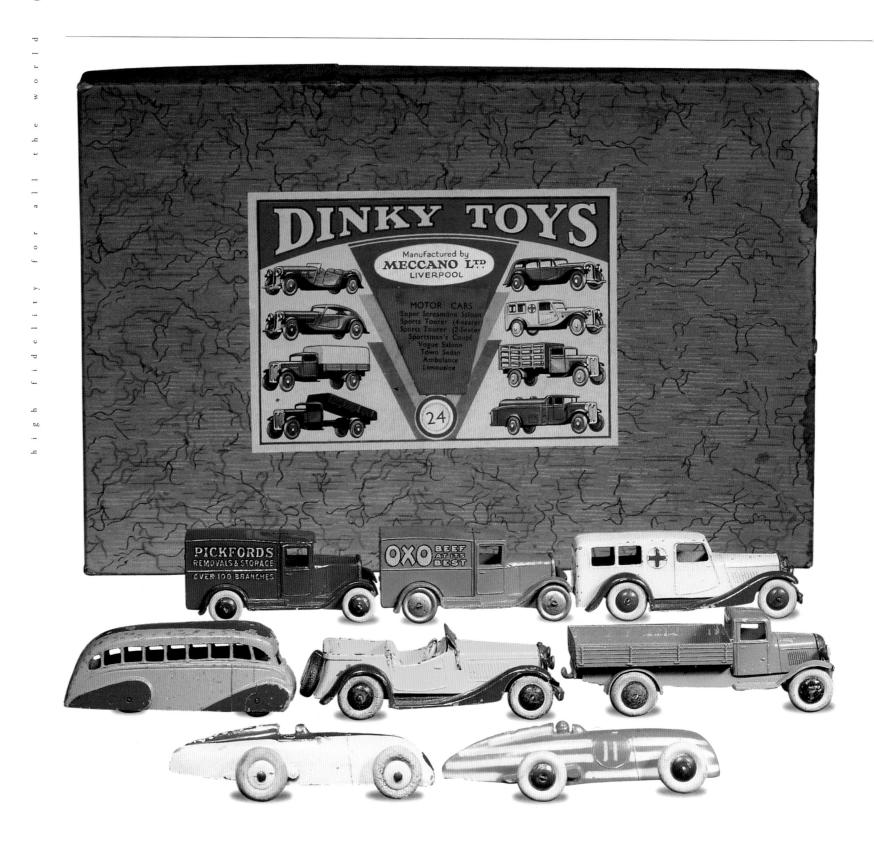

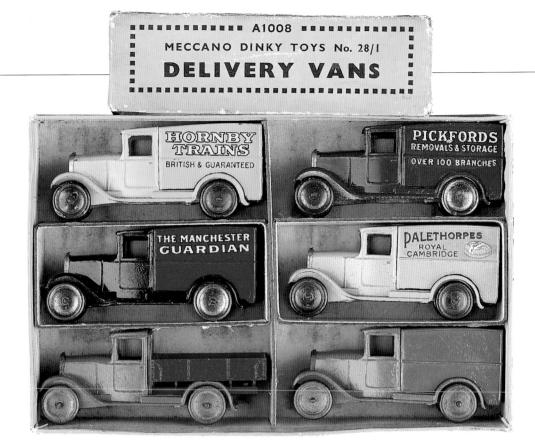

left: Four of a boxed set of 1934 Dinky Delivery vans. The plain van and the truc are part of the first automotive diecast toys from Meccano Ltd.

2

Ч

-

0

t y

е |

p

4

Ч

far left: Fine examples of early cast Dinky toys with typically bright colours (8cm/3in, 1934–36, UK).

below: Examples of the later Dinky Delivery Vans. These models suffer from metal fatigue and can be distorted (mazac, 8cm/3in, 1935-39, UK).

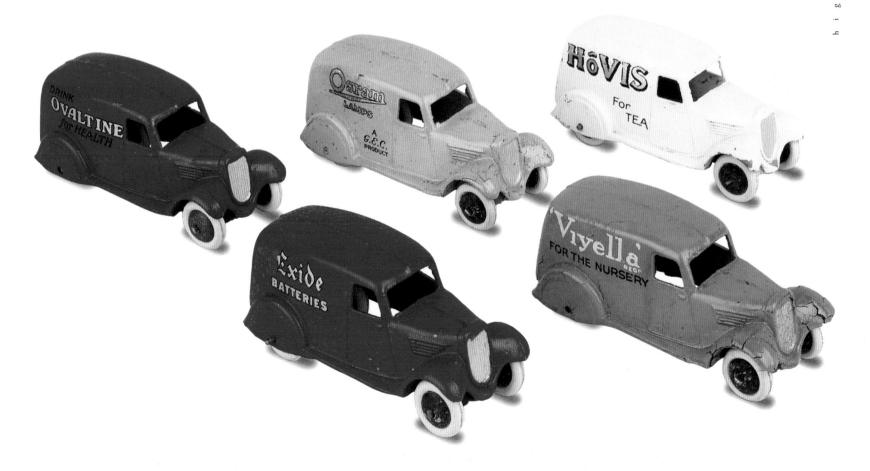

By the 1930s, European cast-metal toys were mainly being made in England. Taylor and Barrett, often referred to as T&B, made soldiers, and farm and zoo animals in lead as its main line, but it had been making small cars and trucks for sale in local outlets since the late 1920s. Johillco's product was similar but, out of reach of Tootsietoy's lawyers, it copied some of the latter's vehicles, including its Macks, making a searchlight truck, a mobile antiaircraft gun, a mail van, and so on. Incidentally, in about 1935 in Denmark, Birk made a series of six Graham-Paiges, with cast-lead bodies and tinplate chassis, that would also seem to be copies of Tootsies. Johillco initiated

below: A Distler Saloon Car with doors that open and electric lights (tinplate, 51cm/20in, c.1938, Germany). its own tooling for a small Golden Arrow and larger Silver Bullet and Bluebird speed-record cars. Britains, the most important manufacturer of high-quality lead soldiers, created the most desirable of all the cast record cars, the 1935 Bluebird and John Cobb's Railton, with bodies that lifted off to reveal the full detail of the chassis and engine layout. The obsession with record cars was truly worldwide. Britains also made large, 8¹/₄-inch-long trucks and vans, all with the same cab, of which the ambulances and the Royal Mail Van are the most attractive.

MECCANO

Frank Hornby, the genius behind Meccano, was always on the lookout for new products. He was not afraid to try the new pressure diecasting techniques already used by Tootsietoy, and in the early 1930s, he began to produce lead accessories to go with Hornby trains. By 1934, the line had acquired the name Dinky Toys and contained a mixed set of vehicles, the 22 Set comprising a sports car and coupé, truck, van, tractor, and tank. There was also the 24 Set of mainly generic motor cars; the 25 Set of commercials; and the 28 Set of delivery vans. In

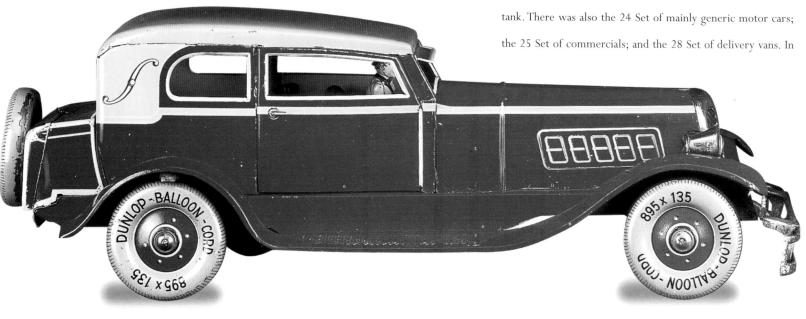

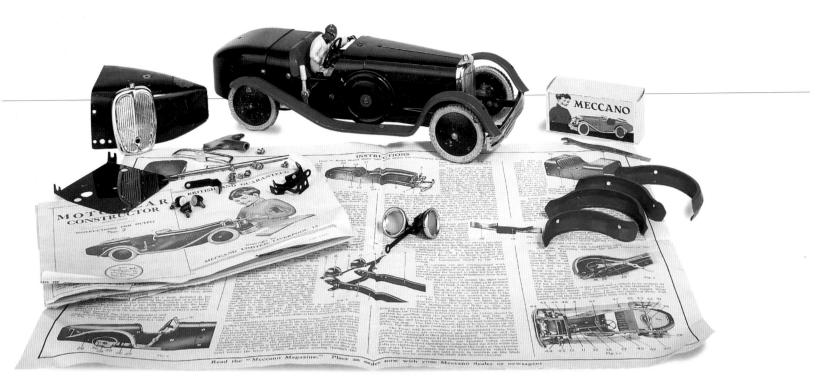

the early to mid-1930s, mazac (zamac) was replacing lead and the vehicle size had increased to what has come to be referred to as "43rd scale." This apparently strange scale is a direct result of the origin of Dinky Toys as railway accessories, because "O" gauge is itself 1/43. They were not slavishly to scale, for the child's imagination has no problem (as the adult's has) playing with toys in a wide range of scales at the same time.

Its house journal, *Meccano Magazine*, promoted all Meccano products (and carried ads for Tri-ang, which made complementary rather than competing lines), and in a schoolmasterly way, it instructed readers how to play with their toys. A 1936 illustration of a road scene is crammed with vehicles: lorries; vans carrying a variety of authentic advertising; cars; gas tankers; motorbikes and sidecars in automobile-club livery, and others. The tinplate gas station has diecast gas pumps on the forecourt, and the traffic is directed by road signs and controlled by lights. Most of the toys were generic, but real vehicles were also being portrayed, including one that can hardly ever have been seen on British roads, the Chrysler Airflow. This pretty model, with its well-

detailed, separate, nickle-plated grille/lights/bumper unit, is a typical example of the quality of Dinky Toys. From 1935, the toys were brightly painted models of real vehicles, and the series culminated in 1939, with the release of the 39 series of six American cars, which were robust, nicely modelled and realistically colored.

Luckily the 39 series cars, and others, were re-released after the war: luckily, because much of the prewar mazac was contaminated with lead, a combination that results in a chemical reaction causing the metal to expand and eventually crack and crumble. Many of the toys that survived the rigours of childhood play have succumbed to the silent effects of this socalled metal fatigue. It seems, however, that if a diecast toy has

above: A part-assembled Meccano No. 2 Car Constructor and its instruction book (30cm/12in, c.1936, UK).

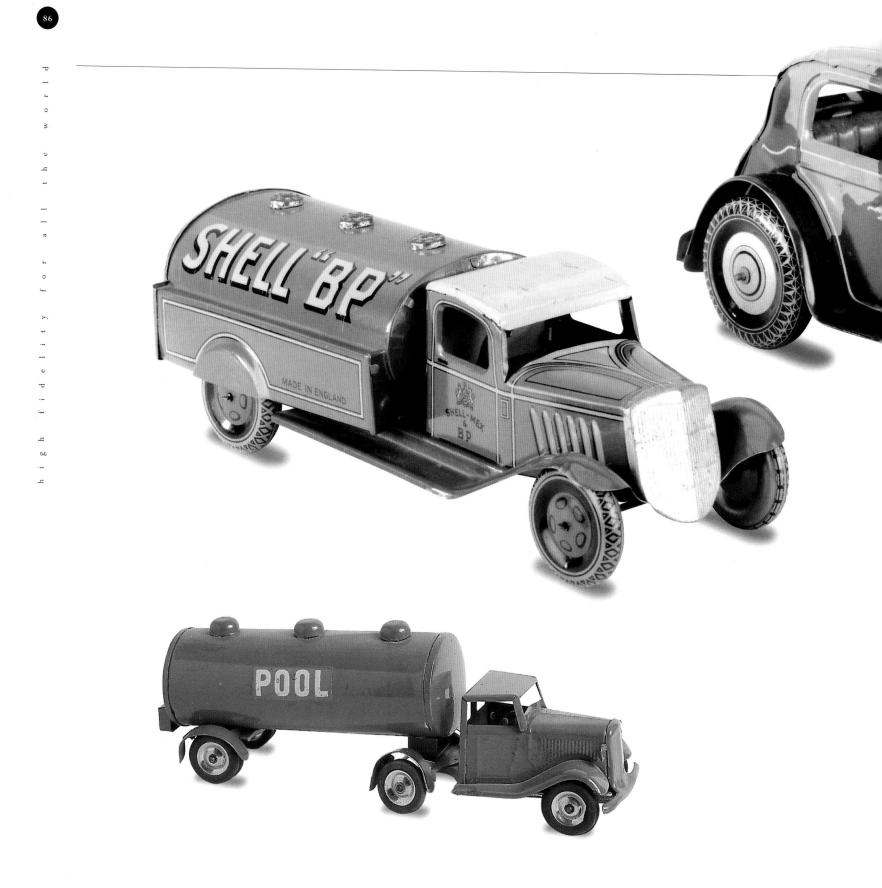

Below: A Wells Shell BP Petrol Tanker (tinplate, 25cm/10in, c.1939, UK) and a Mettoy Army Saloon Staff Car (tinplate, 36cm/14in, c.1941, UK).

Left: Standard Tri-ang Minic models were re-finished in army colours as war approached. In 1940 all British petrol companies combined their resources for the war effort and pooled their stocks, hence the 'POOL'Tanker. The camouflaged models arrived in 1936, with the POOL tankers the last to appear in 1940 (tinplate, 15cm/6in, c.1940, UK).

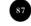

N

e

t h

a l l

0

-

not suffered too much, and if it is kept in an even temperature and not subjected to shocks, it can be held in suspended deterioration. Don't collect early diecasts if you live in an earthquake zone!

So great was the antiwar feeling among the public in Britain that it was not until 1937 that below: A Märklin electric racing-car set with two tracks for the 20v cars (tinplate, 18cm/7 in, c.1935, Germany). So great was the antiwar feeling among the public in Britain that it was not until 1937 that Dinky Toys released the first of its line of modern military vehicles. The packaging in sets is distinctive. While the lid is a plain

> blue with a wordy description of the contents, the interior features a scene, in shades of green, of rolling English countryside through which the vehicles appear to be driving. The value of a toy is enhanced if it is in its original box, but when the box is plain cardboard or an ugly bubble pack, one might wonder what it is that makes packaging collectible. An internal scene or attractive picture on the lid does make the boxes desirable to some extent in themselves. The collector may find a good box and then work to find the pieces that were originally

in it. This is an interesting exercise and leads one to pose the question: can such a made-up set be worth as much as a set that has been authenticated as having always been together?

At the same time that English Dinky Toys were given their name, an independent Meccano factory was being set up in France. Its product mirrored English Dinky, but had typically French designs for its versions of the 22, 23, 24, and 25 series. The models were fewer in number and did not develop the accuracy of their counterparts. After France was overrun by Germany in 1940, the French Dinky factory produced work for Märklin.

Apart from it being the nearest country to England, there was an additional reason for Meccano to expand into France, since there was an existing market there for quality diecast toys. Solido had been chosen as the name for a series of road vehicles by an already experienced diecast manufacturer. Its 1933 catalogue advertises *Les Automobiles à Transformation* in the following terms:

4

0

Ρ

_

What will you do with an automobile in thin tin, fragile lead or papier mâché which will break quickly even if you take great care? You throw it away and you have nothing. What will you do with an unbreakable Solido car? It will be your faithful friend, always to be carried in your hand like Daddy's penknife or Mummy's favourite object. You will play with it everywhere, and if by mischance you lose a piece, you will search for it and not lose it again. You will have become attentive and careful. Mummy and Daddy will reward you by

buying you another Solido.

If only toy cars really had the magical effect of making children more careful and parents so generous! What Mummy and Daddy could have bought from Solido were sets. The smallest one contained one made-up automobile, consisting of a chassis/hood unit and saloon body entirely chromed, plus six painted bodies. A larger set had three streamlined cars, two being entirely chromed, with three spare bodies. An even larger one consisted of four of these 1/35-scale cars, along with two of the smaller 1/40-scale series. Scale is referred to, in this case, not to suggest that these rakish, stylish pieces are models of real cars, vans, and buses, but because they are so much bigger than the nominally 1/43-scale Dinky Toys. Initially the larger ones were fitted with solid chromed wheels, but the smaller ones, and all later models, had rubber tires and a clockwork motor. Germany, too, had diecast toys, for Märklin had also turned its attention to the new process. Their 1939/40 catalogue illustrated a series of delicately cast models. The small selection of road cars, including two aerodynamic vehicles, was mainly generic, though a long, open, black Mercedes and the Volkswagen prototype People's Car were also manufactured. Märklin's silver racing-car toys, mainly Mercedes and Auto Union, are single-piece accurate castings between 4 and 5¹/₂ inches long. One can almost visualize them flashing round the Avus circuit in Berlin. The quality of casting on these was carried over into the company's military series, which resulted in the production of some of the most attractive diecast troop transport vehicles ever made, complete with soldiers as well as motorbikes and artillery pieces.

America emerged from the war in the best economic shape of all the participants – as the world's richest nation, with the strongest industrial base. Indeed, the speed of the recovery in Europe and Japan depended both on America's available markets and on her monetary aid. However, the most immediate effect of the war's end was on her own industry. Tootsietoy was

> already back in business in 1945, reissuing modified versions of the Jumbo and Torpedo series of 1936 and 1940, the best of the bunch being a station wagon. Many

were distinguishable from earlier groups because the dies had been changed, which made production cheaper by simplifying the castings. The station wagon, for instance, had spats over the wheels, so that the axles went straight through from one side of the body to the other, eliminating the need for axle supports hidden inside the casting.

right: A Tootsietoy Playtime Set 7500

of eight road vehicles and two planes

(mazac, 13-15cm/5-6in, c.1950, USA).

In general, collectors consider that the older product is more desirable, sometimes because it is a finer casting or a more complex paint scheme, sometimes because it is more

ΤΟΟΤΣΙΕΤΟΥ

The first new toys Tootsietoy produced after the war, in 1947,

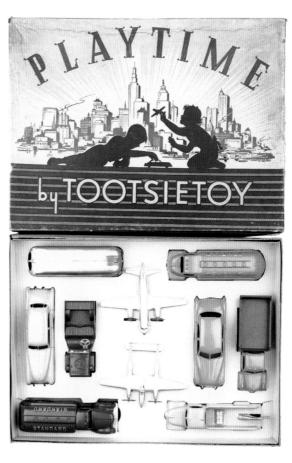

were not good. The accuracy of the design and attention to modelling detail was well below the prewar quality. By 1954 they had not improved, and its Nash Metropolitan Convertible and Corvette Roadster must be contenders for the "worst model ever". Although much of its automotive product was better than this, it did not manage to reattain, never mind improve on, the standard of mid-1930s toys. If you collect particular marques, you might want an example of its 1954 Buick Century, 1956 Triumph TR3 or 1960 VW Beetle, but you would probably put them at the back of the display shelf, well behind those of the European manufacturers. The toys are not particularly hard to find because Tootsietoy produced them by the thousand. A group from about 1960, just before the take-over by the Strombecker Corporation, is still a disappointment: six Classic Cars in approximately 1/50 scale; uninspired three-piece castings, they range from a 1906 Cadillac Coupé to a 1929 Ford Model A in dull colors. Despite the competition, the company is still in existence and utilises the diecasting facilities of China and the Far East.

J.LYONS

3

Co

LTD

HUBLEY

Hubley, which had changed over to diecast toys just before the war, started off by reissuing some of them fitted with black tires instead of white. The new black rubber no longer left dirty streaks on the floor, was cheaper than white, and looked left: Brimtoy Bedford Articulated Boxvans (tinplate/plastic, 15cm/6in, c.1951, UK).

more realistic, so the rubber tires fit-

RIMT

ted to postwar toys all over the world were now black. Hubley cars were rather slab-sided and not very inspiring, except for a later product, a 1955/6 Corvette. With a nicely modelled grill-cum-front-bumper, this is Hubley's best car and its biggest at 13 inches in length. Its line of fire engines, flat-bed trucks, tow trucks and log and car transporters, with Ford or Dodge-style cabs, are also impressive. During the early and

CIRC

mid-1950s, they made an attractive though somber Ford Bell Telephone Truck, with its sides embossed with a ladder and a Bell Telephone logo. It also has a crane operated by a side handle and a trailer carrying a telegraph pole. Some digging tools were supplied as well. A smaller version has an open back. The same cab was used, with a variety of backs, for other, more mundane toys. Tractors, road rollers and a couple of motorcycles complete the Hubley Kiddietoys line.

Many of Hubley's products were issued as boxed sets. The 1949 Fire Department Set contained a Hook and Ladder, a Fire Engine, a Buick Fire Chief Car, a cast-iron motor bike and two cast-iron fire axes — the last use of that material. The 1952 Farm Set consisted of a tractor, plough, disc harrow, spreader, and farm wagon, and so on. The marketing strategy of selling sets — "What a lot you get for the money" — continued right up until the last diecast toys were produced in 1978.

In the early 1960s, Hubley introduced a line of Real Toys (Corvette, Thunderbird, etc.) in 1/60 scale, fitted with the latest toy car innovation, plastic windows, and packed in the new style of blister packaging that hung on wire dispenser racks. Hubley was not inexperienced with plastic. In 1950 it had established a molding factory and had developed a product line of more than 400 items. The late 1960s saw a decline in Hubley's fortunes, and it was bought by Gabriel, which developed larger diecast toys for younger children, including a steerable concept cab advertised as "The shape of tomorrow." The move from prototypical toys brought a change in names to Mighty-Mites and Mighty Metal, lines that appropriately included road-building equipment, road graders, and bulldozers. One toy was to survive Gabriel's demise. The die for a School Bus, among others, was bought by the Ertl Company Inc. in the late 1970s or early 1980s.

STRUCTO AND BUDDY L

Two pressed-steel manufacturers from earlier days, Structo and Buddy L, were still in business in the postwar era. Structo had made (among other things) a Machinery Hauler Truck in 1940, whose well-modelled long hood had a rounded nose, and the company had lost none of its skill during the war. The 1950s model uses a thinner-gauge tinplate and has a crisply detailed short hood, and a square modern-cab style, which was fitted with plastic windows by the end of the decade. The toys were large, typically 20 inches long, and many featured working equipment. There is a Ready-Mix concrete truck with a barrel mixer and a Sanitation Department rubbish truck, whose back operated realistically, though it was not actually "Hydraulic Power Operated," as the decal claims! This group was jazzed up by being fitted with whitewall tires. After the death of Structo's long-time owner, its toy patents and designs were taken over by Ertl.

Buddy L had not forgotten how to make attractive toys, and it started off well after the war with a model of a Greyhound bus, but buses formed a negligible part of its commercial vehicle production. A bright yellow 13-inch Shell open-tail truck from about 1950 has crude, unaesthetic streamlining, but some of the vans and trailer trucks with decalling on the back can be very attractive. A trailer truck made in the same style is much improved by the bright red Van Freight Carriers decal applied to its yellow rear. This is a Buddy L-invented decal that carries its logo but, as before, real adverts were also used.

These advertising pieces became a standard part of the postwar products, and many are most attractive. One decal, eye-catching in its accuracy of reproduction, is an ad for the American Dairy Association that features a beribboned blonde girl writing a letter: "...and Santa I always drink my Milk." The advert diverts attention from the oily-looking, dark green cab unit molded from high-impact plastic. This type of material was dubbed Polysteel and was used in toys in 1952 and again in 1960, when it also made bulldozers. All-steel toys, like streamlined dumpers and more conventional square-cab, so-called Hi-Lift hydraulic dump trucks, were produced alongside these hybrids. Sometimes two similar items would appear in the same Buddy L catalogue, one all steel and one Polysteel. The 1960 Coca-Cola Delivery Truck, at 15 inches long, is all-steel; 1961 saw same-sized steel and smaller Polysteel versions. These were reissued with different decals the following year.

As a general rule, a toy with an invented advertisement on the side fetches more on the collectors' market than an undecorated example, but one with a real ad is worth even more. The bigger and more well-known the brand, the more expensive the toy will be, and if the brand is as big as Coca-Cola (and there are collectors who specialize in buying anything that is a Coke item), prices can reach amazing heights. This price differential on the same basic casting or pressing has allowed the development of a market in reproduction decals. Sometimes new decals are applied, and the toy is sold as a reproduction, to fill a gap in a collection that exist because the actual toy is rare or too expensive. However, unscrupulous collectors and dealers can pass off such items, even though these may have been made with no fraudulent intent, as originals, or indeed may set out from the start to deceive. The solution is to do your homework, so that you know what you are buying and who you are buying it from, thus reducing the risk of being duped.

In the 1950s, Americans were worried by the belligerence of Russia and the Communist bloc and about the spread of Communism in general. Newsreels showed footage – much of it frighteningly loud artillery barrages – of the Korean War, bringing things military to the attention of children. Army trucks had not previously been a large part of Buddy L's production, but now, with interest stimulated, were featured in the line. A US Army Half-track and Howitzer – the truck being 12 inches long – was issued in 1952. The following year, a similar larger piece was released with a whole group being made in 1957/8.

The same era was good for fire engines, always a popular toy. A 1958 catalogue devoted a whole page to a Fire Department Set. The accompanying blurb provides a neat example of the fine state of Buddy L's art: 9

The moment the young Fire Chief dons his own Plastic Helmet, he takes command of his authentic GMC Scale Model* Set, directing the Aerial Ladder Truck into position. The ladder swings in a complete circle and easily raises and lowers. The Fire Pumper adds to the play with its Electric Air Horn blasting and Water Hose unwinding. The detachable Searchlight can be directed by the young Chief to wherever he chooses, as it turns on a swivel and tilts to any angle. The Electric Flasher Blinker warns oncoming motorists. Complete with 4 Firemen, 1 Traffic Policeman and 4 extension ladders. Electric Units operate on standard batteries - not supplied. Auto-fender steel, Poly Non-Mar tires, 'Brite-plate' grilles and...the Buddy 'L' new exclusive paint finish. *Authorized Scale Model GMC Truck Reproduction - General Motors Corporation. The kid in the catalogue advert looks ecstatically happy, but als, was a crazy action car in which only Sam's head and the his parents were probably just waiting for the batteries to vehicle's wheels were made of tinplate. Among Marx's new run down. body pressing fitted with large rear wheels and a pivoting front MARX axle. Some, such as the Old Jalopy and the Jumpin Jeep, were

> Marx was quickly back in business after 1945, initially reissuing prewar products. A new item for 1947 was a sizeable steel bulldozer tractor, 15 inches long, but the line of large steel toys was not pursued. Soon plastic parts were appearing on tinplate items and, as early as 1949, all-plastic toys were being made. Sheriff Sam and his Whoopee Car, the first to use both materi

ais, was a crazy action car in which only Sam's head and the vehicle's wheels were made of tinplate. Among Marx's new issues were numerous variations on the simple, prewar, oblong body pressing fitted with large rear wheels and a pivoting front axle. Some, such as the Old Jalopy and the Jumpin Jeep, were fitted with tin figures, but the selection of Dipsy Cars (which included Mickey Mouse and Donald Duck versions) had plastic figures with springs for necks, so that the heads bobbed up and down at a touch. An early release was a new tow unit for the line of trailer trucks. Still capable of being drawn from a single sheet, the spatted fenders and hoods were now elongated oblong shapes, though the rear fenders were still curved. This is an attractive group, especially if the advertising printed on the trailer is decorative. So speedy was the firm's recovery that, in 1950, Marx was the largest manufacturer of toys in the world, with six American factories and seven that it owned or had an interest in worldwide. Marx even had presence in Japan, where its product – including all-tin versions of the Disney cars – was issued under the name Linemar.

When items were manufactured abroad, on a Swansea industrial park in Wales for instance, the roundel surrounding the Marx trademark carried "Made in ...," in this case "Made in Gt Britain." They were usually versions of the items made for American market, so the subject might be unfamiliar. But what child in the toy-starved days of 1950 would not have been delighted with a 10%-inch model of a battery-powered Pontiac, resplendent in red with a painted white roof and silvered grille, that went forward or back at the touch of a lever? Unfortunately, plastic of this era tends to sag and distort, so examples with all-plastic bodies and heavy tinplate chassis are not very collectible, though the packaging is an excellent example of box art, with a stylish representation of a black Pontiac

By the 1960s, Marx were making many vehicles from plastic. These were mainly nonprototypical chunky toys for little children, a typical example being the battery-powered Big Bruiser wrecker, complete with a pickup truck with a damaged fender and flat tire, and undamaged replacements. From Japan rumble seat operated doors, wipers, antenna, horn, headlights, motor, steering, and forward motion. Much of Marx's product was nonautomotive and even its racetracks – tinplate figure-eight roadways, etc. – carried nonprototypical vehicles. The end of the Marx company was closely linked to the economic and toyindustry crisis caused by the hike in oil prices in the

ALTER

came a "Scootin Tootin" Button Hot Rod. Nine levers in the

below: A Marx Nutty Mads Car, a later example of a Marx Funny Car (tinplate, 23cm/9in, c.1960, USA).

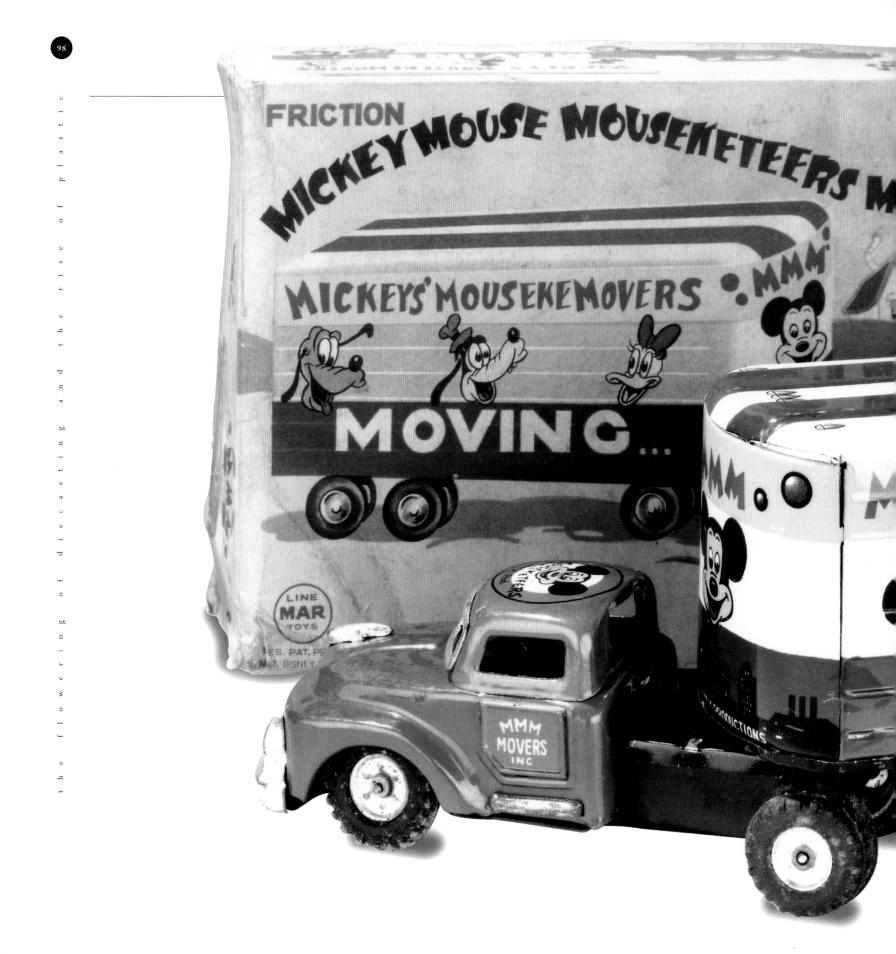

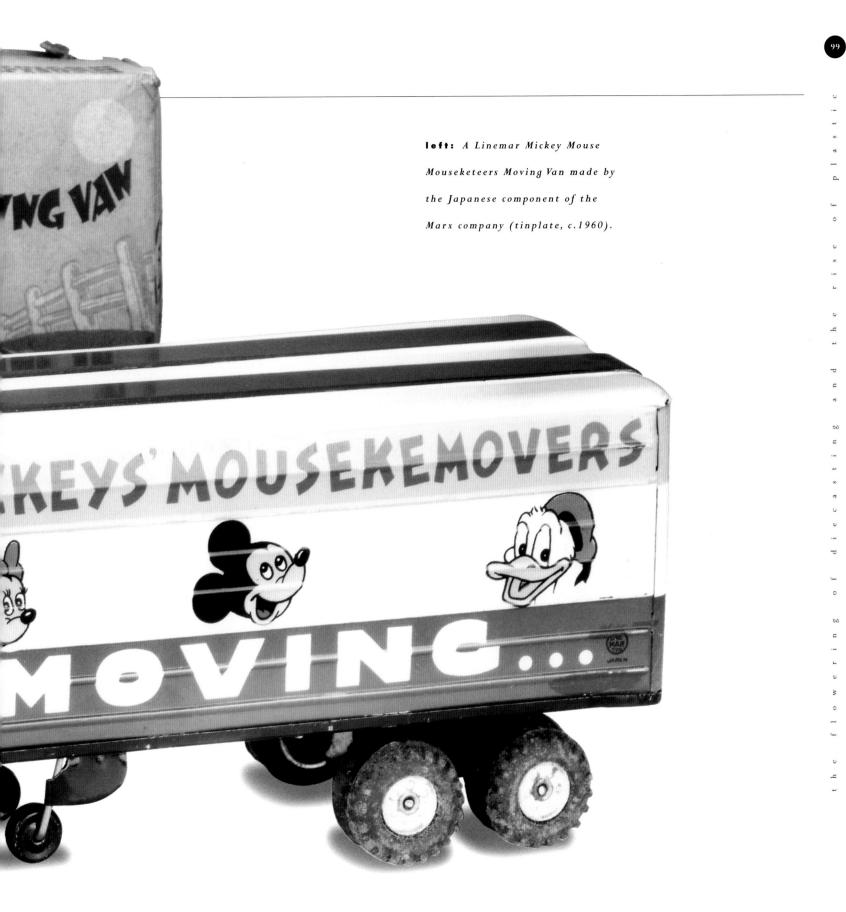

inches and 6 inches

long, sold in five- and ten-cent stores, like Woolworth and JC Penny, and then in discount chains like Walmart, from counter display boxes. The company was into volume production, with 200 different models being made at one time by one hundred employees. Since they were made for many years, these robust pieces with tatty paint are easy to find at rummage and garage sales in America. In about 1980, new management at Midgetoy put the remaining stocks into storage - these were released to collectors in the 1990s by the original owner. Realistic, of Freeport, picked up some original Arcade molds and, using aluminum, a metal available as war surplus, produced Greyhound and Trailways buses in the late 1940s and early 1950s. These were often sold in bus terminals to keep children happy on long journeys. Goodee (Excel Products Co., New Jersey) also produced in the 1950s, but belied its name, for its toys were bad models that had no hope of competing.

Jeep Fire Engine with Tanker Trailer (tinplate, 14cm/5½in, c.1950, France).

q

above: The unusual L'Auto Pin-Pon

nker Trailer
 the war. Midgetoy, of Rockford, Illinois,
 50, France).
 began production in 1946, making diecasts
 in direct competition with Tootsietoy. These were not very

Some new casting firms came in after

ing toys from the original molds.

1970s. In 1972,

the firm was sold to

Quaker Oats, and then, in

good models, being one-piece castings with no undercuts or windows, but they were cheap. Midgetoy trucks and cars, $3\frac{1}{2}$

1976, to Dunbee Combex, which acquired the Marx name.

This group went bankrupt in the grim year of 1980, but watch

out for new products; in 1990, American Plastics began mak-

ERTL

The success story of postwar American diecasting is that of Fred Ertl, who, in the words of a company hand-out, "chose to go it alone in the true American tradition" after he lost his job as a journeyman molder in 1945. Skillfully spotting a gap in the market, Ertl, who lived in Dubuque, Iowa, in the heart of the farmbelt, realized that noone was making farm toys. Using their basement and following the principles for making castiron toys, he and his family started casting aluminum in sand molds to make tractors. Initially the toys were sold from the back of his car, but within four years Ertl – who was a stickler for accuracy – obtained a contract from the Dubuque tractor manufacturer John Deere. He moved to separate premises, and was producing 5,000 toys a day. In the early 1950s, farm implements were added to the line. The quality and accuracy of

above and below: The Marx Brake Test Car – a lever beneath the car is pushed to one side by the screw thread on the rear axle so that the car skids to a stop. Instructions for stopping distances are lithographed (moulded plastic, 23cm/9in, c.1955, USA).

q

50

c

Ertl's product persuaded other manufacturers – Case International, Ford, Deutz-Allis and Massey Ferguson – to grant licenses to make replicas of their farm equipment, for fear of losing out in the publicity stakes. In 1959, the Ertl company moved to Dyersville, Iowa, where the head offices are still located. It was not until 1962 that it had any need to branch out from farm toys into trucks, and not until the 1970s that it moved into making some items in mazac. Indeed, even in the late 1990s, some aluminum is still employed.

OTHER AMERICAN

MANUFACTURERS

Doepke (pronounced Depkee) was another company that decided to go into manufacturing in 1945, not with a new product but with one inspired by the early Buddy L toys. These Model Toys, made from 18-gauge steel, were intended to be faithful reproductions of heavy construction equipment and fire engines. Doepke made about five toys a year, and as new ones were introduced, old ones were dropped, so that they are now very scarce. They were more expensive than those of another newcomer, Nylint. The Korean war made steel difficult to obtain, but it survived.

Among collectors, Doepke is still best known for two early 1950s diecast models, an MGTD and a Jaguar XK120, 40 and 16 and 18 inches long. They were made as dealers' showroom models to promote the popular British sports cars, which were being aggressively exported to America. They are an early example of models aimed at adults, rather than toys aimed at children. They do come into the scope of this book, however, as they were also available in some toy stores as kits. It seems that more bodies were made than windshields and other small parts, and that these missing pieces were reproduced in white metal. An all-diecast example is worth more than one with some replacement white metal parts.

Smith-Miller, known as Smitty, only lasted until the mid-1950s, with a change of name to Miller-Ironside toward its end. Its products were expensive diecasts, but it tried to make price a virtue - they "Cost more because they give more." There was a small and a larger series, the top of the latter being a Mack Aerial Ladder with a 4-foot extension that measured 35 inches long and retailed at a hefty \$25. There was a similarlength, very accurate, long-hooded Mack Mobilgas tanker. GMC, Chevrolet and Ford cabs were also modeled and were fitted with a variety of backs, many of them featuring advertising, such as Heinz, P.I.E., and Coca-Cola. When mazac became scarce, the toys were made of aluminum and even wood, but finished so well that they looked diecast. These beautiful, collectible items are now extremely difficult to find, but good reproductions made to individual order may come on the market. The All American Toy Company made large, expensive toy heavy trucks - Heavy Hauler, Timber Toter, and so on - but succumbed to economic pressures in 1955. However, the dies, molds, and parts were purchased, and parts and new limited editions are now available.

Tru-Scale International fared better. Its products, which were made in pressed steel in 1/16 scale, included International trucks and John Deere farm tractors and equipment. Models were made for International to sell alongside the full-size trucks; the models had an IH (International Harvester) decal on the door; they had a Tru-Scale decal when they were marketed in stores. This tie with International provided a stable market and was partly what enabled the firm to weather the mid-1950s. As International updated its trucks, so the toys were changed to match. Often these vehicles are quite plain, but useful, toys - though some did have advertising on the backs. Interestingly for the size, they eventually had a form of fingertip steering, in which pressure applied to the cab roof altered the direction of the front wheels. In 1971, Tru-Scale was bought by Ertl, who used parts for its International Loadster series but did not continue the name.

David Nyberg and Bernard C. Klint combined parts of their names to form the distinctive, easily remembered title, Nylint. They started off making heavy-duty, scale earth-moving equipment. While early production was quite small, by 1950 they were introducing 20-inch tractor-dozers, and even larger ones at 30 inches. Toward the end of the 1950s, it broke new ground with a toy version of the latest weapon: the guided missile, its carrier and launcher – very ahead of their time, as these toys actually predate the Cuban Missile Crisis. Nylint introduced trucks around 1960, many of them being special-purpose vehicles, from an 18-inch Street Sprinkler to Horse Vans and a Kennel Truck complete with dogs. These sturdy, goodlooking toys provided a sound basis for a firm that is still in business.

One company that truly exploited the postwar baby boom was Tonka. It made tough, good-looking and relatively lowpriced commercials after starting with the almost obligatory earth-moving equipment in 1947. Its early product was based on prototypes: first of all, forward-control vehicles; then, as real designs changed, rounded-fender and then squared-fendertypes based on Fords. From 1961 the toys were all generic. The growing numbers in the line over the years reflects Tonka's increasing fortunes. In 1953 it introduced six toys; in 1954 ten; in 1955/6, a bad time for others, there were fifteen. This then dropped back down before accelerating to twenty-two in 1958 and twenty-nine in 1960. Some of the most attractive, though not necessarily the most valuable, are fire engines. A Suburban Pumper, complete with ladders and hose reel, even had a small metal hydrant from which to draw the water. There was also a Hydraulic Aerial Ladder decalled with the initials T.F.D., with No.5 on the door. These two, plus a white Rescue Squad forward-control van, were readily available in a set for the really lucky child.

Walter Reach briefly enjoyed some success in his attempt to be a second Louis Marx. Under the Courtland name, he issued very well lithographed and neatly formed tinplate vehicles with friction motors. There were two trailer-truck cabs – the first with drivers printed on the windows, the second with cut-out windows – pulling a variety of trailers, the tanker backs had particularly attractive decorative logos of oil and milk companies. The cars, just over 7 inches long, are single pressings, and though the lithography (complete with drivers) is good, they are very simple and similar to the flood of cheap tinplate toys that have more recently emanated from Hong Kong and China.

ALUMINUM, MOLDED PLASTIC, AND POLYTHENE

There was a short vogue for race cars in aluminum or heavy plastic, motorized in a variety of ways, that could either race along the straight or while tethered to a pole. These are fairly obscure, with Thimbledrome being perhaps the best-known name. Ohlsson and Rice cars came to be noticed when a hoard

of engineless ones turned up on the collectors' market. Lack of controllability and variety of action probably account for their poor 960, Japan). success at the time, but they are interesting in that they are precursors to the cable-controlled cars from Schuco and Japanese manufacturers, and the later plethora of radio-controlled vehicles.

Since Banthrico started making pot-metal money-boxes in the form of vehicles in the early 1930s,1/25-scale model cars had always been popular. They were used as promotionals and distributed through banks. After the war, the number of companies producing such products mushroomed as the material was changed to the new plastic. The models were also sold, still as promotional items, through garages, their subjects representing the latest model of each car so that a child could have one just like Dad's. Although these were played with as toys, their primary purpose was as promotional models. While they can not be classed as automotive toys, their interest in the terms of this book lies in that they show just what high accuracy can be obtained with cheaply molded plastic.

Most toy manufacturers were not keen on following the lead of Banthrico and the other manufacturers using plastic. There were firms that made vague prototypical blobs of cars and trucks in plastic, concentrating on lots of gimmicks for plenty of play value. While Renwal did make a neat line in small plastic kits, for twenty-five years, its main production was trucks with generic logo transfers - for gasoline or coal sedans, coupés, fire engines, motorcycles, and racers that are very difficult to get excited about. The firm was first sold to Chein and then to Revell. Ideal descended in the 1960s to polythene – "It's big – it's unbreakable – it's polythene" – but it was hardly collectible. It started, also immediately after the war, producing automotive toys in sizes from 4 to 12 inches. The plastic was shiny, thin, brittle and in pale colors – yellow, blue, and so on. By 1952/3 it was making sets with a tool chest for Fix-It cars, a Talking Police Car and other novelties. Its collectible period dates from the early 1960s, when it produced -"It's terrific, it's MOTORIFIC" - battery-powered cars described as:

far right: The Yonezawa Cadillac Pillarless Sedan with friction motor (tinplate, 45cm/18in, c.1960, Japan). that they are

0

br

C

Accurate to the last detail. Each body, only 41/2 inches long, will satisfy even the most discerning collector.

With a common base which has built-in drive gear, metal-plated parts, and 5-position torsion-bar

steering...Wheels sport white sidewall rubber tires and de luxe aluminum wheel covers. The plastic bodies

have detailed chrome-color trim, clear windows and headlights.

The collector referred to was a child, or no more than a young teenager, but the roll-call of Ideal's now-classic cars presages those found in many of the product lines made for the adult collector from the 1980s onwards: Sting Ray, Continental, Mercury, T-bird, Rolls-Royce, Imperial, Cadillac, Impala, and Jaguar XK-E.

Irwin used polythene as well, though its varied range did have some diecast toys, including a fairly respectable Jaguar XK120 in about 1/32 scale. But the less said about a Barbie Hot Rod, made for Mattel in the early 1960s, the better. The toys were often inaccurately modeled and made in garish colour schemes. Mattel itself was experimenting with a Guide-Whip Racer14 inches long:

Looks and sounds just like the racers that roar round the track at Indianapolis. When the wheels turn, you

hear the roar of the V-rroom unit. The faster it goes, the louder the noise. Use guide and whip-cord to spin car

in circle, steer it in and out. Rev up racer...friction motor speeds it along. High-impact plastic.

0.

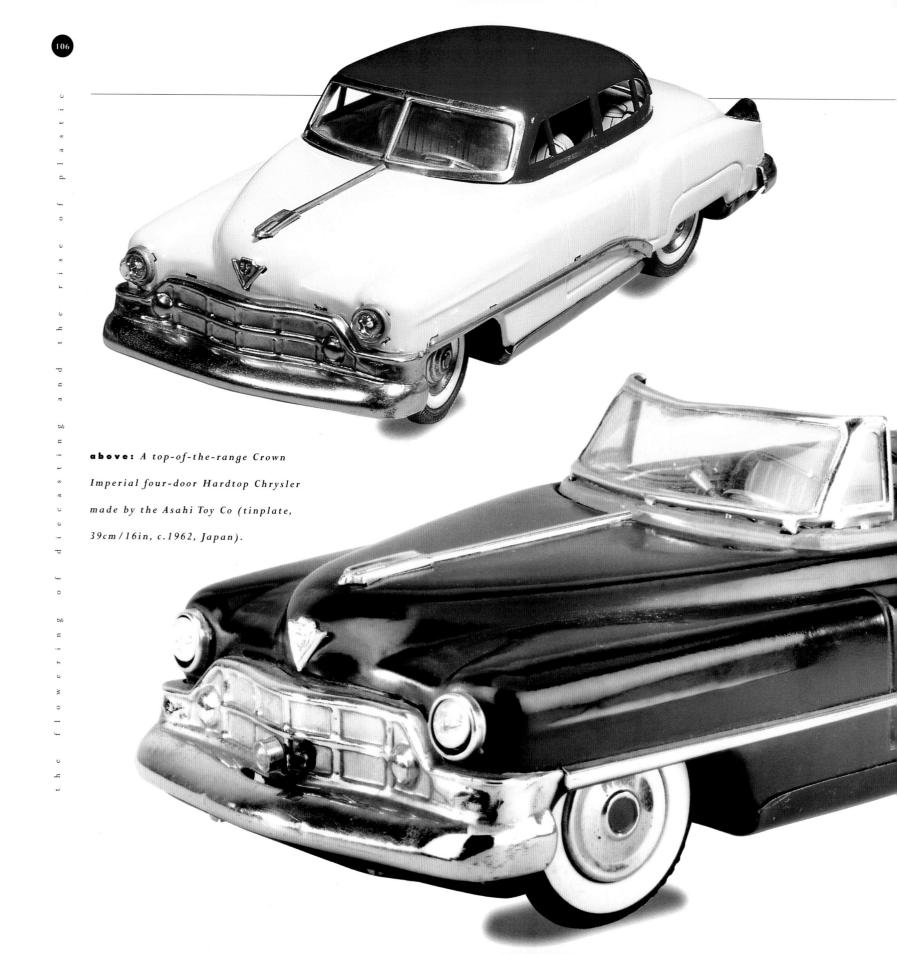

left: A Nomura Cadillac Convertible it is battery operated and has
lithographed seats (tinplate,
34cm/13¹/₂in, c.1953, Japan).

0

above: A battery-operated Nomura Cadillac Hardtop including electric lights (tinplate, 34cm/13^{1/2}in, c.1953, Japan). Difficult to find but made in millions by F&F (Fiedler and Fiedler) are cereal premiums, at 3 inches big for the type, which were enclosed in packets of Corn Flakes, Rice Krispies, etc. With cut-out windows and separate wheels, they are mainly recognizable models of Fords, with some Mercurys in the late 1960s. These were in production from 1945 to 1987, and during the 1954–67 period the cars were marked with the F&F trademark.

Meanwhile, for the child who thought pedal cars passé, there were car dashboard toys, such as the

battery-operated one made by Play-

mobile, "The world's most exciting and beautiful toy." The checklist of working features reads: "Wipers work, turn-signals light up, key starts, motor horn blows...," then, almost as an afterthought, "steering wheel turns." In the first half of the

> 1950s, BMC was making a small line of pedal cars. The tractors, which could be fitted with a trailer behind or a digger bucket in front, seem in its ads to be giv-

ing their riders particular fun. For classy pedal power, you would want to own one of the products of Murray Manufacturing Company of Ohio. In 1948, it made a Pontiac Station Wagon, followed by a Buick Torpedo Sedan with fabulous amounts of chrome decoration (grille, headlights, steering wheel, hood, side portholes, bumpers, and so on), and then a Suburban, a Tractor, a Comet, a T-bird, and eventually a Camaro.

JAPANESE OUTPUT

There were some good imported toy cars on the American market in the 1950s and 1960s, and, although a few came from Europe, the vast majority hailed from an entirely new source – Japan. From the end of the war until 1952, Japan was occupied by the Allies, mainly the American Armed Forces. At first, there was a great fear that Japan would rearm if it could, so its industry was not encouraged; but after 1948 it was allowed to grow

above: The Atom Jet Futuristic Car by Yonezawa comes in seven sections (tinplate, 69cm/27in, 1950s, Japan).

_

3

0

.....

and goods were permitted into America on favourable terms. Japan poured its economic effort into civilian industry, reinvesting its export profits in factories and production technology to great effect. The subcontractor system – with small parts of an item being farmed out to specialist workshops – was well developed, so that soon there were an amazing 300 or so companies involved in toy manufacture, many of them were sited around Tokyo, with some in Osaka. They were mainly making tinplate toys, often friction or battery-powered, and by 1960 half were being exported to America. Decisions about product were at first influenced to a great extent both by the American cars that could be seen on Japan's roads and by the American market. The history of the individual firms is obscure, and the toys are not at all easy to come by now, so the best way of describing Japanese production is by the type of vehicles modelled.

Cadillac had triumphed in its battle with Packard for top place in the American luxury car market, and its big, brute look was heightened by the yards of chrome, the predatory look of its "eggbox" grille, and the aggressive uplift of its bulbous tailfins. By the time the Japanese toy industry was ready to model it, the rear line was emphasized by vertical, simulated air vents. Marusan captured the look wonderfully in 1951 with its 11 inch model, including every possible piece of chrome on it. The car came in all one color - black, grey or white - or with a contrasting roof (say, cream with dark green). Marusan modelled the convertible as well, with seat pattern and dashboard details neatly printed on the tinplate. These were usually friction-powered, but some had batteries and electric lights. Japanese toy vehicles are commonly fitted with clear plastic windows and whitewall tires. The box lids illustrating the contents are works of art in themselves.

inch four-door

The firm of Alps modelled the 1952 Caddy, piercing the chrome of the deep "eggbox" grille, overemphasizing the bumper guards, which had developed into bullet-shaped bumper/grille "bombs," and picking out the V and crest on the front of the hood in gold. Nomura's version, bigger at 13 inches, was not quite so splendid, its chrome less extensive and less well-modelled. It came battery-

above: The collectable Doepke Jaguar XK 120 Sports was intended as a sales aid (diecast, 46cm/18in, c.1950, USA).

d

c

0

powered. Some of the Convertibles were fitted with a tinplate driver and a passenger. Interestingly, one of the Cadillac Sedans modelled by Marusan was later made by both Gama in Germany and Joustra in France from the same

dies. The distinctive Cadillac style from 1959 has been referred to as the "Batmobile" because of the high thin tailfins that protrude sharply from the trunk and incorporate the rear lights. Bandai made both the open and closed cars 11 inches long, following them with the squarer, more restrained 1960 models – all of them friction-powered. Yonezawa exaggerated the angularity and even added contrasting-color trim panels on an 18hardtop. Bandai made subsequent models in sizes ranging from 13 to 18 inches, but other manufacturers made slightly smaller or even larger ones, up to the 22 inches of a 1965 Caddy from Ichiko. ATC Asahi also modelled the 1965 car, and Ichiko made the biggest of the lot, the 1967 at 28 inches.

This roll-call of Cadillacs does not mean that other makes were ignored. Each manufacturer, including ones that have not been mentioned and some that are unidentified, tried its hand at other American cars. Marusan made a good small 1953 Buick, the style with four portholes along the hood sides, and a lovely 1954 Chevrolet Bel-Air, with its winged-bullet hood ornament, in grey or dusky pink with a black top. Alps modelled the 1953 Packard with its wide-mouthed grille. A large selection of Chevrolets was made, including the Corvette of 1958 with its scalloped sides beautifully captured by Yonezawa.

Other makes include the extraordinary Ford Edsel – a fullsize design disaster – which was excellently modelled in both convertible and station wagon form at just over 10 inches long by Haji. Nomura and Yonezawa also made the Station Wagon and the Saloon was released by Nomura and ATC. The 1962 Ford Thunderbird was made, in sizes ranging from 8 to 12 inches long, by Bandai, Yonezawa, and ATC, while another was sourced by the distributor Cragstan.

Buses and commercials did not figure largely in Japanese output, but fine examples exist, from cheerfully printed tractors - Masudaya producing one as a set with reaper, rake, and trailer - to a beautiful Greyhound Scenicruiser and a selection of vans and trucks with excellently lithographed ads on the sides. A small group of television outside-broadcast vans has cameramen on the roof and the lettering of NBC, CBS, etc. The 1950s were brightened by red and yellow circus trucks, the cages having animals lithographed on the side or tinplate animals visible within. There is one that has a couple of giraffes whose necks and heads stick out of slots in the top and move back and forth as the truck goes along; another has rotating clowns on the roof. Racing cars are represented by Yonezawa's 18-inch Indy car, with red flames licking up the nose and from behind the wellbuilt tinplate driver. Futuristic and dream machines, also a popular product, ranged from the relatively common Ford Gyron, made by Ichida in 1960, through the 1956 Alps Lincoln Futura to outright

fantasies epitomized by the Atom Jet. This was made by Yonezawa – 27 inches of green lithographed tin, from its gleaming chrome nose to the tips of its conical rear lights. There are motorbikes aplenty, from staid scooters (early ones having celluloid riders) to a bright-yellow Wegenwacht motorbike and sidecar from an unknown manufacturer.

It should not be assumed from all of this that there was no market for Japanese manufacturers other than America. Mercedes were popular and neat models were made of the 220, 230, and 300 SLs. Likewise, the Jaguar XK line represents Britain, and the Citroën DS19 is in Bandai's Automobiles of the World series. Porsches, Ferraris, Aston Martins, including the James Bond DB5...all the world's quality cars were expertly modelled. Cheaper ones – the Volkswagen Beetle and Saab 93,

helow: The Packard Synchromatic Convertible by Schuco (tinplate/plastic, 27cm/10.5in, c.1959, Germany).

tic, 27cm/10.5in, c.1959, Germany)

yuchromatic 5700

with their curvaceous outlines – were well represented, although some shapes seem less satisfactory: the short, squarish MGTD and MGTF and the unusual bent back of the Renault 750 do not make such attractive pieces. Surprising and charming in their own way are the bubble cars, the BMW Isetta and Messerschmitt, from Bandai.

Japanese cars were modelled too, especially as the home market picked up and that for tinplate toys in the rest of the world fell off or was taken over, either by cheaper products from Hong Kong or by the rival diecasts. Ichiko made 16- to 18-inch-long models, including a Datsun Berlina in 1960, a Nissan Gloria Hardtop in 1970, a Datsun Fair Lady, and, even as late as 1979, a Toyota Celica. Long before this, in 1959, ATC

below: A battery-operated Jaguar XK 120 Coupé by Distler (tinplate, 21cm/8.5in, c.1955, Germany). Asahi itself had started making diecasts, in about 1/42 scale, of Japanese prototypes; it called the line Model Pet. Taiseiya joined in two years later with the Micro Pet series,

with a friction motor, and that was followed by the unmotor-

ized Cherryca Phenix. These dies were taken over in 1966 by Yonezawa and the models became part of the well-known Diapet brand.

SERMAN MANUFACTURERS

Tinplate production resumed in Europe in 1946 and, to get things going quickly, prewar tools were dusted off and put to use. Lehmann had created a line of small, simple tinplate

toys in the new 1/43 scale in the mid-1930s, just the sort of thing that could be made quickly and easily. A small group, including a saloon, tourer, truck, and racer, was named Gnom (from gnome, or dwarf). They were 4 inches long and were given a painted rather than a lithographed finish. The Gnom did

not last long after they were re-released because the factory, which was in East Germany, was confiscated. When Lehmann reestablished itself in the West in 1951, its production was of entirely new lines.

Schuco, a brand name created from that of the company Schreyer & Co., had been making toys since 1912, eventually developing its famous clockwork pecking bird. Schuco's skill at inventing cunning devices led it, in 1934, to make an approximately 6-inch one-piece toy car, with a fifth wheel maintained transversally underneath that prevented it from falling off the table – a much-copied device. The Examico 4001 (most Schuco cars have names that end in "co" or "to" and are given long numbers) was similar to a BMW 327 and had a clockwork motor and a mechanism giving four speeds, plus reverse and neutral, as well as steering. Unfortunately, Schuco clockwork motors are not as strong as the bodies or the rest of the mechanical parts, and many are broken. A

nonworking mechanism reduces the value of a toy, but, if it would only go forwards anyway, the reduction will be only so much. The more complex the maneuvres the toy is capable of, the more a broken mechanism will reduce its value. There are some more robust Schuco vehicles, and those of the type that stop and start as you blow through roof vents often still operate, but they are perhaps the most common anyway, so of relatively less value. Most of this group was in production for a short time before the war and for several years afterwards, even up to the late 1950s. This makes the prewar

above: Arnold Tin Lizzie with remote control and four passengers (tinplate, 24cm/9.5in, c.1950, Germany).

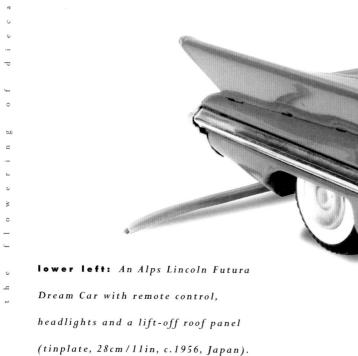

Course 300

P

far left: Gama Cadillac, no. 300, with a friction motor (tinplate, 30cm/12in, c.1956, Germany).

d

0

ч

below: A Bandai Ford Flower Delivery Van, no. 433, with a friction motor (tinplate, 30cm/12in, c.1955, Japan).

in the center of the roof, and a set of posts around which to steer the toys. "No more sliding about on one's knees when playing with this car," the leaflet announced. In 1950, it returned to the market, to be followed the next year by developments

versions much more valuable than the reissues, so it is good to know how to tell the difference. As a rule

> of thumb, prewar German toys are marked "Made in Germany DRGM"; postwar ones are lettered "Made in US Zone, Germany";

above: This type of van was made for promotion or as a toy (plastic, 26cm/10in, c.1960, USA).

> and later ones, after the Allied sectors were dispensed with, "Made in Western Germany." The price differential between the extremely expensive early Schuco Radio 5000, for example, resplendent in maroon and cream or twotone blue (and whose musical box plays a now politically incorrect Nazi jingle) and the reissue is such that it is vital to be able to tell them apart.

> The Auto 3000 – which had what in German was called *Fernlenk*; in French *Avec guidage à distance*; in English *Telesteering* – was released by Schuco in 1936 and was the first taste of a successful marketing operation. The small, clockwork tinplate car with a guide wire terminating in a steering wheel located

of the type. The simpler Ingenico (engineer) consisted of a much larger-scale American-style car, guided in the same way by a wire terminating on a peg in a hole in the roof, packed in kit form within a box, with accessories such as road signs. The motor, clockwork or electric - the latter either powered by large batteries attached to your waist or connected to the mains - had to be purchased separately. Later these types were updated with cars that were more prototypical, the Auto 3000 having a VW1200 body and the Ingenico one based on the Opel Olympia. The clockwork Varianto and its battery-powered version Elektro started off with more prototypical vehicles: an Austin Healey, a Buick, a Shell and a BV Aral tanker. These were complete in their display boxes and had an option that enabled them to run along guide wires laid on the ground. Road junctions, buildings and other parts could be utilized to make complex systems. An absolutely complete boxed set is difficult to find and therefore expensive, though many collectors are put off by the holes needed for the teleguide wire.

They are most collected in their home country, Germany, and in their major export market, America, which illustrates the relatively common phenomenon that toys are worth more on the collectors' market in their country of origin. When Schuco failed in the late 1970s, many of its dies were bought by other toy manufacturers. Models, both tinplate and diecast, have been rereleased under the Schuco name and in packaging similar to the original. The distinguishing features of the early ones are rubber tires and a "quality" look to the paint, while the new ones have plastic tires and a brighter, harder look to the finish.

Distler returned to manufacturing soon after the war and produced clockwork-powered models and the battery-operated Electromatic 7500. In case the instructions should be lost, diagrams showing how to replace the batteries are conveniently printed on the tinplate base. These painted models, 8½ to 10½ inches, of Jaguar XK120s, Mercedes, and Porsches are highly collectible. That the latter is the most desirable is a reflection of the popularity of the full-size car and the accuracy of the model. Tippco was still using TCO on its number plates and was making a variety of toys, some with electric lights, ranging from imposing Mercedes saloons such as the mid-1950s 220S to American-style Dream Cars and workaday Volkswagen Minibuses. The quality of the modelling and finish, including that of the chrome, is excellent. JNF, another German manufacturer, produced toys of the vehicles that could be seen on German roads, which were of a lower but still reasonably attractive quality. It also produced generic cars. In the 1950s,

Arnold extended its production into road vehicles. The Jeep, neatly modelled as a Military Police vehicle complete with composition figures, somewhat outshines a Marx look-alike Hot Rod Tin Lizzy covered with graffiti.

Arnold's American-style tourers and saloons have some charm but fail to capture the look in quite the way that many of the Japanese models did.

below: Tri-ang Minic Toys: a Jeep and an Aveling Barford Road Roller (tinplate, 18–16cm/7–6in, c.1957, UK).

Gama is the trademark of a firm established by Georg Adam Mangold before World War II, when its product was not of great significance. In the 1950s, its tinplate was somewhat derivative of Japanese manufacture, but it did make models of German cars (Mercedes, Taunus, and Opel) 8 to 10 inches long, powered by clockwork and wire-guided. Though the remote control plugs in at a discreetly low point on the rear, so that the shape of the toy is not disfigured by it, Gama

below: The 'Games Van' advertising many of Chad Valley's other products (tinplate, 25cm/10in, c.1947, UK).

5/

had a tendency to display its trademark aggressively on the vehicle, an action that somewhat lessened its appearance. It also made slightly squashed-looking smaller tinplate pieces.

However, it was a German firm that represented the swansong of European tinplate toys. Kellermann used the letters CKO as its trademark, and collectors tend to refer to the company's prewar production as Kellermann and postwar as CKO, because of the prominence of the mark. In the early 1970s, CKO retooled and brought onto the market a series of frictiondrive tinplate cars, trucks and buses of exceptional quality, the deep drawing of the Mercedes cab used on a truck and a fire engine being particularly impressive. The 8-inch-long Deutsche Bundesbahn bus, in maroon with a silver roof, is fairly popular with bus collectors, as are the Volkswagen Beetle, Ambulance,

and so on with VW enthusiasts. CKO's car group – Mercedes saloons and racing cars, Ford Capri, Fiat 128 – fail to excite, and the line is not yet very collectible. However, in the 1990s a Chinese manufacturer considered that these were still good toys and reissued the bus.

Most of these German tinplate manufacturers and some others made two or three motorbikes, many of which were equipped with interesting actions. Some were issued both before and after the war and then updated with, say, telescopic forks. Arnold modernized its large, 8-inch flat-twin Zündapp, and the 1950s bike has a bare-headed civilian rider grimacing in the wind. The MAC 700's rider dismounts, swinging his leg over the saddle when the bike stops and remounting when it starts. Tippco also updated its prewar solo and combination machines, one type having the passenger move from side to side as the bike corners. CKO had versions with a similar action, but Neidermier wins the novelty prize with a rider who does handstands on the handlebars. Technofix also made scooters. Schuco's best-known, the Curvo 1000, describes seven different steering patterns. A 1960s issue was updated with a modern-style helmet instead of the previous mixingbowl type, and the rider of the Mirako Peter of 1960 has a shock of blond hair! Motorbike toy collecting is rather specialist, as it is difficult to find these fascinating toys. In order not to be led astray concerning the age of a motorcycle toy, it helps if you know something about the developments of the full-size machine.

FRENCH MODELS

In France, CIJ and JRD, two manufacturers often referred to in the same breath because of the sometime similarity of their products, made models in a material that can be thought of as heavy tinplate or light pressed steel. From 1948 until probably the mid-1960s, CIJ made versions of French cars, generally Renaults, although the odd Panhard made its appearance. The deep, smooth pressings capture the compound curves of the era well, and it is to this line that you should look if you want to collect the best tinplate models of the Renault 750. Sizes increase in scale from about 5 inches up to about 12 inches for the Renault Fregate. Some doors that opened, but the main panel detail was often applied by a line in a lighter shade of paint, a surprisingly effective device. These were usually clockwork, but later some were fitted with electric motors. IRD generally modelled commercial vehicles, one of their earliest postwar products being a Jeep Pompiers (fire engine). It made Citroëns, usually the 2CV. A 2CV car came first, but 1951 saw the introduction of a 2CV van, a neat and pretty pressing that was painted in clear colors and decorated with advertising for Air France, Secours Routier, and so on. This group is highly collectible, being good models. There are many collectors of Citroën and numerous collectors of vans with advertising – all factors that lead to a great demand for these toys. The same cannot be said of the widely distributed Joustra, which also made battery-powered models of French cars (Renaults, Peugeots) up to about 12 inches long.

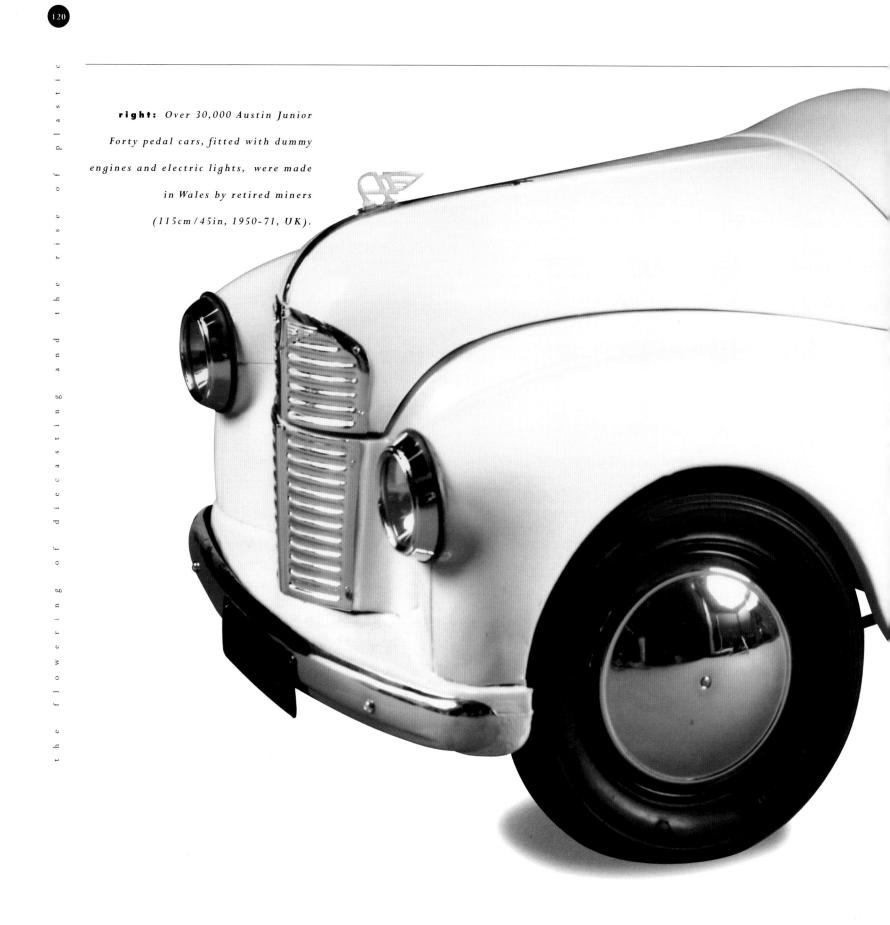

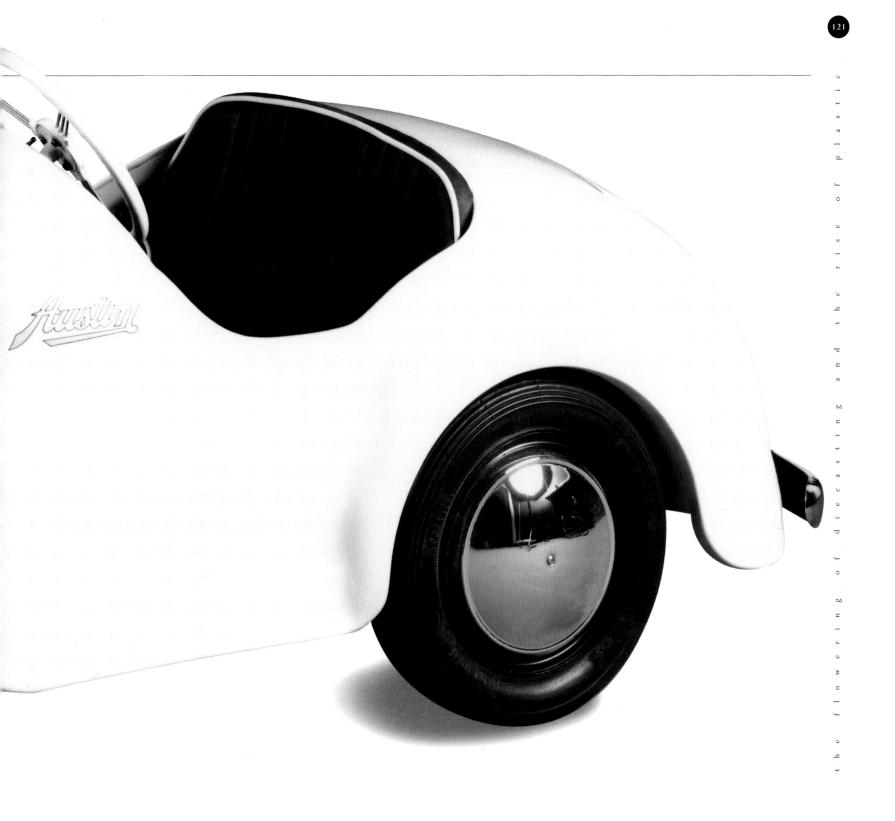

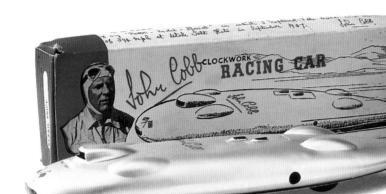

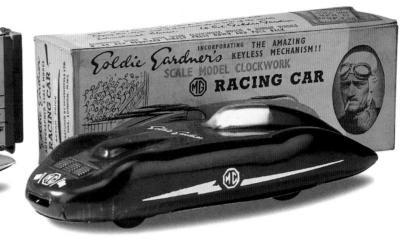

above: Two Minimodels – John Cobb's Napier Railton Land Speed Record Car and Goldie Gardner's MG Record Car.

 John Cobb's
 Unfortunately, Joustra also made poor

 John Cobb's
 generic clockwork toys, rather like sub

 Record Car
 standard Schucos, with mystery actions,

 Record Car.
 including doors that open automatically.

 One impressive piece, if a little over-large, is the Latil Bank Van

 money-box with a lockable body inscribed "Postes – Caisse d'é

 pargne" (Post Office savings bank).

good-quality, painted tinplate Fiats, both the 500B and 500C. There was also a 7-inch-long Jeep. Subsequently there were some slightly larger cars and a bus, but after 1954 the quality and accuracy deteriorated as it reverted to lithographed tinplate.

DENMARK ENTERS THE FIELD

By the 1950s, Denmark had also entered the toy car scene. Before the war, Siegumfeldt had invented the Tekno tinplate models; they were, as their name suggests, partly constructional, and they were nearly all reissued between 1952 and 1955. It is these one is most likely to see. There is one basic rolling chassis/cab fitted with a variety of back ends: plain truck, tow truck, axe truck with removable axes on the side, fire engine with hose reels, ambulance and others. Most are painted in red with a black chassis, as befits rescue vehicles, but the ambulances, 7 inches in length, come in blue and cream as well. There are also rather impressive wooden emergencyvehicle garages in which to house them.

ITALIAN VERSIONS

In Italy, Ingap was making tin toys of a wide range but of very variable quality. Some were people would not want to keep; others ,particularly early on, were very good models indeed. These included a beautiful chromed Fiat 1400 about 8 inches long, fitted with a music box with a tuneful quality mechanism. Despite having switched over to plastic, however, Ingap could not compete with Japanese production and in 1972 was bought out by Eurotoys. Marchesini had been a prolific producer of pennytoys from as early as 1908, and from 1945 to 1952, under its trademark MLB, it made a variety of

d

truck. Its Rolls-Royce, for which many different two-tone color schemes were employed, is particularly attractive, and its Jaguar XK140 drophead coupé is the only known 1/43-scale toy of this car. Some of the dies of this highly collectible series were reused in the 1990s. There is a substantial price differential between the originals and the reissues, and care needs to be taken to distinguish one from the other.

Another short-lived late 1950s offering from JEP was a group of six saloons, whose good plastic bodies were given extra weight by diecast chassis. PR made only two models, both of them Tour de France cycling support vehicles. The Ambré Le Chat, with its cat sitting on the roof, and the Waterman Ink Renault vans are the best of the surprisingly small number of Tour de France toys and vie for the prize for the best specialbodied advertising vehicle models.

Rami's name was taken from a range ("Retrospectives Automobiles Miniatures") at the Château de Rochetaillée motor museum in Lyons. The thirty-five or so 1/43-scale models of veteran and vintage cars in the museum were partly intended as souvenirs and have always appealed to adults rather than children. Minialuxe made Old Timers, Tacots, as well as modern cars in plastic. These fair models are not really collected outside France and hardly at all in Britain, where there is a considerable prejudice against light plastic in favor of weighty diecast. Many other small manufacturers that often made poor-quality items – Clé, Gege, Cofalu – are little known outside France, except for the occasional gem, like the tiny Routieres-labelled beer-barrel truck.

GERMAN PRODUCTS

Märklin, which had some experience with diecast before the war, actually introduced its small postwar series with the release of a plastic version of its MAN Aral articulated tanker. The range is in 1/45 scale, slightly smaller than usual, and indeed the models - Borgward Isabella, Volkswagen Karmann Ghia, and so on - have a delicate air about them. Each consists of a diecast body, tinplate chassis, and rubber-tired wheels, with no interiors or glazing to detract from the beautiful accurate castings with their excellent finishes. Prämeta was a surprise visitor to the scene in 1952. With no toy experience, it cast only four models, plus a Volkswagen promotional, with clockwork, steering, and a gearbox with three forward gears and reverse, in 1/32 scale. Both body - with the windows indented, not cut out - and chassis were thick diecastings and very heavy. Finished in chrome or painted, Prämeta's Jaguar XK120, Buick, Mercedes-Benz 300, and Opel Kapitän were available for about five years. If you find one, make sure you obtain the policeman-shaped key with which to wind it up.

The late 1950s saw two German tinplate manufacturers, Schuco and Gama, turn to diecasting. Schuco opted to make some of the smallest diecasts, its Piccolo line being 1/90 scale, like Wiking's plastic toys. These delightful, desirable models are solid castings with fair detail. From 1960, Schuco also produced a 1/43-scale Micro-Racer series. The scale was conventional, but these diecasts had a clockwork motor and their steering was controlled by turning the exhaust pipe. The cles as the Ford Vedette and the highly desirable Citroën Traction Avant. In the later years of the decade, several significant developments took place. A small group of excellently modelled American cars (by then windows and white, treaded tires were standard) included a Chrysler New Yorker and a Plymouth Belvedere, with a Ford Thunderbird and a Chrysler Saratoga to follow later. A range of probably the best-modelled diecast military vehicles ever made was also released. Finally, in 1959 Dinky's old digit/letter numbering system broke down and was replaced by an all-number one.

Solido, the main French player, reintroduced some of the prewar Junior bolt-together models and at the same time a new series that included models of Studebakers and Fords, and one that was supposed to be of a Tatra. This series continued until 1960, with the quality improving dramatically around 1953. Its 1/40-scale Rolls-Royce Silver Cloud, Peugeot 403, etc. are good models and are fitted with clockwork motors. During the mid-1950s it also made a series in the smaller 1/60 scale. Solido is best known for its 100 series, which was introduced in 1957. These 1/43-scale diecasts are excellent castings with very good detail, and the line was continually improved, with the introduction of opening doors and hoods, engine detail, suspension, plastic parts, and so on. Where decals were fitted ,they were superb. New commercials and military vehicles followed at the beginning of the 1960s, and vintage and classic cars from 1964. The 100 series dies were also used under license by Dalia in Spain and elsewhere.

Another prewar firm, CIJ, got back into business in about 1950 making (usually French) saloons. These simple castings are most attractive, capturing the lines of the full size well, and have an enthusiastic following. Its commercials are mainly of Renaults. The 1,000kg (0.98 ton) vans have excellent paint finishes and a line of mainly domestic French decals: Boucherie ("butcher"), Teinturerie ("dry cleaner"), etc. The Renault tankers with their later Saviem versions sport authentic liveries: Shell, BP, and so on. The Europarc logo was no doubt adopted to make them appear more European, but it remained very French. In 1963/4, CIJ bought out JRD and reissued some of its Citroën dies as CIJ, but unfortunately not that of the splendid Unic van Hafa Motor Oil, or the multi-wheeled Izoard 6-axle Load Carrier and their variants. In 1966, for reasons that are obscure, CIJ vanished without a ripple. However, not all the dies were lost, and there have been many reissues, in particular of the IRD Citroëns.

Norev launched themselves onto the scene in 1954 with a series of excellent 1/43-scale cars in plastic. The plastic was self-colored, and duotone effects were produced by molding the different colors separately: a roof or a side strip in one color with the main body in another. Though attractive, these models do not seem to have been exported and they are mainly collected in France itself. Quiralu used to be aluminum casters, as the last three letters of its name suggest. In 1957, it went briefly into the 1/43 diecast mazac toy world. It produced good solid models that even included a vast Berliet Sahara

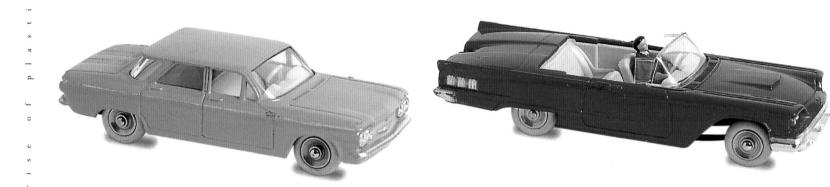

years, introducing circus vehicles in 1960 and making a most unusual Ecurie Ecosse racing-car transporter, among others, to

above: Dinky Toys, France Ford

Thunderbird Convertible and Chevrolet

Corvair Sedan (mazac, c.1961, France).

rival Dinky Supertoys. When Corgi introduced the first of its American cars in about 1/48 scale, which had all the flair of the originals – the 1960

Studebaker Gold Hawk, the 1961 Ford Chevrolet, and the 1962 Ford Thunderbird, to mention but a few – Dinky must really have started to get worried.

Seeing that diecast toys were such a significant part of the market, Lines Bros thought it had better get in on the act. Its Spot-On series, at exactly 1/42 scale, came out in 1959. It was good quality and had a nice mix of cars and trucks. All rigidly scaled, the eight-wheel and trailer trucks are very impressive, particularly the Shell BP tankers, though many feel that the models lack the flair that would have been imparted by emphasizing slightly the distinctive aspects of each vehicle. The line – short-lived, as Lines Bros abandoned it in favour of continuing the Dinky toys after it rescued them from Meccano – has exhibited a collectors' price phenomenon that can be observed with Minic and some others as well. A surge of popularity and

subsequent increase in price perhaps occurs because a good collection comes onto the market. As supplies dry up, this can be followed by a plateau that lasts for a year or two, or even (as in the case of Minic) a drop, to be followed by another price rise, and so on.

FRENCH PLAYERS

In France, the Dinky factory dusted off its prewar dies and the company reintroduced its by now very outdated product, making a minor concession to modernity by at last fitting rubber-tired wheels as standard. However, it was soon supplied with new tools made by fine workmen, who brought the delicacy and flair that so typifies French Dinky. The Studebaker trucks, it is true, are a little workaday, but the Fords decorated with delicate transfers – such as SNCF (the state railways) and Calberson – are works of art. The Panhard trailer trucks replaced the Fords in 1952, are few in number but have excellent paint finishes and decals – the yellow Kodak box truck, with its red lettering, is particularly attractive. For the most part French Dinky concentrated on producing contemporary French vehicles, and the early 1950s saw models of such vehi-

0

the simultaneous production of its perfectly-scaled Dinky Toys miniature. This fine, up-to-the-minute new

model, based on the maker's own blueprints, faithfully reflects the sophisticated lines of the high-performance

New as to-day! Meccano Limited are proud to mark the launching of the magnificent new Triumph Herald with

two-door saloon. An outstanding feature is its independent suspension - just like the prototype! Fitted with

transparent windscreen and windows, it is available in the duo-tone finishes of the actual car. Insist on Dinky

Toys...they've got everything.

This car was also finished in a variety of authentic colors to be used as presentation pieces by Triumph. In 1964, Dinky was still producing good, detailed vehicles capturing perfectly the lines of some of its American models, but change was coming. Despite Dinky's success, the whole Meccano group was felled by the expense of retooling Hornby Dublo trains, from threerail to the new, market-dictated two-rail system – yet another example of Meccano's late reactions.

CORGI

Corgi and its little Welsh dog mascot was created by Mettoy, whose factory was in Wales next to that of Marx UK, in order to chase and worry Dinky. From 1948 to 1951, in addition to continuing with some tinplate, Mettoy had been making generic cast toys, some dubbed Castoys – a saloon, a bus, and a Morris 8Z van in about 1/35 scale. The Morris 8Z vans are quite collectible, especially when decorated in BOAC, Post Office Telephone, Royal Mail, or other genuine livery. Its 1/20scale diecast Vanwall made for Marks & Spencer is an impressive piece. The Corgi range began with a group of excellent models of the stolid British cars that were on the roads at the time – Austin Cambridge, Morris Cowley, Vauxhall Velox – all deliberately chosen for mass appeal. Great thought was given to the efficiency of the manufacturing operations, and some vehicles were selected because it would be easy to make changes of livery and accessories to make a visually different toy. The Riley Pathfinder was made because it would easily transform into an authentic police car. The first vans came in a multitude of versions, and, most importantly of course, they all had windows. Corgi continued the successful formula for many have coincided with them being given a yellow box with a color-coded dot on the end. On the collectors' market, a trade box will frequently turn up with part of its contents. It is common for a box to be made for the American distributor brought up to its full complement of mod-

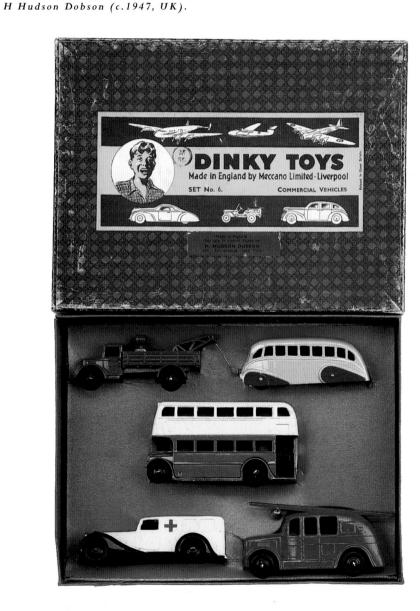

els, but it becomes anomalous if a late, post-individual-box color is included – if, for example, a Riley saloon in a late color (say, cream) is put in the trade box. Similarly, an individual piece (say, a blue and white Triumph Herald) might be put in a box with a green color dot, which should have held the green and white one. The cars in both of these examples would have a reduced value in the eyes of a wary collector. The superb and eagerly collected Dinky commercials generally referred to as Supertoys – trucks, vans, and tankers – date from this period. Because of the variety of renumberings and box changes during the 1950s and the amount of restoring, refinishing, and outright fakery since (especially on models that are screwed together), collecting them can often be a very expensive minefield.

Dinky were so successful that Meccano, its parent company, somewhat rested on its laurels and did not seek innovation, though it had introduced a neat line of military vehicles. Indeed, it was even slow to react to the competition posed by new companies. Dinky considered Lesney to be no competition – as indeed it was not. It was more than two years after Corgi was launched in 1956, advertised as "The ones with windows," that most of the Dinky issues were fitted with windows. Solido and Tekno beat it on the introduction of suspension. When Dinky did get round to following suit, it did it well and also made a point of getting the models right by liaising with the manufacturers. The full-color ad on the back of the May 1959 *Meccano Magazine* announces: Morestone went on to become Budgie in 1959 and made an interesting line of unusual items – an airport refueler and BOAC baggage-loader truck among them. An oddity of large scale are the diecast Foden trucks from Shackleton that were made from 1948 to 1955.

LESNEY MATCHBOX

The success story of the beginning of the 1950s was that of Lesney. From mixed beginnings with a large-scale Moko Lesney road roller, low loader, bulldozer, etc., via Coronation coaches (for the Queen's coronation), Smith and Odell started the Lesney Matchbox 1-75 series in 1953. Small-scale, beautifully cast, and well painted, these good representations of vehicles the child could see on the road soon got a grip on the market. The size of the models increased a bit over the years, but the series has never gone past seventy-five. After it reached this number, old models were dropped to make room for new. Such was the enthusiasm for the intricacies of the casting changes, wheel changes and color variations that Matchbox toys were probably the first individual brand to have its own adult collectors' club set up. When Yesteryears - all-metal models of vintage cars, a traction engine, and a steam roller, beautifully painted and decalled - were started in the mid-1950s, they immediately became a hit with adults. Many were bought to decorate the mantelpiece rather than to be played with. This has led to an amazing survival rate of what was intended as a toy, and though high prices are obtainable at auction for "rare"

pieces, a slightly marked unboxed toy receives no interest. A similar system of replacing models on the same catalogue number has led to a bewildering number of series overlapping in time, and those who collect Yesteryears tend to specialize in the range and have a deep and detailed knowledge of the variations. The Yesteryear numbering system was later simplified.

DINKY

Dinky was back in business in 1945 in time to make toys for Christmas - not that many British children would have received one because of the number that were being sent to America, where the 39 series of American cars found an eager market. The export effort continued for some time, with the extended use of prewar military dies well after they had been dropped from the home catalogue. There was a considerable hiccup in the early 1950s when mazac became scarce because of its use in equipment for the Korean War, and experiments were made with aluminum and plastic; but by the mid-1950s Dinky was riding high, with an expansion in sales that had led to the opening of a new diecasting facility. There were so many vehicles in the line that the old series numbering system had broken down, and in 1953/4 new numbers were allocated. At about the same time, individual boxes were introduced. This was a time of great significance for the collector. Vehicles that had been in production with the early numbering system (when the models were packed in trade boxes of four or, more commonly, six) were still available and renumbered. This may or may not

d

Tri-ang Centurion, the finest equipped pedal motor in the world. Specification: Length 48½" (123 cms). For ages 4 to 7 years. Welded, heavy gauge pressed steel body with chromed radiator grille and bumpers. Ball-

bearing crank drive. Adjustable pedals. $9\frac{1}{2}$ " dia. large section cushion tyred wheels with chromed caps.

Accessories: dashboard mounted 'Radio' which plays a popular tune; electric headlamps and red tail light with

on/off switch; opening boot which houses batteries, etc; safety handbrake; mechanically operated windshield

wiper; trafficators; dummy gear shift lever, A.A. badge and rubber aeroplane mascot. It is a beautifully

designed car with brilliant chrome and enamel finish.

It is to be hoped that the tune was popular in America, which was the car's intended market. Not only had this Tri-ang pedal car been styled along American lines, but the language of the description was transatlantic: for example, "windshield" and "gear shift lever" being American equivalents of the British "windscreen" and "gear lever." The Christmas 1961 catalogue featured a Noddy Car, a rare example of character marketing in pedal cars, and a symptom of the new craze, go-karting. The mid-1960s offerings featured real vehicles once again – MG Midget, Jaguar Mk X – in steel, and even a plastic-bodied Rolls-Royce. High-density polythene was now sturdy enough to create complete vehicles, and soon tractor diggers and other items, difficult and dear to make from steel, became popular.

The late 1940s in Britain was characterized both by firms that picked up the prewar pieces and by a new group: those with technical skills looking for some way to employ them. Among these little firms were Charbens, Benbros, and Timpo. Usually, the material and casting were poor in quality and the items small, although Timpo's simple van casting was lifted by its beautiful Smiths Crisps diamond transfer. In the mid-1950s, Crescent made ten fine 1/43-scale racing cars with drivers. Britains carried on where they had left off in 1939, with updated versions of its military and farm equipment. It also developed the Lilliput Series of military and civilian vehicles. 1961 catalogue says: "SCALEXTRIC brings the excitement of motor racing to your home. Motor racing in miniature – and all you have to do is assemble the track, plug in the Control unit and connect up the Transformer/Rectifier (or Batteries) and away you go on a skilful, thrilling race." Slot-car enthusiast clubs were established and still operate. The cars are generally collected by those whose interest is in one particular marque (Vanwall, Jaguar, etc.). No doubt inspired by Victory, which was producing 1/18-scale plastic battery-powered models of British saloons and sports cars, Lines Bros introduced a group of similar 1/20 pieces. It boasted that "More than just toys, these true scale models are precision built replicas of actual cars taken from official drawings." They may have been, but Victory's ten or so models are superior and very col-

lectible, despite distortion of the plastic that has caused the roof of, for instance, the Morris Minors to rise to a point in the center. Rovex, part of the Lines Bros empire, made the approximately 1/86-scale Minix, "The greatest little cars in the world," in the late 1960s. These are fairly pleasing little self-colored plastic moldings of British cars of the period. Minic Motorways also represented the products of the domestic car industry. Designed to fit with the Tri-ang "OO" railway system, it was in effect a slow slotcar system, as were the later Minic Motor racing sets.

PEDAL CARS

The pedal car from this postwar era that is seen most often, the J-40, is based on the 1949 Austin A-40. It will comfortably take two small children side by side and was originally manufactured for sale in showrooms. During its twenty-year production, however, many of the nearly 33,000 made found their way onto fairground rides and have since been rescued and refurbished. Lines Bros had been England's major manufacturer of children's pedal cars since the 1920s and was still in full swing in the mid-1950s, when its catalogue featured twenty-three variants of pressed-steel types,

ranging from the pretty basic to the:

MECHANICAL

below: A Shackleton Foden FG Flat Truck with a powerful clockwork motor in the cab driving through a scale propeller shaft and differential (diecast mazac, 30cm/12in, c.1950, UK).

ANOTHER SHACKLETON

MECHANICAL SCALE MODEL

PRECISION BUILT CONSTRUCTIONAL SCALE MODEL READY ASSEMBLED

A

above: Dinky Hudson Commodore Sedans arranged in chronological order from left to right (10cm/4in,

d

record cars – Goldie Gardner's MG and John Cobb's Railton – both with beautifully pressed one-piece bubble bodies.

In an attempt to get back into business 1950-59, UK). and build up exports, as the government demanded in order to repay the American war loans, Tri-ang scoured the upper regions of its factory for the bits and pieces that had been stored during the war. The first postwar tinplate Minics that it made are thus difficult to distinguish from the earlier product. The more complicated toys - the Rolls, Bentley and Daimler cars - were later released in a simplified form and by 1947 new liveries, including those of railway companies, were appearing on trucks. From then on, apart from the buses and other odd items, the product became simpler, with flat-fronted trucks appearing, plastic being employed, and the old clockwork mechanisms replaced by push and go. The plastic named cars - Riley, Austin, Morris Minor, etc. - are not good models but have survived in such small quantity that there is some enthusiasm for them. Larger sizes were also introduced, including such items as a plastic Sherman tank that puffed out white smoke from the end of the barrel. A large

range of garages in anything from card to wood was still available in the mid-1950s. The bottom end of Tri-ang's stampedsteel products at this time are reminiscent of the streamlined Marx-cum-Wyandotte commercials, but larger trucks and vans were also made, including an 18½-inch) van carrying ads for a variety of Lines Bros products. This sort of size was continued, with circus trucks being the most interesting variants. The mid-1960s saw the introduction of a new range of large diecast cab/chassis units based on the BMC 5 and 7 tonners, the best of which were fitted with a good representation of a horsebox. Among the vast range of amorphous steel trucks was a type with a Thames Trader cab. There was also a new series of Sit-'n'-Ride vehicles, with a steering wheel sticking out of the roof, in steel and a new heavy plastic.

The similarity between the names Scalex, Startex and Scalextric – the last a range of 1/32 slot cars introduced by Lines Bros in 1957 that ran on an electrified track – is not accidental. Three of the Scalex models (Ferrari, Maserati and Austin Healey) became the first electric-motored Scalextric and were still made in the original factory. Subsequent models were plastic, and the scale eventually became 1/24. As the

BRITISH MAKES

British tinplate manufacturers also turned their attention from war work back to toys after 1945. Wells-Brimtoy resumed its manufacture of cheap, lithographed tinplate toys, but in 1949 brought out a new product. The mechanical Pocketoys - small, as the name indicates - were in tinplate, but many had cabs in the up-and-coming material, plastic. The early ones have wellmodelled, long-hooded cabs and attractively lithographed backs, and there are some good buses and trolley buses, but the cheaper production has anaemic, flat-fronted cabs with less pleasing rears. There are also a few, such as the Buick, with diecast bodies. Not long after, Welsotoy, an all-plastic, smallscale range of vehicles, included Bedford trucks, buses, Morris Minors, etc. These poor-quality items failed to compete with the cheap and cheerful tin imports that were made by the thousand or their quality large pieces by the Japanese. Chad Valley began by taking over the small Ubilda line that had originated years before with Burnett; it also made a small series of cars, racers, buses, and vans, including the famous 10-inch Chad Valley Games Van, which advertised its own products.

Chad Valley was adept at using a variety of materials – wood for baby toys, card for board games, cloth for dolls and teddy bears – so it is no surprise to discover that they made, as early as 1950, a group of approximately 1/43-scale clockwork, diecast road vehicles. These included a double-decker bus, a Commer Avenger coach, Guy vans, Guy Motors, and Lyons Ice Cream vans, plus four Rootes Group cars: Humber Super Snipe and Hawk, Hillman Minx, and Sunbeam Talbot. All of this latter group were also available from car showrooms and are eagerly sought by collectors. It is unusual for so large a part of a small line to attract such attention, but they are prototypical, very well modeled, and unusual in being clockwork-powered diecasts that were also exported to Europe, North America, South Africa, and Australasia.

Minimodels made an early appearance after the war, producing a few Scalex clockwork but keyless tin racing and sports cars in 1948. In the mid-1950s three of this group became Startex, which were wound up by pulling the exhaust pipe! The main claim to

below: An Ohta Austin A50 Saloon with a lithographed interior and a friction motor (tinplate, 20cm/8in, c.1959, Japan).

C

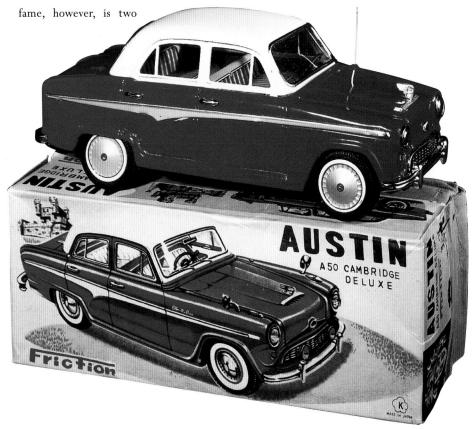

Ford Fairlane sedan is especially sought-after by collectors, who also seek the rest of the line despite its slight lack of accuracy of shape and detail. Gama's early diecasts, such as the Volkswagen ADAC from 1959, are simple castings with roughly riveted tin baseplates, made for the home market. Though improvements were constantly being made, Gama's series never reached the major league for quality and detail. Various scales have been employed, and there are many earth-moving and heavy-engineering vehicles – all with the GAMA name prominently placed. Its Mini-Mod line of German cars is pleasant and features 1/43-scale Opels, BMWs, Mercedes-Benzes and VWs, among others. In contrast, there is a series of oldtimers in ghastly metallic colors that are so bad that it would be surprising if any child wanted them; unsurprisingly, few collectors do.

Meanwhile, plastic toy cars were being made by two new-

comers. Siku was a long-established company, having been in business since the 1920s. It turned to the new plastics and issued its first series of models in 1953. These were in 1/60 scale and within ten years 200 different models had been made. They were well detailed, with a broad spread of subjects, and are particularly well collected in Germany. Indeed, they are difficult to find outside mainland Europe. Aware of the need to increase the play value of its models, Siku also made a comprehensive line of accessories. Feeling that plastic was losing out in

the market, it changed its material to diecast in 1963. Wiking made 1/40-scale Volkswagen promotionals in plastic before changing the scale, in 1955, to 1/90. This is the scale of HO railways, HO being the continental equivalent of OO or Dublo, and the early pieces (with no window holes in the bodies) were conceived as railway

below: Dinky BMC Minivans

(8cm/3in), Plymouth Sports Suburban (10.5cm/4in) and a Corgi Volkswagen Van (diecast, c.1963-65, UK).

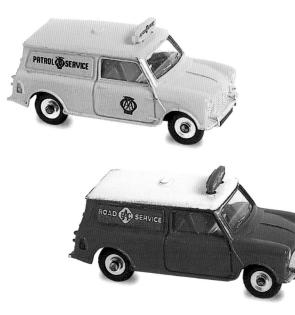

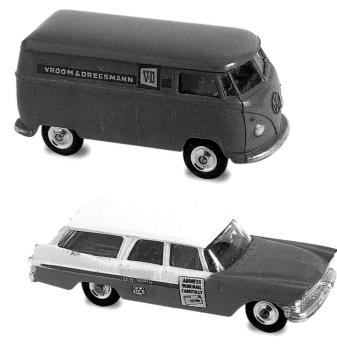

accessories. Later, clear plastic windows were fitted. A huge variety of vehicles has been made, and in 1969 even

smaller versions in N gauge were added

with decal decoration, has no motor (18cm/7in, c.1948, Denmark).

50

c

to the catalogue. The line has been extremely successful, and the earlier items *penmark*). in particular are widely collected. HO is an especially popular scale in Germany, where plastic is considered a perfectly acceptable material by collectors. Other producers have joined Wiking in its niche, aiming at both children and adults. To find current production, look in railway shops.

ITALIAN MODELS

Italy's earliest and most collectible diecast series, Mercury, started production immediately after the war in 1945 with generic vehicles, but the company very soon moved onto make more accurate models. There were two parallel series in approximately 1/40 and 1/80 scales. Accuracy of scale was not a high priority, and the sizes moved around a bit in the 1950s; but by the end of this period, Mercury was making models in approximately 1/43. In 1959, it had a rethink and introduced a new series, which reused the catalogue numbers from one onwards. It made some really beautiful models, of which the Cadillac

Eldorado and the Studebaker Golden Hawk are both particularly fine and accurate. Just as land-speed-record cars were the popular toy of the 1930s, these exotic American cars were the craze of the 1950s and 1960s. Mercury also produced some excellent commercial vehicles. Its Viberti tankers are a unique and colorful group with attractive decals, including the mythical beast logo of Agip. Its Saurer vans, are also a much soughtafter part of this wide range of subjects and scales. Mercury had the field to itself until 1960, when Politoys began producing average plastic models in 1/41 scale.

Two other Italian manufacturers, Rio and Dugu, both made veteran and vintage vehicles from the early 1960s. Too small and fragile to be good toys, Rio models (mainly metal with plastic parts) were highly detailed and immediately popular with collectors. They are all still in Rio's production schedule and make an attractive display, but there is virtually no chance of their appreciating in value. Dugu made a different group of models of inferior quality, but these are now out of production and have an enthusiastic following, particularly in Italy. There are other names that the real Italian enthusiast might try to collect, but EGM, Icis, Samtoys, etc. are of little interest beyond their country of origin.

OTHER EUROPEAN

MANUFACTURERS

The Danish firm Tekno began diecasting in 1946, making a series of Ford V8 trucks identifiable by the V8 delicately cast on the hubs. It followed these with Buick, Dodge and Triangel police, fire and ambulance vehicles. When cars were added to the range, they too were of very simple construction, the XK120 being merely a flattish cast body with a tin baseplate. Quality and detail steadily improved, until the Tekno line became one of the best. Its Volkswagen and Taunus vans, with superb decals, were made in a great variety, many of them as promotional items. It seems to be almost impossible to collect the complete series, as every so often a new version pops up that has not been seen before. The larger commercials are well documented, however, and the line features accurate Carlsberg beer trucks with their distinctive canopied cab roofs. Vilmer made a group of smaller, much more toy-like diecast cars and trucks. These are pretty, with good paint finishes and decals, but they were not made in sufficient quantity for many to have survived.

Holland had contented itself with importing toys until the late 1950s, when Lion Car established itself with a good selection of 1/43-scale road cars. These were mainly of the homeproduced DAF, but Lion also made a highly collectible Renault, VW, Opel, and DKW, all of which could be seen on Dutch roads. The molds for most of this group were also used by Lange, which was intertwined with Tekno in Denmark and Jefe in Spain, but all the models are so identified on their bases. Light commercial vehicles came later and, in 1963, in a foretaste of the direction in which Lion was to head, the first of the DAF trailer trucks appeared, along with a Eurotrailer carrying the names of the transport firms. Best Box also has to be mentioned, mainly because its 1/70-scale castings seem to be indestructible – except for the two Formula 1 cars, Cooper and Lotus, that they also made for Mini Dinky.

Spanish diecast production was as derivative as its tinplate, though Dalia's use of Solido dies was at least officially sanctioned. Dalia made Tekno vans under license and probably had a similar agreement for its line of Mercury scooters. It also added a few Spanish Seat models. (Seats were Italian Fiats made under license.) Anguplas was innovative, making 1/86-scale plastic models of reasonable quality of unusual cars and commercials, but these are now almost impossible to find.

Elsewhere, virtually every country with a diecasting industry made toy cars. Gasquy-Septoy in Belgium made simple Septoys and a small, but highly desirable group of Gasquys: Willys Jeep, Studebaker Champion, Chevrolet Sedan and, most unusual of all, a Tatra. In Czechoslovakia, behind the Iron Curtain, Igra was making plastic moldings, without cut-out windows, of Tatra and Skoda cars.

To name just a few companies in other countries, Micro Models of Australia made a line of simple but attractive vehicles, including a fire engine and a post van, while Canada had an attempt at diecasts (London Toys) in the 1950s.

THE BEGINNING OF THE END OF

By the second half of the 1960s, aspects of the flower-power era were beginning to percolate down to children in general, affecting the whole population, not just those who were hippies or the children of hippies. The power of the Beatles was abroad in the world, and the passion for popular music on 45rpm discs was beginning to spread down the age groups, making the young throw off childish things at ever-earlier ages and spend their money on music and clothes, leaving behind the "square" toys of previous years. This was, of course, a very gradual

below: Barney Rubble's Wreck from the Flintstones cartoon series by Marx (tinplate/plastic, 20cm/8in, c.1965, USA).

RUBBLE'S

WRECK

0

50

E

trend, for adults initially resisted the new anarchy of child-driven purchases. It was an especially difficult time for decision makers who were engaged in long-term successful toy businesses: they were used to competing with other similar companies for a share of the toy trade, but not to needing to grab a proportion of the general market. Though some companies, like Meccano, did get into extreme difficulties, for most the mid-1960s was a period of gradual change and decline.

BUDDY L

In this period, Buddy L commonly used a very modern-looking cab with a wrap-around screen on many of its 13- to 15-inchlong commercials. Styled on the clean-cut, square lines of a cab type used by GMC and Dodge, it is generic but realistic. The interest lies in the back of the trucks: a kennel truck has a clear plastic back, through which can be seen twelve different dogs, each housed in its own compartment; a Coca-Cola truck has crates of bottles; a zoo truck has cages with doors for half-adozen different animals; and a milkman truck has rather oversized bottles of milk. The same vehicle was used for some of a wide range of campers produced during the 1960s. There were only a few larger trucks, but one that uses the same basic cab pulling a trailer with three cages is most spectacular. The 26inch length of the Wild Animal Circus truck - bright red, containing a lion, a tiger and an elephant - is reminiscent of the toys of earlier years. The impressively named Big Brute earthmovers are only 61/2 to 12 inches long, but, even at that, they did make good-sized sandbox toys. There was also an impressive series of Mack Hydraulic Dumpers for about ten years beginning circa 1965 - if collecting construction machinery is your enthusiasm.

Buddy L also issued an even smaller Big Brute fire pumper, but larger fire engines (especially snorkel pumpers) were

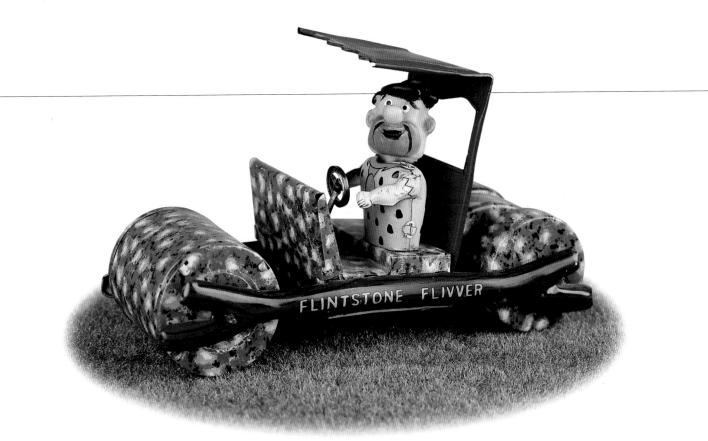

issued in a variety of sizes in the late 1960s. The early 1970s boasted the appearance of an American LaFrance Pumper, 25½ inches long, complete with snorkel boom, cherry-picker basket, hose pipes, and extension ladders. With a feature harking back to the 1930s, the nozzle of the snorkel squirted water when a garden hose was attached to it. Soft-drink advertising – Coke, Pepsi, and Canada Dry – was found on the backs of Buddy L trucks of varying lengths using a typical concept cab with a very deep windscreen as recently as 1975. More prototypical was a series of delivery step vans fitted with sliding cab doors and conventionally opening ones at the rear. Most of these, such as the Borden's milk van, carried advertising and many were made in small quantities as promotional items, making them an interesting subject to hunt for at rummage sales and garage sales fairs. Buddy L made some preschool play-

best engender mirth. There was a line of 3-inch or so Brute Buggies in colors from lavender to fuchsia. Larger-size pieces can cause collectors to groan; for instance, the 1970 Japanese-made Ol' Buddy's Rod-ster, 10½ inches of limegreen steel body and chassis with a bright blue plastic hood, complete with silver plastic engine stack.

things that little kids loved, but among collectors these can at

OTHER AMERICAN COMPETITION

Nylint continued to make toys that mirrored the types made by Buddy L, with whom it was in direct competition. One odd item is a highly impressive large pressed-steel van made as a 1980 Olympics remote broadcast van. Lettered with the Nylint trade name and ABC, it came complete with cameras and

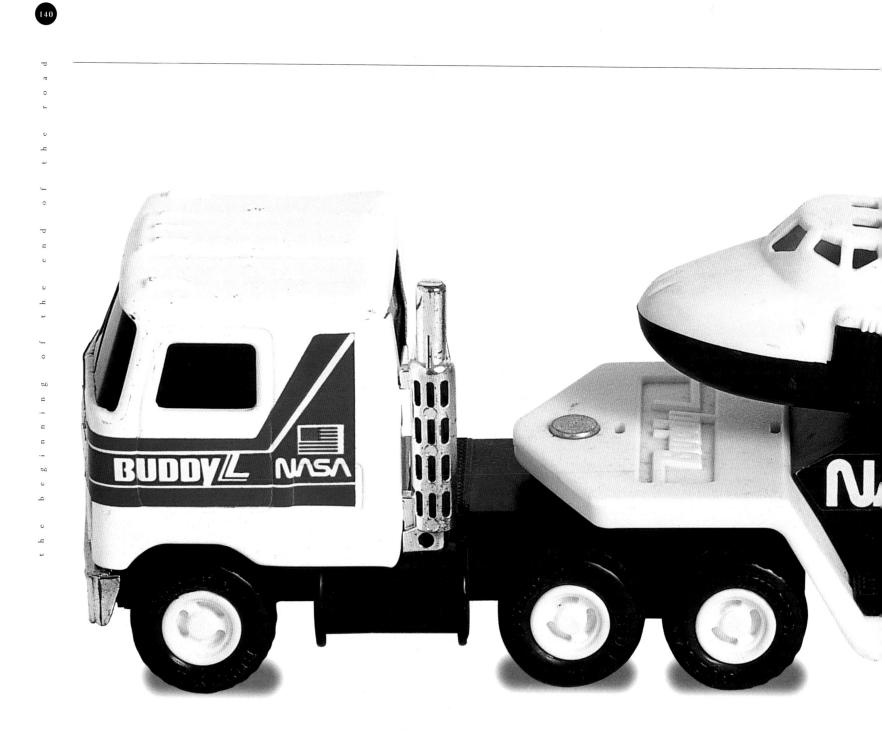

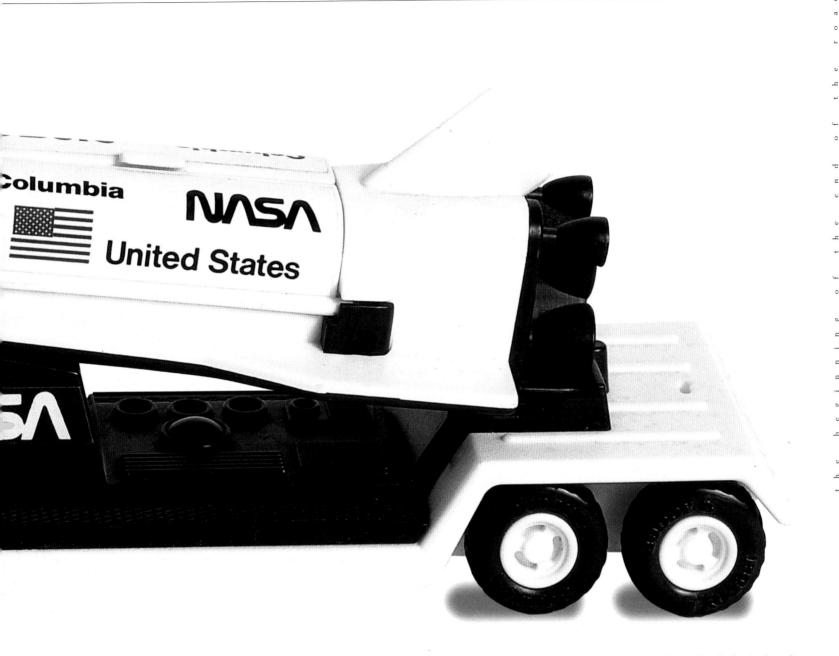

above: A Buddy L Mack Articulated Low Loader with NASA Space Shuttle. The decoration is achieved by stickers. (tin/plastic, 28cm/11in, c.1979, Japan).

	cables. By now, large toys such as these were being packed in	countries that withdrew from the Olympic Games after a row
	open-fronted, thick corrugated cardboard boxes that displayed	over the Russian invasion of Afghanistan.
	the contents clearly on shop shelves. They held together so well	By the mid-1970s, Tonka was also thriving, with Tonka
	that it was frequently difficult to get the toy out without tear-	Corporation established in Canada, Tonka Limited in the UK
	ing the box, and it is rare to find complete packaging from this	and Tonka Gmbh in Germany. Its catalogue, or Look Book lists,
	era. The Olympics van may have survived intact simply because	on the front "Five ways to look at Tonka Toys," which sum up
	souvenirs of the Moscow Olympics did not sell well in those	their marketing strategy:
O Look at the strength. Virtually all Tonka Toys include extra strong axles that won't bend even under the standing weight of a 200-pound adult.		
② Look at the steel. There's a lot of it in Tonka Toysand it's the same thickness found in the bodies and		
fenders of new cars.		
O Look at the tires. The second se	hey're guaranteed for the life of the toy. And	they're attached to stay on, even under

severe play conditions.

-

r 0

h e

0

n d

~

0

ы 50

u u

b e g

the

• Look at the realism. Realistic proportions. Realistic details. And realistic functions performed by working

mechanisms on many models.

G Look at the finish. Two coats of real truck enamel protect all steel toys. It's highly chip resistant. Non-toxic.

Dip-coating and electrostatic spraying provide total coverage to protect metal against rust.

Persuasive words – indeed, the answer to a parent's prayer! Small Tonka-Tote toys could be purchased with the bynow obligatory launch ramp. Sizes increased, from Funnies, Hot-rods and the like, through a low loader with bulldozer and car transporters in three sizes to impressive action earthmovers, including the Mighty-Tonka crane, 30 inches long, complete with swivelling grab-bucket and realistic action. Based on reality they may have been, but most make no pretense at all to being models rather than toys.

This period saw the brief appearance of a number of firms whose small product lines fascinate the collector because they are uncommon. Finding a Cigarbox model, packed in a carton similar to that from which the product got its name (obviously derived from that of Matchbox), might well arouse one's interest in this group of 1/60–1/70 toys, made by Aurora in 1969, with plastic bodies and diecast chassis. Their nicely detailed moldings have the

decoration spraypainted on, a system cheaper than that of applying a decal. The more familiar name of Champ of the Road appeared in the late 1970s. This was an American marketing company whose 1/50-scale trucks, with diecast cabs and plastic backs, were made in Hong Kong by Universal. At the time, the line also included some reasonable diecast cars. Sourcing from Hong Kong was to become an increasing feature of American and, subsequently, European toy

production, as companies in the First World were hit by rising prices and economic recession. The reputation that Hong Kong had for producing "rubbish" **below:** A Buddy L 'Ol Buddy's Rod-Ster' with a steel body and chassis and plastic seats, hood and engine (steel/ plastic, 27cm/10.5in, c.1970, Japan).

above: A typical example of the Mattel 'Hot Wheels' Hot Rod (5-6cm/2-2.5in, c.1975, Hong Kong).

-

C

was soon swept away as the Far East soon began to develop into a major zone of manufacturing.

Ertl was going from strength to strength in the 1970s. It had already begun to branch out from farm toys and, to broaden its base away from farming areas, had decided to sell to the general retailer. In 1964 it produced its first trade catalogue. A national sales force was established, and in 1967 Ertl became a subsidiary of the Victor Comptometer Corporation. Victor considered the move to sell to traditional toy outlets very important; it provided capital to consolidate Ertl and enable it to buy companies such as Structo. Toward the end of this period, becoming even more successful, Ertl began to branch into the hobby market. In 1977, however, the whole of Victor and its subsidiaries merged with Kidde Inc., a move that saw it become just one of the 180 companies owned by Kidde worldwide and set Ertl up to face the rigors of the times. One of the first steps was to send dies to whichever part of the world would be able to produce the toys most cheaply, beginning with Hong Kong, rather than manufacturing only in Dyersville.

HOT WHEELS

Topper Toys had been one of the manufacturers that had built up its trade using a lot of plastic in its products to satisfy the increasing demand for toys that accompanied the postwar babyboomer years. It had gone on to develop a popular line under its Johnny Lightning name, consisting of custom-car types based loosely on full-size vehicles. Topper had a Custom Ferrari and XKE, as well as a Custom Spoiler and Turbine, a Frantic Ferrari, and a Sand Stormer that would run on a raceway set with track and speed launchers. Unhappily for Topper and many other companies, Mattel launched Hot Wheels in 1968. The idea was not Mattel's, or Topper's, or even Marx's, who sold its Loop-the-Loop racer set in 1931. The latter had a tiny car 1³/₄ inches long positioned at the top of a tinplate track that terminated in a run-off from a 360° loop, allowing the car to whiz across the floor. The new idea was the same as that of any child who has ever rolled a stone down a hill, or a spool of thread down a slope, but Mattel picked it up, packaged it, and exploited it for all it was worth.

The first production vehicle, a Chevrolet Camaro, was ready in May 1968. As the catalogue says: "Hot Wheels are the fastest metal cars in the world! They don't need batteries, or electric current, or motors – yet they out-race, out-stunt, out-distance every other miniature metal car on Hot Wheels Action Sets..."The cars and the sets were custom-made for each other, but it is an impressive enough claim anyway. "Hot Wheels are THE custom class cars for collectors. They're California Custom styled with red stripe tires, 'mag' wheels, moving parts, wild, California paint jobs! Hot Wheels are for the collector who likes to race."This collector was the boy, not the adult. The secret of Hot Wheel's success lay on the next page: "Exclusive Torsion-Bar Suspension. Low-Friction Wheel Bearings! Go Faster...roll farther on."

The thin-axled, low-friction toy was backed up with a host of marketing ploys, such as the collectors' button in each bubble pack. The cars – Cougar, Mustang, T-bird, Barracuda, Corvette, and so on – were bound to be popular, finished in brilliant colors with lots of extras sticking out, just like the real custom cars that any child could now see on television. Several sets of curved and angled tracks were available; the cars raced around by gravity, but almost immediately Super-charger impeller units were available to give added oomph. Collector cases were supplied to house your precious cars. The sixteen models were initially made in the United States, but by 1972 all were being made in Hong Kong. Each car (the original custom cars being followed by a line of futuristic vehicles) was available in ten or more Spectraflame colors. Every year, changes were made to the products and new lines were added. In 1970 Mattel added an engine to a group and called them Sizzlers. In 1979 there was a character merchandising line, The Heroes, which included Spiderman. To promote its product, Mattel sponsored race teams, and in 1971 Hot Wheels teams could be seen in action in drag races not only in America but also in Britain, at the Santa Pod Raceway. Constant invention and renewal of the appeal of the product paid off handsomely.

> **above:** The Tootsietoy '63 Chevy Corvette' and '40 Ford' – neither has a motor or steering (diecast metal and plastic, 13cm/5in, c.1970, Hong Kong).

COLLECTORS' ITEMS

In the mid-1960s, the Hess division of the Amerada Hess Corporation, a company completely separate from the prewar German Hess toy company, ran petrol and service stations. In 1964, Hess put an oil-tanker toy on sale in these stations. After

below and right: Two typical cheap lithographed cars from the late 1960s and 1970s. The left model was made in Hong Kong, the right in Japan. the success of the first, it continued to issue a new one annually at about the same time of year, just in time for dad to be badgered into buying one as a Christmas present. but this is such a specialist area that few are likely to know which year's issue is scarce (and therefore expensive) or common (and thus cheap). If you want to collect them seriously, as opposed to picking one up because you like it, the best bet is a good price guide.

In the mid-1960s, a new family firm called Winross was established to make toys based on White trucks, and demand for its toys built quickly. The decalling was

CHAMPION

Gulf

The good-quality plastic models of Hess tankers were made by Marx

CHAMPION

in Hong Kong until the 1970s. They came complete with batteries, and the boxes were strong and well designed. As an additional incentive to purchase, a savings bank feature was added in the early 1980s. These attractive models were issued for sale as promotional items, but many will have been played with as toys. Most, however, remain perfect in their boxes and, having caught the imagination of the adult, are enjoyable to collect. General rules – such as that the lack of a box or damage to the model reduces the value on the collectors' market – still apply,

applied by the silk-screen

process, which gives excellent repeatable results at a reasonable cost. The demand for these models as promotionals from companies that ran White trucks was strong, and the word *toys* on the packaging was diminished in size; soon all pretence of their being playthings was dropped. The vehicles are about 1/64 scale and rather simple in shape to allow for the automated silkscreen decalling process. There was also the demand from collectors, and some of each run was diverted to them, via a separate marketing company. In 1976, the "promotional only" policy was suspended for the production of thirteen Bicentennial commemoratives portraying the original States of the Union. Immensely attractive, these sets were eagerly sought by collectors, many of whom thought that they would appreciate in value. They did not take into account, however, the quantities made or that the sets would be a brief enthusiasm, much like yesterday's newspaper. Winross has its own following, and its story is not unique. It is, however, one of the earliest and best-documented examples of how current toys for children turn into models for collectors.

As the collectors' market built up during the 1970s, so did the demand for replacement parts. Kenton and Arcade cast-iron parts were easily broken or lost, and whole chassis or drivers, for example, were recast in lead. Indeed, entire cast-iron items were re-created in lead or, later, cast iron. In general, a cast-iron piece that is riveted together is probably original, while one that is screwed together is almost certainly not. Tires were made to fit all sizes and shapes of 1930s toys, and one could buy new axles for Tootsietoys. Eccles company of Burlington, Iowa, even had an extensive catalogue of slush pieces recast from the original molds. So, let the collector beware!

JAPANESE PRODUCTS

In the early 1960s, Japan was producing quality diecasts in 1/43 scale, the first ones being simple castings with tinplate bases. These arrived in Europe and America only by means of exchanges between collectors. It was not that they were made for collectors (they weren't), for these models of Japanese cars were intended for sale at home. Indeed, outside their home country, Japanese cars were then an unusual sight on the roads, and they were often spoken of in derogatory tones. How wrong can you be! Japanese car with 'null-b

makers began in familiar style by mimicking the West and then surpassing it in quality, **below:** A Zee Toys Turbo Trans Am with 'pull-back-and-let-go' motor (diecast, 10cm/4in, c.1980, Hong Kong).

reliability and design. The toy manufacturers followed the same pattern. Around 1964, Cherryca Phenix began plating its models before painting them. This not only gave a lustrous paint finish, but enabled the window surrounds to be realistically chromed by leaving them free of paint. The bases were cast, opening parts were fitted, and the hood could be lifted to reveal the engine – often fitted with a five- instead of a six-ter-

below: The detailed and accurate Ford Thunderbird and Capri by Solido (diecast, 10cm/4in, 1965-80, France).

minal battery. Little mistakes like this may have caused great hilarity abroad, but the laughter subsided when people realized that Model Pet, brand name of Asahi, had invented a method of opening the hood of its Toyota Sport 800 that not only gave it a wonderful fit and a realistic action, but also managed to circumvent the many patents that Solido had taken out in an attempt to dominate the market. A few Model Pet cars were fitted with electric lights and other gimmicks, but the most desirable of the early versions are – as so often – a group of American cars: Dodge, Ford, Chevrolet and Buick. In the 1960s, there were not many collectors of Japanese diecasts, either in Japan or abroad, so the quantity of mint boxed models is very small. The demand, particularly from Japanese collectors, who understandably want their toys back, is high – and so are the prices. As time went on Asahi product began to decline and there was little comparison between a 1965 Toyota Corona, with its finely chased grille, and its last model, a Datsun Cedric of circa 1973, which were not exported in any quantity, and there is little interest in them.

Diapet, a brand name of Yonezawa Toys, one of whose trademarks is its initial letter Y, embarked on an ambitious program. From 1965 to 1970, its models were 1/43 scale, but by 1980 they had varied widely, from the larger 1/40 to the much larger 1/30, as it was perceived that children liked bigger toy cars. An early gem was the Diapet Porsche 911, along with a Nissan Sylvia Coupé and a Datsun Fairlady Sports with well-fitting opening parts. The bulk of its product was

Castrol

modelled on Japanese prototypes, though the occasional topof-the-range European or American car was also made. Collecting Diapet is complicated by the fact that most of its catalogues are in Japanese, and by frequent renumberings, in 1972,1973, 1974, and 1977. Each model was made for only three or four years before being updated. This is another reason for their scarcity, compared with makes like Dinky that kept on producing a toy as long as it kept selling. Around the end of the 1960s, there was a poorly documented marketing tie-up between Yonezawa and the American importer Cragstan that led to a group of Sabra (Israel) American cars being labelled "Detroits" in a Japanese catalog

above: The Ichiko Ford Taunus Driving School Car with remote control (tinplate, 23cm/9in, c.1965, Japan).

being labelled "Detroits" in a Japanese catalogue. Sablon from Belgium were also in the same catalogue. One American car that must win the prize for the most over-the-top Yonezawa vehicle is its 1980-ish Lincoln Hearse, fitted out with a gilt plastic rear superstructure of pagoda roof with flying dragon. It proved instantly popular among collectors! Sakura was the name coined for the Yonezawa Super Car line, which was briefly available from 1976, the first being a 1/43-scale Lamborghini Miura. Models with better detailing followed in its well-collected World Famous Car Series, including a Rolls-Royce and some American subjects.

From its base of being a general toy-producing company, Tomy started production of the Tomica line in 1971 with six diecast cars in scales from 1/60 to 1/65. Reminiscent of

below: The Chevrolet Corvette Stingray by Kidco (diecast, 16cm/6.5in, 1974, Hong Kong). Matchbox 1–75s, they fit a standard box. From the start, their play value was enhanced with plastic gas stations, multistorey garages and the like. Tomy's first

year of serious entry into the model-car field saw the production of thirty models, with twelve more listed as "coming soon."Tomy started as if it meant to go on, and the line is still in production. A short time after Tomica began, Tomica Dandys were released. The mixed scales, 1/40 to 1/50, of this larger series cause anomalies that annoy the collector, but not the child: its 1/49 Toyota Crown Saloon ends up smaller than the (in full size shorter) Honda Civic, which was modelled in 1/43 scale. In the late 1970s, Edai Grip produced a small line of well-made Formula 1 racing cars and super-cars in 1/43 scale, and a selection in the considerably larger 1/20 to 1/28 scales. Kado, which started around the same time, worked in a variety of scales, making some lovely road cars and, most interestingly, a group of vans with fine decalling.

DINKY CHANGES HANDS

The mid-1960s was the time of the most significant amalgamations of toy-companies in Britain, when the successful Lines Bros group rescued the ailing Meccano Company. The combination should have been a world-beating one, as Lines Bros

brought to it the inventiveness behind Dinky, once the world's most popular 1/43-scale diecasts. Lines was sufficiently impressed with the existing and planned line of Dinky Toys that it put its full energy into it and allowed its own Spot-On series of vehicles to fade quietly away from 1961. Rumors abounded in the collecting fraternity, whose network now spread throughout the First World, of a fire at the Tri-ang factory in Ireland having destroyed the dies...thus providing an early lesson in not believing all you hear. The prosaic truth that a firm acts for economic reasons in discontinuing a line was considered too uninteresting a story to be credible!

Despite its promise, Dinky rather wallowed in the late 1960s, apparently without much direction. It toyed with character merchandising, a potential gold-mine, its first coup being Gerry Anderson's puppet television series *Thunderbirds*, though few have ever heard of Stripey the Magic Mini with Candy, Andy, and the Bearandas. The colored stripes on the Mini are of such poor quality that even an example that has never been out of its packaging may not be of the quality usually expected in a mint boxed item. Highly sought-after by Mini collectors, who may not care about the figures, the striped versions are very difficult to find in a condition to satisfy the persnickety collec-

tor. In the late 1960s,

Dinky introduced speedwheels, as did every other manufacturer, so powerful was the threat of Mattel's Hot Wheels.

Building on work already started by Lines Bros, it also made a long-lived range of military models. In an attempt to keep costs down, stickers were substituted for transfer decals, and it made half a dozen models in 1/42 scale

for export to America. These Hong Kong Dinks, as they are colloquially known, were of poor quality and the project was abandoned.

The year 1971 proved to be a particularly bad one. The whole of the Lines group went into liquidation, when, alarmed by a general recession in the toy trade, the bank called in its heavy loans. Dinky ended up in the hands of Airfix, which had been specializing in the manufacture of plastic kits since just after the war. An attempt to break into the large size with 1/25-scale cars was not a success – surely it could have chosen a better subject than the Ford Capri, popular though it was with young men? Some of the standard models were packaged

above: A Rambler Marlin and an Oldsmobile 88, typical late 1960s Corgi models (diecast, 10cm/4in, c.1966, UK). as metal kits complete with paints. A few large steel Mogul toys were introduced to compete with Tonka. There was an increasing use of plastic parts to keep costs down – but all to no avail. Collectors wrote to Dinky complaining about a choice of subjects that pleased neither the child nor the adult, but the collectors' market was dismissed as unimportant. Amid the economic disarray and strikes of 1979, the factory closed. Matchbox eventually bought the Dinky name in 1987 but none of the dies; in 1988, it released the so-called "Dinky Collection," a new set of models for adults!

CORGI'S UPS AND DOWNS

By contrast, in 1965 Corgi was riding high without having to rely on television puppets. It went to the top, securing the rights to James Bond 007's Aston Martin. When it came out, it created such a craze that, in staff canteens, before giving the toy to their son, grown men would be seen "testing" the mechanism that fired the gunman through the opening roof, covering their teacups to stop the passenger from falling in. The Corgi production list for that year is astounding: January – eight existing castings refinished as military vehicles; February – Ferrari Berlinetta, a Monte Carlo Rally Mini Cooper S, a Farm Tipper; March – Walls Ice Cream Van, Joe's Diner Mobile Canteen (recolor), Rover 2000 Rally Car, the Saint's Volvo P1800, Mini Countryman with surfer, Forward Control Jeep, a farm and a rally gift set; April – 1910 Renault 12/16, Ford Mustang; and so on. A mere year after Hot Wheels first rolled, Corgi replied

with Rockets, and the next year Whizzwheels were fitted to the main series, giving an unfortunate nonprototypical appearance. Corgi's reaction to the slump in 1971 was to sell a factory, an action partly forced by the discovery that the upper age of children buying or being bought toy cars had dropped from fifteen in the late 1950s to eleven, representing a dramatic reduction in the size of the market. The 1/36-scale Formula 1 racing cars of 1972, despite their excellent decals, have less collector appeal than earlier product. Nevertheless, Corgi's fortunes picked up, and the factory had to be expanded. The 1/18-scale Formula 1 JPS was accompanied by a marketing tool, an educational "Tramline Project Book showing how we can learn [road safety] from the Grand Prix Greats," illustrated with Corgi cars. Though its profits went up - partly as a result of the decline in sharpness of casting detail and decoration - sales volume dropped worryingly again. While there was some recovery, 1980 saw a dramatic fall in production and the first Corgi losses since 1971. Thereafter, the decline was virtually continuous. Shareholder rights issues, rationalization, the attempt to go into computers...nothing stemmed the flow of cash out of the company, and it was effectively closed in 1983.

Lesney was badly shaken by Mattel's introduction of its low-friction axles. These toys were direct competitors in the American market, which Matchbox had previously had to share only with Topper's Johnny Lightning. In the attempt to compete with the rolling success of Hot Wheels, there was a rapid change in the style of the 1–75 line. Soon, all had suspension

e beginning of th

and oversize wheels. Some collectors, deciding that the charm of the line had gone, quickly gave up collecting the toys or gradually ran out of enthusiasm. By deliberately producing color and decal variations – technical variation collecting having been the life-blood of the Matchbox enthusiast – Lesney sought to encourage collectors and widen the market. On average, there were three totally new models per catalogue issue in the period 1965 to 1980, with about four changes in color across the group. Multiplying these seven "variations" by the seventy-five numbers in the line gives a total in excess of 500 "new" toys/models to be bought by the child or adult – a winning system. Yesteryears, which were increasingly being bought by adults for themselves, were given the same treatment with, up until 1980 at least, pretty much the same success.

The scene in Britain at the time was dominated by the three manufacturers – Dinky, Corgi and Matchbox – but other firms were poking a toe in. Britains made – unusually for the period – a group of motorbikes in 1/32 scale; Lonestar modelled some 1/45-scale American prototypes (Corvair, Rambler, and Sunliner), along with a Rolls, and DCMT/Impy tried to compete with Corgi Junior and the Matchbox 1–75s.

FRENCH DECLINE AND RISE

French children had plenty of choice of toy cars. Even though Dinky in France was part of the Meccano empire, and therefore involved in its take-over by Lines Bros, it was left alone and continued to act independently of England. Indeed, from 1965 a group of new "Super Détail" models were made, adding a new dimension to the excellent existing line. They had opening doors, hoods and so on, and covered a variety of types – from a Ferrari 275GTB, through Peugeots and the Citroën 2CV, to Alfa Romeos. The opening parts fitted neatly, and the paint finishes were good. New military

above: The battery-operated Matchbox 5 Chevy Hot Rod Racer (plastic, 25cm/10in, c.1985, China).

ing was as awe-inspiring as the early 1960s of Rod Racer Brockway Bridgelayer, which unfolds road-985, China). way before it. Among Dinky's general commercials was a spectacular yellow and red Pinder Circus GMC truck and trailer, which was partnered by a Peugeot 404 and Caravan. These two items come high on many collectors' want lists and are consequently very expensive compared with the average run of toys produced at this time. The 1400 series of super-detailed cars and racing cars culminated in 1971 in a catalogue that featured the Citroën Présidentielle on its front cover. The exquisite grey finish of President de Gaulle's official

models were produced at this time, but noth-

car, the special DS, makes this most desirable piece a fitting swansong for French Dinky, which no longer could deny the economic problems around it. Winding down in the first half of the 1970s, it revamped models to keep it going until it shipped some of the dies to Spain, where, until 1981, cars were made for French Dinky by Pilen. In 1980, it turned to Solido for a short time to make simple models, dubbed Cougar, for them.

CENTER LINE

MOROSO

CHAMPION

SIMPSO

Solido continued to produce the 100 series, with all its different types of car, truck, military vehicle, and the veteran and vintage types they had recently introduced. The gradual demise yourself decoration kept factory costs down and gave children extra pleasure – even if some of them were rather inexpert at affixing them. New "Age d'Or" (Golden Age) models were added within the 10 series in the mid-1970s, but in 1980 the whole lot was shaken out into a separate group with a new numbering system of its own. This, along with some commercials in a smaller scale with uninspiring decals, and the continuation of Solido's excellently modelled military vehicles, formed its low-key response to the problems in the European toy trade.

Sometimes there was a choice of decora-

tive schemes or race numbers. This do-it-

of French Dinky, however, opened up the market for models of French saloons and estates, of which Solido took full advantage. Its catalogues from the first half of the 1970s contain the evidence. The 1972 100 series production was boosted in the 1973 catalogue by an Alpine 310 GT, a Citroën GS, a Ligier JS3 LM, a Renault 17TS, and three non-French cars. The new series 10 began with a Renault 5, a Peugeot 104, and two Matras. To brighten up these good basic castings, Solido sold sheets of decals. Some of the spectacular Le Mans cars were supplied with all the decals fitted; others had them attached to the side that showed through the box window, with the ones for the other side and fitting instructions supplied in the packaging.

BELL

The adult passion for sports racing cars, especially the Le Mans cars in France, prompted Safir to change direction in 1971. Gone were the old-time veteran models. In came the latest Lola, Porsche, and Ferrari in a variety of different sponsor liveries. Marketed as Champion, they – like JEP's models in earlier times – had a plastic body on a diecast chassis. Such was the quality that you could not tell what they were made of until you felt that the upper part was warm while the lower was cold. (You can usually tell if a part is plastic or metal by the way it feels if you hold it against your cheek, no matter what the ambient temperature.) The quality and authenticity of the decals were excellent. In the late 1970s, Safir issued a line of all-metal Formula 1 racing cars and also a few in 1/20 scale, including the Citroën 11BL and Alpine. Its light commercial vehicles shared the good-quality decals.

0

Norev turned from plastic to metal in the early 1970s, producing prolific quantities of very fine, light castings. It kept some of the old dies in production, but now made the toys in metal. Its plastic "Moyen Age" models of cars from the 1920s and 1930s were sold off, to become the nucleus of the metal Eligor line in 1976. Norev continued to make toys, and then turned to producing many promotionals and "specials." These are models commissioned by a firm or individual for resale to celebrate an event, rather than as a promo for the firm whose name is on the side. This successful side of the business is still in operation. Eligor went on to produce a very wide range of cars and vans, with advertising aimed directly at the collector. Majorette was founded in 1966 by M. Veron, whose name (turned back to front) was the origin of the name Norev, to produce toy vehicles for youngsters. These 1/60-scale diecasts towed trailers and had other features to enhance their play value. Road sections, filling stations, and figures were all added later. Additional scales, larger at 1/24 and smaller at HO, were brought in to expand the line. There was, and still is, a great emphasis on point-of-sale display units, and the toys can be found in small shops, large supermarkets, and airports. These are toys aimed squarely at children and are not often collected.

Mention must also be made of France Jouets (FJ), which made 1/45-scale diecast military and commercial vehicles between 1959 and 1969. To begin with, it made neatly cast GMC trucks in many guises, then followed with Willys Jeeps and a good series of Berliet Stradair trucks. A selection of the dies was subsequently used by Safir in the 1970s, using both metal and plastic.

GERMANY WAVERS

Even in Germany, the strongest European economy during the 1970s, experienced a similar shrinking of the toy industry. Even though there were no financial crises - indeed, the Deutschmark was going from strength to strength - the population trends were the same: the baby boom was over, so there were fewer children in the target age group; and the upper limit of that group was lowering, as diecast toys were put aside for more interesting teenage pursuits. The market was shrinking and that was that. Märklin continued its line, gradually deleting old models (cars first and then the commercials), so that the early group was gone by the mid-1970s. At the same time, it was replacing them with the 1800 series, with the current standard features, including interiors, opening doors, and suspension. There was a marketing tie-in with Mercury from Italy, and for a time both lines were found in the same catalogue. Similarly, in another agreement, Märklin and Tekno were featured in the same Danish catalogue. By 1977, however, cars (including Märklin's own slot-car system) had ceased to be made.

Schuco made a series of thirteen German cars in 1/43 scale from the early 1970s. By varying the liveries – ADAC, taxi, police, fire chief, and so on – it stretched the

above: The beautifully designed Citroën DS Presidential Limousine was the last toy made at the French Dinky factory (15cm/6in, 1970, France). catalogue numbers to thirty. These rather stolid castings are not much sought-after outside Germany. There was a "financial break" in 1977, but they were made for only two years or so after they returned. These did not sell, and stocks lay around on shop shelves for years. During the same period, there was a 1/66-scale series of diecast cars with opening doors, based on German and other prototypes that are particularly sought-after by collectors of small-scale vehicles. At the other end of the scale, Schuco continued with the types of battery-powered and radio-controlled cars that had always been its forte. Though good toys, these have not sparked a major following. The whole of the Schuco group soon went into liquidation.

RW-Ziss was brave enough to start up in 1963, making

of the decade. Its old-timers fell into two distinct groups; RW were nicely detailed, while Ziss were a bit rough-and-ready, approximately the quality of Rami in France. Since the early 1970s, NZG has been making diecast trucks and earthmoving equipment (scrapers, diggers, etc.) in a variety of scales. However, it is a difficult group to classify. Although they are suitable as toys, they are very expensive excellent models that look as if they were promotionals, and not initially aimed at the collectors' market. If you want to collect plant (construction equipment, cranes etc.), however, you can hardly do better. Gama continued to make some reasonable vehicles, but concentrated on the toy market with motorized, remote-steering,

large-scale versions. Siku made some diecast 1/27 vehicles but also continued as before with 1/32, 1/55, and 1/60 toys. Many have working features and are quite delicate castings. However, perhaps because of the strength of the mark, they were expensive to buy as toys; and, despite their undeniable quality, have failed to find a following outside Germany - a fact not helped by an inefficient distribution system. Cursor's products, in nicely detailed 1/43-scale plastic, were never intended as toys. They were models of early Mercedes and Benz, intended to be sold in the Stuttgart museum shop, and are thus a hybrid between promotionals and models for the collector. Of all the companies that produced small-scale series, everpopular in Germany Wiking was taken over by Siku in 1984. As Wiking faded from the scene, Herpa became the best known make. Made in 1/87 scale, these mainly German prototype cars, buses, and other commercials were aimed specifically at (railway) modellers and collectors.

OLD NAMES AND NEW

By 1970, the quality of the new models of the Danish Tekno was falling a little, perhaps as a consequence of its founder's death the previous year. The next couple of years were most complicated. Some of the late production, made while the company was owned by Lange Legetøj, has the Tekno logo blanked out. After the factory closed, some models (Volvo saloons, for example) were assembled elsewhere from parts. The quality of these is not so good; there are often no boxes, and the provenance is unclear. Transfers for some of the trucks were also "rescued" and used to refurbish old models or finish new ones. Care should be taken in buying anything from this era. In 1972, Tekno's assets were sold to a Dutch company that concentrated on the Eurotrailer trucks, but also made some smaller ones, as well as a Saab 99. These are all marked "Made in Holland," carry authentic liveries,

below: The Asahi 1950 Buick Coupé was issued with its own license plate number and ownership registration (tinplate, 27cm/11in, c.1980, Japan).

and are popular with truck drivers and commercial vehicle collectors. Similarly, and appealing to the same market, Lion Car concentrated on large box trailers and trucks with very highquality advertising decals. At this time, Belgium was known only for Sablon, a 1968 line of nine 1/43-scale diecast cars that was available in shops, but was also adopted as promotionals by the Jacques chocolate manufacturers.

In Italy, Mercury continued to make 1/43-scale diecasts, but there was a flood of new names. Politoys, which had been

below: A Saratov RAF Minibus with special decoration for the 1980 Moscow Olympics (diecast mazac, 11cm/4.5in, c.1980, USSR).

making plastic toys, began – in a pleasant RAF Minibus for the 1980 ecast mazac, 980, USSR). making plastic toys, began – in a pleasant change – a new metal series in 1965 that was accurate and of good quality. Its Penny series dates from 1966. Later its name changed to Polistil. Mebetoys, which became a part of Mattel, started making toys of the same high

quality in 1967, though this had fallen off somewhat by the end

of the 1970s. Edil made a few Italian cars. Pocher created a series of semi-promotional Fiat saloons – 500, 600, 1300, and 124, some in the odd scale of 1/13 – in the mid-1960s. Yaxon picked up on the enthusiasm for racing cars and, from 1978, made 1/43-scale diecast F1 cars. Brumm began its long reign in 1975. The founder of the company had been a part of Rio, and the story goes that there was a falling out and a lawsuit, which prevented him from starting up in competition for a specific length of time. At the first opportunity, he did so, beginning with a small series of historic steam road vehicles, using a lot of plastic. These were aimed at the collector, as were the 1/43-scale cars and the racing-car series, which is still being continued today.

New arrivals were the feature in Spain. Eko made a wide variety of very small 1/88-scale plastic cars, commercials, and military vehicles. Though the moldings are good, they are

not yet really collectible, as are its 1/43 veteran and vintage vehicles. Joal and Pilen both started making 1/43-scale diecast in 1968. The latter made ten Formula 1 cars that were good enlarged "copies" of the Politoys Pennytoys. Road cars were added to the line in the 1970s, and there were some interesting choices of subject, nicely modelled, but some of the sports coupés were treated to a rather horrible plated finish. Most of Pilen's production was copied from elsewhere, though its manufacture from obsolete French Dinky dies was legitimate. It also was the source of late French Dinkies marked "fab en Espagne." Joal made good models, even if the early ones did appear to be copies of the Tekno E-Type Jaguar, among others. Later toys, however, including a wide range of commercials, were original. Metosul, from Portugal, had its origin in the Osul plastic toys of 1950-55, but it came to notice in 1966 with metal copies of Corgi, Dinky, Tekno, and other manufacturers. Its main claim to fame is a Mercedes Benz 200 in various taxi versions, and an extensive selection of liveries on Atlantean double-decker buses. A brief fad among collectors,

these are now of interest only to some of the specialist bus enthusiasts. Production ceased in 1989.

As wealth spread around the world, so did toy cars. Gamda

began production in Israel in 1965, making military and civilian subjects: some from the execrably bad English River Series; others, including a superb Willys Jeep, original. However, the mainly 1/43-scale line is on,

the whole, not good. Gamda, now branded as Sabra on the models, exported its own American cars, labelled as Cragstan, to America between 1969 and 1972. Buby, of Argentina, was using Solido dies under license and also producing its own line of American cars. Nicky bought old Dinky Toy dies to make a series of poor, badly finished castings for the Indian market. There was a brief flurry of excitement among collectors when the first Novoexport/Saratov products appeared from the USSR in 1970. These are diecast models of Moskvitch, Gaz, and other Eastern European makes. The saloons, brakes, and so on are pleasant castings, though they tend to suffer from metal fatigue. Ironically, when the Iron Curtain came down and they became more readily available, the Western collector seemed to lose interest in them.

above: A Chevrolet Corvette Stingray (11cm/4.3in, c.1970, Israel) and a Chevrolet Police Car (11cm/4.3in, c.1970, Israel).

e Kost aus aller Welt.

JM (2) Johnson Matthey

8 9

FROM TOY AUTO TO MODEL AUTO

It is not easy to fit the automotive toys released over the past two decades into the context of the hundred years or so such that toys have been made, or to present a coherent story of this recent period. There is still manufacturing activity in countries throughout the world. Some toy companies have turned to producing only adult collectibles; some have stayed resolutely manufacturers of children's playthings; others try to profit from the best of both worlds. And you never know what is around the corner, as more countries embrace capitalism, and their children become a market sector. One factor that is liable to distort perceptions about this period is the remarkable difference in the willingness of companies to hand out information. While some produce brochures in quantity, others are too busy making product to waste time answering questions. Still others are so busy protecting their trademarks - a most valuable commodity in the 1990s - that they seem obstructionist. Dealing with recent events also raises another problem: the latest episode can seem hugely important, whereas in fact the manufacturers and products of the late 1990s may be dwarfed in significance by something more exciting in the future.

ERTL

In America, Ertl has shown remarkable consistency in the quality of its product ever since, seemingly unaffected by the general problems in the toy market, it expanded its Dyersville plant in 1980. Along with an ever-developing farm-toy line, Ertl has made road and racing vehicles in scales ranging from 1/64 to 1/43 and 1/25. With keen awareness of what would be popular, it made both classic cars and popular race cars – many, such as that of Richard Petty, with accurate decalling. Its character merchandising vehicles – spin-offs from successful television series such as *The Dukes of Hazzard* and *The A-Team* – are marketing lessons in themselves. In January 1984, a doublesided full-color *A-Team* flyer featured a 1/16-scale pressed-steel van and a Corvette; a 1/25 pressed-steel Peterbilt truck and trailer; a 1/48 pull-back van; a 1/64 diecast van and Jeep; a plastic radio-controlled van in 1/40; a plastic Corvette and van in large scale; and six other items, ranging from a plastic kit to a Wrist Racer – a little van attached to a wrist strap with a launching attachment.

The classic cars Ertl introduced in the first two years of the 1980s, most of which lasted in the catalogue for only two or three years, consisted of a mixture of European and American marques, ranging in date from 1948 (Jaguar XK120) to 1970 (Mustang Boss), but soon its product was entirely American. The 1984 catalogue included Nascars – made of plastic and metal and had a simple radio-controlled mechanism – ride-on tractors, construction toys in scales from 1/64 to 1/16, and funny toys for tots. Full-function radio-controlled cars were added later. This pattern of mixed materials over a wide range of products, with emphasis on character merchandising and race cars, led in the mid-1980s to no fewer than eighteen licensing arrangements being acknowledged.

By 1988, there were six flyers listing farm toys, and prod-

ucts were being aimed at specific markets; some were made available only in America, others only in Britain, and so on. The preschool market was catered to, but still keen on accuracy, Ertl was making excellent models. Its Blueprint Replicas 1/43-scale '88 Fiero GT packaging tells us that the model was made in Korea and was "Manufactured under license of Pontiac Motor Division, General Motors Corporation."The full sales pitch follows in a closely worded blurb:

Taking a spin in a hot '88 Fiero GT tells you this car is styled for performance. The famous Tech IV engine has

a new secondary force balance system to smooth and quiet engine operations, and the new suspension is

designed from the frame up to enhance ride and handling...

Impressive! Is Ertl trying to sell you a toy, a model, or the fullsize car? Among its 1990s 1/12- and 1/18-scale diecast Muscle Cars, the increasingly wacky full-size liveries were reflected in, for instance, the 1970 Hemi 'Cuda decorated in Plum Crazy Purple and the AAR 'Cuda in Vitamin C Orange with black stripes. The 1997 Ford F150 is finished in a classier Moonlight Blue. The 1/18-scale STP Pontiac Grand Prix is a beautiful model finished in the silver paint scheme specially designed for the 1996 season of the Daytona 500 to celebrate the twenty-five-year association between Richard Petty and STP. Ertl's policy, developed over fifty years, is to appeal to every age group and to every enthusiast for things on four wheels.

RACING CARS

The zeal for racing cars is worldwide, with circuits in America, Europe, Australia, and Japan, but America has such a passion for the sport that many different series have developed. While the Daytona 500 is the race of legend, heralding the start of the season, it is not in fact the earliest of the races, which go on somewhere in the vast country from February to November. Races have been developed for any and all types of vehicle, from road

above: Racing Champions Ford Fastback Racing Car in different liveries (mazac, 8cm/3in, c.1992, China). **above:** A Chevrolet Camaro Z28 by Zeetoys with a pull-back motor (diecast, 10cm/4in, c.1982, Hong Kong).

cars through heavy articulated trucks to specially developed, types that create new race categories. The successful drivers have become famous, and sponsors (from STP to McDonald's) use the vehicles as mobile advertising billboards, often changing the decoration from race to race. The toys produced in response, as always, have mirrored the real world – trucks, hot rods, sprint cars, pro-stockers, dragsters, and funny cars have all been modelled in a variety of scales from 1/64 to 1/24. As the sport became more and more commercialized, with famous drivers and advertisers tying up their names as trademarks and making licensing agreements, so the system was extended to toys. No longer was a firm happy to allow its logo to be used to secure free advertising. It wanted to

below: A Richard Petty STP Car (c.1991, China), a Matchbox Ford Thunderbird (c.1991, Thailand), and a Matchbox Buick Le Sabre (c.1987, Macau). be paid for the use of its name, claiming that a toy with fictitious decalling would not sell as well as one with a popular real name, and that the owner of the name deserved a slice of the cake. The twenty-

five to thirty years of this development have been mirrored by the changes in hobby types from one predominantly collecting toys to, increasingly, collecting models.

Ertl was not the only existing toy manufacturer to make race cars. Matchbox and Mattel did, too. Hot Wheels was a line ideally suited to take advantage of the developments in racing over the past thirty years, and Mattel, moving into sponsorship itself, could now make a Hot Wheels toy of a car carrying the Hot Wheels logo! Currently, under the Pro Racing label, it is catering to the toy trade, with \$2 bubble-packed toys, and to the collector, with a deluxe version of the same vehicle with rubber tires and better tampo, at up to three times as much. Mattel's latest innovation is about as up-to-the-minute as possible. Its Computer Cars are bubble-packed onto the backing card, along with an interactive disc, compatible with Microsoft Window that contains three short "game/ drives". Some of the early Hot Wheels are worth considerable sums, but even a current issue can suddenly become highly desirable and shoot up in price. The Pro Racing label was to be launched at the Daytona 500, but full stocks were not ready, so the first products were rushed. Some were packed the wrong way around in the bubble packaging, an accidental variation that makes them scarce and therefore worth more. One product, over which there was a hitch in the licensing agreement, was subsequently withdrawn, and this even greater scarcity has resulted in a still higher price.

FAR EASTERN MANUFACTURERS

The distant diecasting factories of Hong Kong had increasingly been contracted by American and European manufacturers to make products for inclusion in their own lines, labor costs being so much lower there that the increased transport costs could be absorbed. In the mid-1970s, however, the names of Hong Kong manufacturers began to appear on toy vehicles that were sold in supermarkets in Europe, in outlets such as Woolworth in Britain and primarily in chains such as K-Mart in America. Some of these were commissioned, and others were sourced by importers. Typically, they were cheap when they were available, had speed wheels of varying types and were of variable quality. Playart made toys with rather ill-fitting doors in about 1/40 scale, picking cars from all over the world. Tintoys, whose catalogue numbers are prefaced WT, made classic, sports, and modern cars. Universal, Lucky Toys and Wildwheels made for Cragstan are names you may come across, though they are often found only on the packaging, which enables the series name to be changed with ease for a different market.

Ideal made a good line in steeds for Evel Knievel, the stunt motorcyclist, as well as dragsters and Nascar-style stock cars. Wondrie Metal made some reasonable-enough-for-the-price 4inch-long pull-back classic cars in the mid-1980s, some nasty ones half the size, and a range of American cars that came "freewheel", "pull back," or "leaping" Summer Metal Products made a wide range of vehicles, including truck rigs and fire engines.

Yatming toys were made in Hong Kong and distributed by Norev in 1988, but by 1989 they were being manufactured in Thailand, where they made copies of Tomica. The

Welly line was first made in Hong Kong and later in China, and at the end of the decade it was being given away with gasoline in Britain. These are just a few examples from what could be lengthy catalogue of names.

Some lines have been made entirely in the Far East but have their registered addresses in America. Zylmex and Zee marked their metal toys and seem to have made their product for K-Mart in 1980 at least. Zylmex's small-size Dynamights include these unlikely companions: Citroën, Honda 600, Cement Mixer, and Fire Engine. Zee made a selection of Grippers: Wheelies, with good castings, some with tampoprinted decals with pull-back motors that will do a wheelie at the end of their run; Classics, Explorers, and Formula 1 cars. Zee are still increasing their lines. Road Champs – which

above: The Road Champs Elgin Pelican Street Cleaner (diecast/plastic, 9cm/3.5in, 1993, China).

THE COLLECTORS' MARKET

The year 1981 marked the beginning of the virtual demise of toy vehicle production outside of the Far East, with the exception of France, Italy, and one or two other small pockets, as the world market swung toward producing models for collectors. These satisfy the collectors' demand for greater accuracy and

right: Diapet made this rare and unusual Honda Stream Motor Scooter (10cm/4in, 1984, Japan).

Я

more detail, and the price is inevitably higher. Resin and white metal allow high-quality, small-series, specialist production at a reasonable cost,

but by the time the vehicles have been hand-finished, as small production runs dictate, the cost of manufacture can shoot up. Large manufacturers, instead of trying to make a profit out of manufacturing what the child or man in the streets wants, are increasingly making something first and then trying to convince the public that they want it, through the use of limited editions and special marketing schemes.

Although some firms do not make limited editions that are advertised as such, a deliberate shortness of supply keeps collectors' interests fired up. Promotionals are issued by gas stations, and marketing devices make sure that stocks of less desirable pieces are sold: the inclusion of one exclusive item in a set, for instance, means that the collector is obliged to buy the whole package to obtain the one that is really wanted. Racing Champions have been in the 1/64 market for some time, and it, Pit Road, and others have paid for a license from race organizations such as Nascar and print the year's events list on the back of their packaging. Revell, perhaps better known as a plastic-kit manufacturer, is now in this growth area as well. A name from the past, Johnny Lightning, is being used to market a line of limited-edition models that can claim to be genuinely limited, because the company announces

the length of the run on the box and numbers each vehicle. Despite their name, these are not toys but are directly aimed at the collector. K-Mart has joined the system and, next to the toys on its shelves, you can find limited editions that are not numbered but are limited only to the number it has decided to commission. Woolworth has its own line of racing Haulers, made, as is most of this type of product, in China.

Collectors frequently gather at the swapmeets, expositions, bourses, or toy shows - the names vary around the world. There are clubs you can-join to make sure you get the what it is considered the market will stand. Price guides are essential for the beginner, as are those above: Matchbox Chevrolet Corvettes magazines that are independent of the (diecast, 8cm/3in, c.1981-86. UK organizations with a vested interest in promoting collectibles. Knowledge is important. For instance, if you collect Hot Wheels, it is essential that

latest issue of almost anything "collectible," at a price set at

and Macau). that you know all about the twenty wheel types. One magazine

Ξ

that is independent (except of course that it needs to attract

paid advertising to survive) carries the following ad:

Be your own boss...earn big money selling all lines of NASCAR collectibles. I can show you how you can

become a Dealer and where you can sell your products to hundreds of hungry

collectors...how you can tap into this new market that is just exploding with each passing day. Don't miss the

train. Get aboard today & start earning that extra money you need easily...

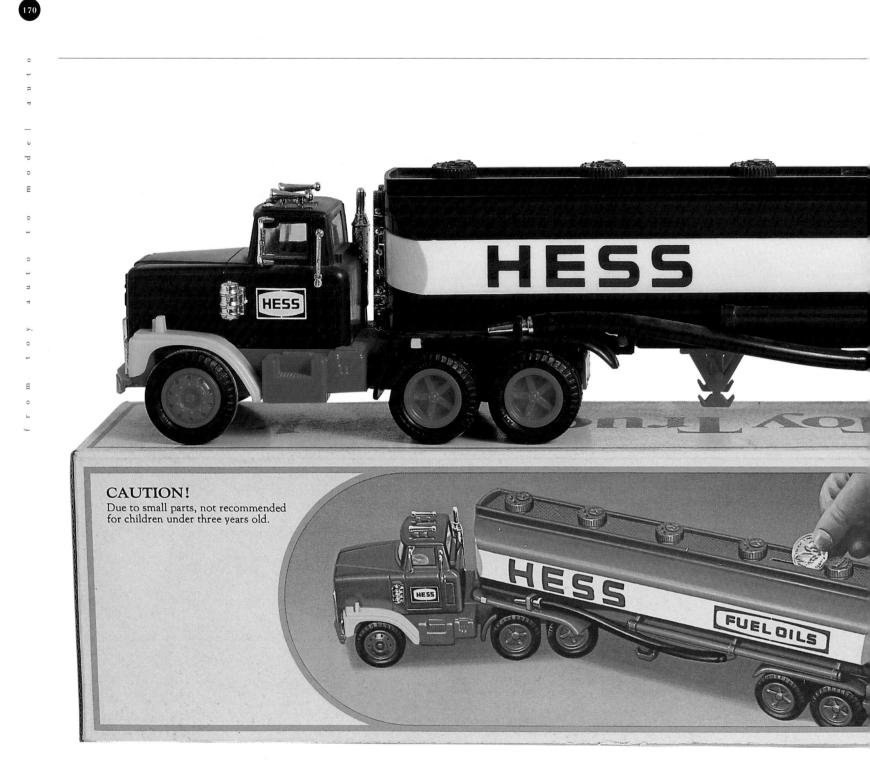

FROM TOYS TO MODELS

In Britain, when Corgi was rescued from the financial collapse of Mettoy by a management buy-out, it immediately started the shift from toys to models, though it kept some of the toys in 1/35 and 1/43 scale, as well as the Junior line, in production. In 1985, it reissued four Corgi Classics - Rolls-Royce, Bentley, Ford Model T, and Renault - each in three different colors. Thereafter, there was a rapid expansion into the collectors' market and an accompanying reduction in its toy output. The takeover by Mattel in 1990 provided much-needed financing for the plethora of new collectors' models in a wide range of liveries. Specialization continued, with a growing emphasis on buses. All the new ideas, many concentrating on limited editions, were aimed directly at the collectors' market. The tie with Mattel was brief, for in 1995 another management buyout divorced the two, enabling Corgi to make exclusive arrangements with UK bus companies for using their liveries and to concentrate entirely on models for the collector.

Matchbox's difficulties were solved when it was purchased by the Universal Toy Company of Hong Kong in 1982. The Yesteryear line was marketed as Matchbox Collectibles, but the small Matchbox 1–75

left: A Fuel Tanker by Hess with the tanker acting as a money box and battery-operated electric lights (plastic, 33cm/l3in, 1984, Hong Kong).

toys were still aimed at children. The Dinky name was bought by Matchbox in 1988 for its nostalgia value, and in the hope that the desirability that the old toys had developed would rub off on the new, Macau-manufactured Dinky Collection, a range om toy

of classic sport and saloons aimed at the collector. A new name on the scene, Lledo, was created by reversing the last name of Jack Odell, formerly of Matchbox, in 1983. Its six toys-cummodels harked back to the beginning of Matchbox and Yesteryear, with five of them being horsedrawn vehicles. Very soon, special liveries and promotionals were featured on a small series of basic castings, not to any particular scale. Any pretense that they were toys was soon dropped. The packaging was still marked "not suitable for a child under 3 years" though this statement is actually a safety regulation. Vanguards, a line of 1950s and 1960s English cars and light commercials, was introduced in the 1990s to compete in the nostalgia market. This area of appeal was widened in 1997 with a merchandising tie-in with Coca-Cola .

Solido is the French example of manufacturing changing from toys to models for collectors. Its vintage and classic cars were originally conceived as just another type of toy car in the gamut of its production of racing cars, saloon cars, old cars, but increasingly during the 1970s it realized the potential of the adult buyer. In 1980, Solido marketed its Age d'Or (Golden Age) line separately, aiming it directly at the company's existing following of adult collectors. Solido is still going strong, owned since 1981 by the toy manufacturers, Minialuxe. It was one of the first to realize the commercial importance of the collector. Many of the Minialuxe dies were reused in the 1980s and 1990s by Solido itself, and others were released under the Verem label. When the first group of Golden Age was re-released, Solido dropped the price and retailers and collectors found that they had paid more for models in the past than they could buy them for in the present. This led to the continuing debate about the effect that reissues have on toy values. Solido made a small group of saloon cars for Dinky at one point very late in that firm's life. All these models are correctly marked underneath, but their similarity and the multitude of reissues can cause confusion among the unwary. Norev, who was still making promotional vans, later joined up with Solido/Minialuxe for a joint marketing operation.

Germany was left, after Siku's take-over of Wiking in 1984, with two toy manufacturers. Siku itself became the more prolific, continuing to make good-quality diecasts, in several scales that were well finished in bright colors and with a variety of action features. Gama, still a little uninspired, concentrated on 1/24-scale tractors, old-timers and a line of 1/43scale cars, including a group of semi-promotional Opels. Schabak, which had come to the fore after buying some of the Schuco dies when that company failed, made good contemporary 1/43 to 1/25 cars and light vans. In the expensive price line for a toy, they are often produced as promotionals for the motor trade. NZG are also in the promo market, making models of Porsche and superb contractors' plant. Conrad does the same making models for Audi and also high-quality, beautifully finished commercials and plant that are popular with collectors. Old Schuco dies are being used to produce new models. As a general rule, if they are fitted with rubber tires, they are

72

Ξ

originals; if the tires are plastic, they are reissues and consequently of lesser value.

Many of the Italian toy companies are still in business, producing toys of sufficient quality to be bought by collectors as well. Polistil make 1/16-scale classics like MGA, Morgan, etc., and modern and racing cars in almost every other size you can think of down to 1/66 scale. Mercury and Mebetoys are still manufacturing, both in 1/43, and the latter in the larger 1/25 scale as well. Burago, which had been making its samesize classics - such as the Citroën 11BL, Jaguar XK120, and modern racers like BMW and Ferrari, a type that is still continuing - created a most successful line of 1/18-scale classics in 1980. Finished in eye-catching colors and packed in classy black window boxes, these are the epitome of, in marketing jargon, "perceived value" or, in plain speak, "what a lot you seem to get for your money". Indeed, it is a bit of a puzzle how a European company can make these to sell at such a comparatively low price. Standardization and volume of production must form a major part of the answer. At the bottom end of the Burago line, it makes cheap 1/43-scale cars, Saab and so on. Firms such as Box have joined the other manufacturers aiming purely at the collector.

The Spanish companies Pilen and Joal, are still in the toy business, the former making cars and the latter concentrating on a very

good, solid line in construction and farm machinery. In the mid-1990s Joal made no cars or ordinary commercials, but recently a few excellent castings have begun to appear, including one of a low loader carrying a helicopter. Vitesse, from Portugal, is a major producer of highly detailed 1/43-scale vehicles aimed at the collector. Some are sold under the Vitesse name, but the firm also manufactures for many other brands. Japan's major toy names, Diapet and Tomy, continue as before, making competent castings. They have been joined by Shinsei, which concentrates on 1/25 to 1/78-scale commercials and construction equipment, modelling national brands. Japan being a major manufacturer of full-size plant. Fifties, from the decade the name suggests, produces Buicks, Thunderbirds, and so on in 1/25 scale.

above: Burago produce the Porsche 911 Carrera and Chevrolet Corvette – both are beautifully decorated models (diecast, 10cm/4in, 1997, Italy).

TOY STORES

Recent visits to two stores with world-famous names were quite revealing. Toys"R"Us is almost entirely a true toy shop, selling many of the American brands mentioned in this chapter. Some of its items of stock are good examples of how automotive toys change, yet stay the same. Nylint and Buddy L are still

above: The ERTL Pontiac Fiero 88 Coupé in the Blueprint Replicas range (diecast/plastic, 10cm/4in, 1988, Korea). making typical hook-and-ladder toys; Kenworth makes car transporters and the like, with electronic light and sound effects that almost outdo the full-size ver-

sions. There's even a Talk"n"Go fire truck with a seventy-fiveword vocabulary in fifty different random phrases, which operates at the press of a button. Kenworth's pedal cars line from baby push-and-ride plastic toys to battery-powered Jeeps and buggies suitable for ages five to nine. The top of the line costs more than you might pay for a ten-year-old full-size car, though the price pales into insignificance compared with that of the electric Mercedes 230SLK Sports, tractors, and other vehicles on sale in the Mercedes-Benz main showroom in London.

Hamley's, the leading London toy store, has a mixture of toys and models for the collector. Though price is some guide as to which are which, it can help to tell by looking not just at the product, but also at the purchaser. Who is watching the radio-controlled demonstration? Is it the father or his son who decides which Scalextric slot car to buy next? Is that man who is consulting his female companion discussing the suitability of a model for a nephew – or for display in their own living-room?

THE TOY TRADE IN THE MID-1990s

How did the toy trade see itself in the mid-1990s? The British magazine *Toy Trader*, in its July 1995 issue, reviewed the current situation in the toy-vehicle field. According to information supplied to them by Mattel:

The vehicles market is a wide and diverse category ranging from the ubiquitous three-inch remote controls to slot car sets. Vehicles currently have about 11 per cent share of the total toy market with value worth in excess of £180m. Although it's more stable than many sectors within the toy industry, its diversity makes it difficult to establish just who is in the driving seat. Miniature vehicles dominate the sector with a 41 per cent share, and competition within this category is fierce, with lots of players producing similar products. Tough competition has led to a diversification into feature-led miniature vehicles and the more profitable high price

vehicle accessories such as play sets.

The magazine reviewed the British market manufacturer by manufacturer and produced an assortment of gems of disparate information. Minichamps (which produces models for the collector) was sponsoring Benetton's Formula 1 team. Amerang was shortly to release a 1/18-scale Elvis Presley 1995 Pink Cadillac in conjunction with Graceland and Elvis Presley Entertainment. Note that these are not toys, yet they are featured in *Toy Trader*. Benjamin Toys was distributor for Tootsietoy Hard Body cars, trucks, and farm vehicles, as well as Jaditoy diecast tractors, earthmovers, and playsets. Majorette and Solido had signed licenses to produce diecast models of the Mini, Triumph Spitfire, and Range Rover. Kyosho had launched examples of MGB, Austin Healey, and Triumph TR3, while Mattel had Morris vehicles, Minis, and Range Rover. Siku, Europe's biggest-selling range of diecasts, had introduced over thirty new models that year (several of which were variations on their standard product), including a very smart cement mixer. The UK distributor for Siku was also handling the collectibles, from Wiking and Roskopf and the railway accessory line from Busch. Majorette's wide range of vehicles included heavy-duty transporters and bulldozers, and could be bought as build-your-own-site sets. Its Turboom vehicle fires caps as it crashes and falls apart, while the Traffic Jammers – four American classic cars – play music when you press the hood. Coca-Cola and Cadbury's advertising was also featured.

Matchbox made a wide range of Motorcity playsets, one of

which has the police defending the city, with electronic sirens and crash sounds adding to the realism. Mattel - as ever - had Hot Wheels, and Road Maniax was its futuristic vehicle playset. Rico, in its radio-controlled line, had Raging Bull, a pickup truck with wheelie-action spins and hopping turns. Burago's newest item featured in the Toy Trader magazine was yet another Mercedes-Benz. Micro Machines from Toy Option, launched in 1987, have sold over a billion toys, with thirty-five percent of boys between the ages of four and nine owning at least one. The latest addition to the Toy Option offerings is an Auto Dealership set, which has a rotating rooftop car carousel, a paint booth with color-wheel preview, sliding showroom doors and a rotating vehicle platform. There is a list of Tomy products, including a radio-controlled car transporter that can carry fourteen diecast vehicles. Tyco have made a pickup truck, Fire Power, that can fire foam missiles up to 20 feet.

In America, Hasbro, which own Tonka, stated in its 1995 annual report that "Brands and product are king in the consumer products industry" and featured the concept "edutainment" – an ugly portmanteau word that surely has a strong future in marketing, combining as it does the venerable idea of learning with play.

TOY FAIRS AND AUCTIONS

To see toys, collectors, and dealers *en masse*, you can attend one of the many toy fairs that now occur almost every weekend all over the world. Their venues and times are published in the hobby magazines available in news stands, from specialist model shops, or by subscription. Not only are these fairs a source of both toys and models, but they are one of the best ways of finding out what is available and gaining the lore that enables collectors to make wise purchases. Stalls at these meets sell replacement parts for old toys. Tyres are required by many and these dealers fulfil a useful purpose. It is also interesting to see the wide range of parts available – one gets a strong insight into what might have been replaced on a toy being offered for sale. Maybe collecting toys is a hobby (though some may think of it as an investment), but it makes no sense to spend money unwisely or be caught out by a persuasive dealer, if you can help it.

In recent years, there has been a rise in the quantity of toys that are selling through auction. To begin with, it was mainly expensive pieces of early tinplate and cast iron that were considered near enough to antiques to be auctioned. As the popularity of collecting has grown, however, so the range of toys at auction has increased, coming far more up to date; the number of auctions has also increased. Many auction houses have a great deal of experience and describe the toys accurately, although even the most careful can make a mistake. Others, however, do not have the same expertise. It is worth bearing in mind that auction rules vary in each country and that, even within one country, the regulations governing public auctions are very much stricter than those for private ones. Be careful. Buy what you like at a price you can afford. Take any future appreciation in value as a bonus, not a right. Enjoy yourself.

I N T R O D U C T I O N

0

Ξ

0

The following section aims to provide information that will benefit collectors and first timers alike. An extensive glossary, split into three sections, explains the many manufacturing methods involved in automative toymaking, collectors' terminology and a more general glossary. Thereafter, the reader is supplied with a fascinating list of some of the most expensive prices ever paid for automotive toys. Last, and not least, a thorough list of useful addresses is provided, including the addresses of the major auctioneers, the many museums that include some of the classic toys, and leading collectors and dealers.

G L O S S A R Y

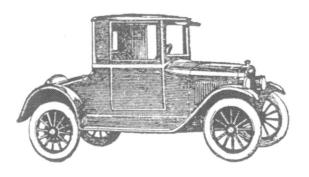

MANUFACTURING METHODS:

Cast Iron: The gravity casting of molten cast iron into molds of preshaped, glued sand that are made round an original master.

Diecasting: Method using molten metal forced into hard steel dies under great pressure.

Injection Molding: Similar to diecasting but with plastic material used instead.

Master: The prototype or original piece, often made by hand, giving the definitive shape for the part to be cast or molded.

Mazac (UK): Zamac (US): This is an alloy of zinc with a small addition of aluminum and traces of copper and magnesium. This alloy is the base for most diecast models and toys.

Pressed Steel: Where heavy gauge steel sheet is cut and pressed into the shapes between male and female platens under great external pressure.

Rubber: Similar to diecasting but using a rubber mixture as the molding material.

Tinplate: Similar to pressed steel but using a very much thinner gauge of material, usually tinplated, before use.

Wooden Toys: Usually made from carved wood, and then painted.

COLLECTORS' NOMENCLATURE:

Boxed: In the same box in which it left the factory. **Character Merchandising:** Models, usually made under license from a film or TV company, showing popular characters. They are used to increase the public awareness of the characters concerned. They are also known as spin-offs in commerce. **Chipped:** Having its original paint but with some play wear. Often described as slightly or heavily chipped.

Decal: Decoration applied to a toy by the use of a water- or spirit-based slide transfer on a backing film.

Japanned: A decoration applied to a finished toy by using a very hard varnish, often black. This applies only to early toys and was not used significantly after about 1920. It originated in Japan, hence its name.

Lithographed: Decoration applied, usually to tinplate sheets, by a multicolor, multistage printing process, where the decoration is applied to the flat surface before it is cut and shaped. Metal fatigue: The expansion and apparent rotting of mazac

toys when they expand and break. This is

caused by the electrochemical action due to

traces of lead and cadmium in the alloy

making the model expand.

Mint: A model that is in the same condition as when it left the factory.

Promotionals: Models made or decorated with the specific aim of promoting a particular brand name, often a food or other consumable.

Reproduction: A newly manufactured model as a replica of an earlier piece, sometimes from the original tooling. **Restoration:** The refurbishing, to a greater or lesser extent, of a damaged or worn toy to its original appearance, sometimes

with the intent to deceive a future owner.

Tampo: Decoration applied to a toy by means of a precoloured transfer roller or stamp.

Three-rail/Two-rail: Toy trains terminology; three-rail has the current flowing through both running rails with return through a centre rail, two-rail has outward flow through one running rail and return through the other.

GENERAL MOTORING TERMS:

Artics (UK): Semi (US): Articulated truck rig, tractor with mounted semi-trailer.

Bonnet (UK): Hood (US)

Boot (UK): Trunk (US)

C

0

Cabriolet (UK): A body style with a folding hood, usually padded, and with glass wind-up side windows – also known as a "convertible."

Cam: A projecting pip on a shaft or wheel.

Commercials: Commercial vehicles, such as trucks, buses, vans, tankers, etc.

Dickey seat: An occasional seat that folds up out

of the boot, using the bootlid as its back, also known as a "mother-in-law seat," or "rumble seat" (US).

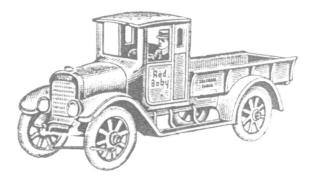

Dimestore: Shop where conventionally all items cost not more than a dime.

Doctor's coupé: An enclosed two-seat car body style, usually dating to before 1930.

Drophead coupé: see Cabriolet

Engine (UK): Motor (US)

Estate car (UK): Station wagon (US)

Flywheel: A heavy rimmed wheel designed to absorb rotational power.

Hood (UK): Top (US): The folding roof of a convertible or other openable car.

Kick panels: Panels for passengers to rest their feet on. **Landaulet:** A closed car, the rear portion of which has a folding hood that could be opened in fine weather.

Leaf-spring suspension: Suspension by means of springs made up of several lengths of tempered steel laid together. **Limousine:** A large, fully closed body style usually having a partition between the driver and the rear passengers.

Monocoque (UK): Unibody (US): A design where the body and chassis are combined into one structure giving better strength, and often cheaper to make.

Mudguards (UK): Splashguards (US)

Overriders: The vertical additions to front and rear bumpers to avoid cars overriding each other in minor collisions and becoming locked together. **Peen:** Use of a hammer to swell a rivet and, usually, produced a domed finish (as fixing the bases to toy cars).

Petrol (UK): Gasoline (US)

Play value: Modern jargon for how much a toy has been, or is perceived will be, played with.

Roadster (UK): An open two-seat sporting car, or "runabout" (US).

Running board: Boards along the body sides to be used as steps to gain access to the interior, usually connecting the front and rear mudguards. They were also usually rubber-coated to avoid damaging the vehicle's paintwork. Not much used since about 1950.

Saloon (UK): A fully closed body style for four or more passengers – "sedan" (US).

Semi-trailer: A trailer with axles at the rear only, the front is mounted onto the tractor unit.

Shooting brake (UK): Station wagon (US)

Silencer: (UK): Muffler (US)

Snorkel pumpers: Fire appliances with extending boom for the hose.

Spats: Half-round removable panels covering the rear wheels on some car designs. Used for aesthetic reasons.

Sulky: A two-wheeled horse drawn vehicle for one person.

Telescopic forks: Motorcycle front suspension with integral

cylindrical springing and shock absorbers.

Tonneau: An early open-car body style; later, a waterproof cover for open cars seating areas.

Tourer: A four-seater open car.

Trade only: Sales to retailers only, not to the general public. **Vis-à-vis:** Early open vehicles where the driver sits in the rear seat with the front passenger looking towards him, literally 'face-to-face' from the French originators of the design.

Windscreen (UK): Windshield (US)

Wing (UK): Fender (US)

TOYS-SOME TOP PRICES

Ξ

DATE	L O T N U M B E R	DESCRIPTION	PRICE REALISED	RECORD
May 1992		A rare tinplate Märklin four-volt electric ocean liner 'Augusta Victoria'	£42,000	Record for a Märklin boat
20 December 1994	Lot 21	Twenty-volt electric Swiss-outline "Crocodile" articulated electric locomotive	£35,200	N/A
17 May 1990	Lot 489	A Märklin 00-gauge LMS E800 locomotive and tender	£24,200	N/A
20 December 1994	Lot 113	A steam triple-screw twin-funnel battle cruiser	£18,700	N/A
May 1991	N/A	A rare Märklin twenty-volt LMS R742 Passenger Train set, with original box	£15,400	Record for a single 00- gauge train set
October 1994	N/A	"Bentalls" delivery van Dinky Toy	£12,650	World record for a Dinky Toy
17 September 1997	Lot 327	A Märklin clockwork 4-4-0 MR locomotive No. 2609	£10,350	N/A
June 1994	N/A	"Blondin Cyclist"	£7,200	Record for a single Britains figure
17 September 1997	Lot 156	A rare prewar Dinky Toy "H. G. Loose" promotional delivery van	N/A	N/A
19 September 1997	Lot 184	A Yonezawa "Atom Jet" futuristic car	£4,370	N/A

A D D R E S S E S

MUSEUMS-UK

Abbey House Museum Abbey Road Kirkstall Leeds Yorkshire LS5 3EH

England

Arundel Toy and

23 High Street

Arundel

West Sussex

BN18 9AD

England

Bethnal Green Museum of

Cambridge Heath Road London E2 England

C. M. Booth Collection of

Falstaff Antiques 63–67 High Street Rolvenden Kent TN17 4LP England

Chester Toy and Doll 12a Lower Bridge Street Chester Cheshire CH4 8JW England **Cotswold Motor Museum** and Toy Collection The Old Mill Bourton-on-the-Water Gloucestershire GL54 2BY England The Cumberland Toy and Model Museum Banks Court Market Place Cockermouth Cumbria CA13 9NG England **Dewsbury Museum** Crow Nest Park Heckmondwike Road

Dewsbury West Yorkshire WF13 2SA England

Gloucester Folk Museum

99-103 Westgate Street Gloucester Gloucestershire GL1 2PG

England

House on the Hill Toy Museum

0

Stansted Mountfitchet

Essex CM24 8SP

England

Ironbridge Toy Museum

Banbury Road Gaydon

Warwick

CV35 OBJ England

The London Toy and Model

21 Craven Hill London W2 England

Museum of Childhood	Richmondshire Museum	MUSEUMS-USA
42 High Street (Royal Mile)	Ryders Wynd	
Edinburgh	Richmond	Antique Toy Museum
Lothian	North Yorkshire	Exit 230, I-44
EH1 1TG	DL10 4JA	PO Box 175
Scotland	England	Stanton
		Missouri 63079
Pickford's House Museum	The Sussex Toy and Model	USA
41 Friargate	Museum	
Derby	52–55 Trafalgar Street	Bauer Toy Museum
Derbyshire	Brighton	233 East Main
DE1 1DA	Sussex	Fredericksburg
England	BN1 4EB	Texas
	England	USA
Pollock's Toy Museum		
1 Scala Street	Tintagel Toy Museum	Museum of Childhood
London	Fore Street	8 Broad Street
W1	Tintagel	Greensport,
England	Cornwall	New York
	PL34 0DD	USA
The Precinct Toy Collection	England	
38 Harnet Street		Museum of the City of New
Sandwich	The Toy Museum	York
Kent	Dedham Arts & Crafts Centre	5th Avenue and 103rd Street
CT13 9ES	The High Street	New York
England	Dedham	NY
	Sussex	USA
	CO7 6AD	
the state of	England	Nashville Toy Museum
		2612 MaCanala Dila

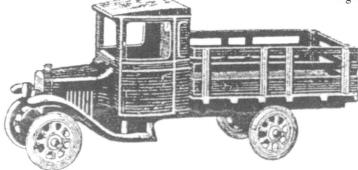

u o

Ξ

0

с о

2613 McGavok Pike Nashville TN USA

Remember When Toy	CHRISTIE'S	Christie's Rome
Museum	ADDRESSES	Palazzo Massimo Lancelotti
Box 226A		Piazza Navona 114
Canton	Christie's South Kensington	00186
Missouri	85 Old Brompton Road	Rome
USA	London	Italy
	SW7 3LD	
Sullivan-Johnson Museum	England	Christie's New York
223 North Main Street		502 Park Avenue
Kenton	Christie's	New York
Ohio	8, King Street	New York 10022
USA	London	USA
	SW1Y 6QT	
Toy and Soldiers Museum	England	•
1100 Cherry Street		Christie's East
Vicksburg	Christie's Scotland	219 East 67th Street
Mississippi	164-66 Bath Street	New York
USA	Glasgow	New York 10021
	G2 4TG	USA
Toy Train Museum	Scotland	
Paradise Lane		
Strasburg	Christie's Amsterdam	
Pennsylvania	Cornelis Schuytstraat 57	
USA	1071 JG Amsterdam	
	The Netherlands	
Washington Doll's House &		
Toy Museum	Christie's Geneva	
5236 44th Street, NW	8, Place de la Taconnerie	

5236 44th Street, NW Washington, DC 20015 USA

1204 Geneva Switzerland

OTHER AUCTION-EERS' ADDRESSES

Bill Bertoia Auctions

2413 Madison Avenue Vineland NJ 08360

USA

g

Bill Bertoia Auctions

65–69 Lots Road

London

SW10 ORN

England

Hake's Americana & Collectibles

PO Box 144N Pennsylvania 17405 USA

Mapes Auctioneers

1600 Vestal Parkway West Vestal NY 13850 USA

Phillip's

101, New Bond Street London W1Y 0AS England

Phillip's Bayswater

10 Salem Road London W2 4DL

England

Phillip's New York

406 E. 79th Street New York NY 10021 USA

Richard Opfer Auctioneering, Inc.

1919 Greenspring Drive Timonium MD 21093 USA

Sotheby's London

34—35 New Bond Street London W1A 2AA England

Sotheby's New York

1334 York Avenue New York, NY 10021 USA

LEADING

COLLECTORS AND DEALERS

Tony and Jack Grecco

Mechanical Banks, antique toys 2413 Madison Avenue Vineland NJ 08360 USA

Bill Bertoia

Toy soldiers and related items PO Box 3490 Poughkeepsie NY 12603 USA

Jim and Patsy Carlson

Schoenhut Collectors 7939 Cabarfae Trail Clarkson, MI 48348 USA

Carl Lobel

Toys of all eras Box 74A Warren VT 05674 USA

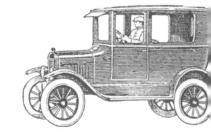

I N D E X

A

A-Team 164 Accucast 92 Acme 18 advertising 60, 61, 95, 97, 102, 138, 139, 166, 175 Age d'Or 155, 172 Air Drive Coach 71 Airfix 151 Alfa P2 racing car 51-2, 55 All American Toy Company 102 Alps 110, 111; Lincoln Futura Dream Car 114 aluminum 100, 101, 102, 104 ambulances 73, 78, 80 Amerang 175 American Flyer trains 19 American La France Water Tower 38 American National Automobiles 41 American Plastics 100 American Railway Express Truck 35 Amos 'n' Andy Fresh Air Taxi Cab 63 André Peugeot (201) vans 53 Andy Gump car 45 Anguplas 135 Arcade 7, 45, 47, 67, 147; Yellow Cab 44 Argentina 161 armored vehicles 75; Armored Auto 35; Armored Tank 35 Arnold 117, 119; motorcycles 61; Tin Lizzie 113 Asahi Toy Co.(ATC) 110, 111, 112, 148, 149; Buick Coupé 159; Crown Imperial 105 Aston Martin, James Bond's 152 Auburn Rubber 71, 74 auctions 176 Audi 172 Aurora 143 Austin: Junior Forty pedal car 120 Australia 135 Aut Lala van 24 Auto (3000) 116 Auto Dealership 176 Autobahn-Kurier 75 Aveling Barford Road Roller 117 AWSG see Günthermann

B

Bakelite 46, 55 Bandai 110, 111, 112; Ford Flower Van 115 Banthrico 104 Barbie Hot Rod 105 Barclay 71 Barney Rubble's Wreck 138 Bassett-Lowke 19 batteries 117 battery-powered cars 104-5 Belgium 135, 149, 160 Benbros 126 Benjamin Toys 175 Bennett, Gordon 27 Benz, Karl Friedrich 12 Best Box 135 Bicentennial commemoratives 146-7 **Big Brutes 138** Bing Brothers 7, 19, 25-6, 47, 53; Brake 20; Motor Car Figures 26; Open Tourer 14, 30; 'Platform' Fire Escape 23, 26 Birk 84 'Bluebird' land-speed car 48, 84; Bluebird II 39; Bluebird III 50 Blueprint Replicas 165, 174 BMC 108, 124, 173; Isetta 112; Minivans 133 Boat-Tailed Speedster 22 Borden 45; milk van 139 Box 173 boxes 88, 128, 146 Brake Test Car 101 Brightlight Filling Station 66 Brimtoy 53, 79-80; Bedford Articulated Boxvans 93 Brinks 45 Britain 53-5, 79-81, 123-30, 153, 171-2 Britains 84, 126, 153; Builders lorry 81 British Racing Green 80 British Toy Fair 168 Brockway Bridgelayer 154 Brumm 160 Brutes 138, 139 Bub, Karl 30-1, 47, 50, 75; Four-Light Limousine 27, 52 bubble cars 112 Buby 161 Buddy L 7, 39-41, 61-2, 94-6, 138-9, 174; International Coach 40; Low Loader 141;

Ol' Buddy's Rod-ster 139, *143* Budgie 127 Bugatti: Grand Prix Type (52) 55 Buick 110, 173 Burago 173, 176; Chevrolet Corvette *173*; Porsche (911) Carrera *173* Burnett 53, 123 Busch 175 buses 28, 60, 117, 161; clockwork 26; Deutsch 118; GMC 45; School 94; Trolley 80; Greyhound buses *45*, *62*, *69*, *94*, *100* Butler Bros 16, 20, 35, 38

C

C. A. W. 71 Cadillac 109, 110; Gama 115 Canada 135 Capri 148 Caravan 154 Cardini 52 Carette 19, 25, 28-30, 50; Limousine 30; Tourer 30 Carette, Georges 28, 30 Case International 102 cast-iron 14-15, 20-2, 46, 67, 147 Castoys 129 cereal premiums 108 Chad Valley 123; Games Van 118, 123 Champ of the Road 143 character merchandizing 45, 151, 164; see also Barney Rubble's Wreck 138; Charlie McCarthy; Disney; Elvis Presley; Fred Flintstone; Heroes; Noddy Charbens 126 Charlie McCarthy 66, 66-7 Chein 42, 104; Royal Blue Line Motor Coach 67 Cherryca Phenix 112, 148 Chevrolet 110; Camaro 144, 166; Corvette 110, 145, 169, 173; Stingray 150 Chicago Century of Progress 45 China 93, 104, 119, 167 Christmas tourer 50 Chrysler Airflow toys 46, 62-3, 85 Chrysler: Hardtop 106; Roadster 41 Cigarbox 143 CIJ 51-2, 78, 119, 131 circus toys 18, 111, 124, 138, 154 Citroën 52, 119; 11BL 173; Clover Leaf 55;

d e x

ц

-

DS19 111; Fire Engine 77; Présidentielle 154, 157; Traction Avant 131 Citroën, André 52 CKO 118-19 Clark, D.P. 17, 18 classics 171-3, 175 Clé 132 clockwork 17, 18, 19-20, 21, 22, 23, 39; Motor 65; Omnibuses 26 Cobb, John: Napier Railton Record Car 122, 124 Coca-Cola 172, 175; trucks 61, 95, 138 Cofalu 132 collectors 8, 147, 148, 151, 152, 171-3 Computer Cars 166 Conrad 172 Corgi 128, 129-30, 151, 152, 153; 171; Classics 171; Volkswagen 133 Cougar 154 Coupé 'n Trailer 63 Courtland 103-4 Cragstan 111, 149, 161, 167 crane, Mighty-Tonka 143 Crazy Cars see Funny Cars Crescent 126 Crown Imperial: Hardtop Chrysler 106 Cursor 159 Curved Dash Oldsmobile 18-19

D

Czechoslovakia 135

DAF 135 Dalia 131, 135 Dandy: Miniature Farm Tractor Outfit 35; Roadster 34 dashboard toy 108 Datsun: Berlina 112; Cedric 148; Fair Lady 112 Dayton Friction Toy Works 17 Dayton Group 6, 17, 18, 34 Daytona (500) 165, 166 DCMT/Impy 153 De Dion 51 Deere, John 101 Denmark 84, 122, 135 Dent and Williams 21–2 Dent Hardware Co. 21-2, 44 Deutsche Bundesbahn bus 118 Deutsche Reichspost mail van 47

Deutz-Allis 102 Diapet 112, 148-9, 173; Honda Stream Motor Scooter 168 diecasting 8, 22, 70, 71, 84-5, 88-9, 92-3, 101, 132, 147, 148, 156, 158 Dinky Toys 8, 83, 84-5, 88-9, 127-9, 151-2. 153, 171-2; BMC Minivans 133; Collection 152, 171-2; Delivery vans 83; Export Set No. (6) 128; French factory 130-1, 154-5, 161; Hudson Commodore Sedans 124 Dipsy Cars 96 Disney cars 96, 97, 99 Distler 31, 47, 75, 117; Fire Engine 76; Jaguar XK (120) 112; Saloon Car 84 Doepke 102; Jaguar XK (120) Sports 110 Doll et Cie 47; Open Steam Wagon 49 Don, Kay 50 doors, opening 158 Dowst 22 Dugu 134 Dunbee Combex 100 Dux tolling 78 Dynamights 167

E

Eberl 47 Eccles 147 Ecurie Ecosse transporter 130 Edil 160 EGM 134 Eichner, G. L., & Sons 23 Eko 160 Electric Rolls pedal car 81 Electromatic (7500) 117 Elektro 116 Elgin roadsweeper 7, 46 Eligor 156 Elvis Presley Entertainment 175 English River series 161 Erie toys 70 Ertl 8, 94, 101-2, 103, 164-6; Pontiac Fiero 88; Coupé 174 Ertl, Fred 101-2 Erzgebirge, Saxony 13 Eureka 81 Eurotoys 122 Examinoco (4001) 113

F

F&F (Fiedler and Fiedler) 108 fairs, toy 13, 40, 45, 168, 176 farm toys 101-3, 164 Ferrari 173 Fiat: (1400) 122; 18BL lorry 52; saloons 160 Fiero GT 165 fire-fighting vehicles: early 15, 18, 22; Buddy L's 95-6; Fire Chief's Car 44, 63; Citroen Fire Engine 77; Distler Fire Engine and Station 76; Fire Power 176; French 119; L'Auto Pin-Pon 100; Jeep 100; pumpers 138-9; Talk 'n' Go 174; Turntable Ladder 70 Fire Escape, 'Platform' 23, 26 Fischer 31, 47 Fix-It cars 104 Flying Limousine 19 Flying Racer 19 Ford: Camel vans 69; Capri 151; Edsel 110; Fairlane Sedan 132-3; farm equipment 102; Flower Delivery Van 115; (40) 145; Gyron 111; Model A 43, 47; Model T 12, 20, 34, 44; Sedan 45, 46; Thunderbirds 111, 148, 166, 173; V-8 Coupé 46; Vedette 130; Woody station wagons 69 Ford, Henry 6, 34 France 6, 22, 31, 50-2, 78-9, 81, 88, 119-22, 130-2, 154-6, 172 France Jouets (FJ) 156 Fred Flintstone's Flivver 139 Funny Cars 66, 66-7, 97, 143 Funny Flivver 43

G

Gabriel 94 Gama 110, 118, 132–3, 158, 172; Cadillac (300) 115 Gamage, Arthur Walter 25–6 Gamda 161 garages 124 Gardner, Goldie: MG Record Car 122, 124 Gasquy-Septoy 135 Gege 132 Germany 6–7, 8, 12, 13, 16, 19, 20, 21–31, 41, 46–50, 74–8, 89, 112–19, 132–4, 156–9, 172 Gilbert, A.C. 34, 41 Girard 42, 63 G-Man Pursuit Car 66 GMC buses 45 GNB see Bing Brothers Gnom 112-13 Golden Age 155, 172 Golden Arrow 50, 55, 84 Gong Bell 15 Goodee (Excel Products Co.) 100 Graham-Paige 68-9, 84 Great Lakes Exposition 45 Grey Iron 22 Greyhound buses 45, 62, 69, 94, 100 Grippers 167 Guide-Whip Racer 105 guided missile 103 Günthermann 7, 25, 27-8, 47, 50, 75; Open Tourer 26; Vis-à-Vis Motor Car 24

н

Hafner 19 Haji 110 Hartoy 168 Hasbro 176 Haulers, racing 169 Hausser 75; Prime Mover and Field Gun 75 Hearse 149-50 Heavy Hauler 102 Heinz delivery truck 61, 62 Hercules trucks 42 Heroes 145 Herpa 159 Hess 7, 19, 25, 28, 47, 146 Hill Climber Friction Power Toys 17; Two-seater Car 16 Holland 135, 159 Honda Stream Motor Scooter 168 Hong Kong 104, 112, 143-4, 145, 146, 167, 171 Hong Kong Dinks 151 Horch (830BL) Convertible 75 Hornby, Frank 84 Hornby Dublo trains 129 Hot Rods 143, 144; Tin Lizzy 117 Hot Wheels 144-5, 166, 169, 176 Huber Road Roller 46 Hubley 8, 46, 67, 93-4; Corvette 93; Farm Set 94; Fire Department Set 94; Ford Bell Telephone Truck 94; Real Toys 94 Hubley Kiddie Toy 67

Ichida

Ichida 111 Ichiko 110, 112 Icis 134 Ideal 104-5, 167 Igra 135 India 161 Ingap 52, 79, 122 Ingenico 116 International cab (Buddy L) 62 International Harvester 40, 102 International Loadster 102 International trucks 102 iron-casting 14 Israel 161 Irwin 105 Italy 52, 79, 122, 134, 156, 160, 173 Ives 19

J

J-40 pedal car 125 Jaditoy 175 Jaguar XK range 111; (120) 103, 105, 110, 112, 173; (140) 132 Japan 79, 92, 97, 108–12, 123, 147–50, 173; Pontiac model 97 Jeep 117, 117, 122; Fire Engine 100; Jeepster 92; Willys 161 Jefe 135 JNF 117 Joal 161, 173 Johillco 80, 84 Johnny Lightning 144, 152, 168 Jouets en Paris (J de P; JEP) 51, 78, 132 156; Citroën 52 Joustra 110, 119, 122 Joy Riders 43 IRD 78, 119, 131 Juguetes Y Estuches: Streamlined Saloon Car 64

K

K. B. N. see Bub Kado 150 Kansas Toy & Novelty Co. 70 Kellermann 47, 118 Kelmet 38 Kennel truck 138 Kenton 21, 22, 44, 147 Kenworth 174 Keystone 38 Kilgore 46 Kingsbury 19, 38–9, 50, 62–3; Land Speed Record Cars 38 Klint, Bernard C. 103 K-Mart 169 Kodak box truck 130 Korea 165 Korean War 95, 103, 127 Kosuge 79 Kyosho 175 -0

L

La Salles 69 Ladder Truck Co. No. (1) 13 Lange 135 Latil Bank Van money-box 122 L'Auto Pin-Pon: Jeep Fire Engine 100 Lehmann 7, 12, 16, 19, 23-5, 46-7, 112-13 Lehmann, Ernst Paul 23 Lesney 127, 128, 152-3 Liberty Chime 15 light and sound vehicles 39 Lilliput series 126 Lincoln Toys of Nebraska 70-1; Hearse 149-50; pedal car 68 Lindstrom 42 Linemar 99 Lineol 75; Army Ambulance 73 Lines Bros Ltd 53, 55, 81. 124, 125, 130, 150-1; Tri-ang Ford Royal Mail 43 Lion Car 135, 160 lithography, offset, early 16 Lledo 172 London Toys 135 Lonestar 153 Louisiana Purchase Exposition 24 Lucky Toys 167 Lundahl, Fred 39-40 luxury toys 35-6

M

Macau 171 Machinery Hauler Truck 94 Mack Aerial Ladder 102 Mack trucks 41, 44, 68, 84; Bulldog 41, 42, 66; Hydraulic Dumpers 138; Low Loader *141*; p u

Mobilgas tanker 102 magazines 169, 176 Majorette 156, 175 Mangold, Georg Adam 118 Manoil, Jack and Maurice 69, 71 Marchesini 122 Märklin, Gebrüder 8, 47, 75, 88, 89, 132, 156: Clockwork Motor 65; Electric Lighting Set 65; electric racing car set 88; Motor Fire Engine 21; Road Engineer's Steam Roller and Trailer 34; Standard Fuel Tanker 65; Streamlined Tourer 64: Tractor 51 Marshall Field & Co. 16 Marusan 109, 110 Marx, Louis 7, 8, 42-5, 55, 61, 63, 66-7, 96-7, 100, 146; Brake Test Car 101; Fred Flintstone's Flivver 139; Mickey Mouse Moving Van 99; Nutty Mads Car 97 Massey Ferguson 102 Masudaya 111 Matchbox toys 127, 166, 171; Chevrolet Corvettes 169; Collectibles 171; Ford Thunderbird 166; Hot Rod Racer 154; Motorcity playsets 175-6 Mattel 105, 152, 171, 174, 175; Hot Wheels 144-5, 166, 169, 176 mazac (zamac) 8, 85, 92, 102, 127, 131 Mebetoys 160, 173 Meccano 8, 55, 75, 84-5, 88, 128, 138, 150; No. 2 Car Constructor 85; Triumph Herald 129 Meccano Magazine 128-9 Meier 31 Mercedes 74-5, 111, 117, 118, 119; electric pedal car 174 Mercedes-Benz 71, 161, 176 Mercury 134, 135, 156, 160, 173 Messerschmitt 112 Metal Masters 92 Metalcraft 61; Heinz delivery truck 61, 62 Metalgraph 52 Metosul 161 Mettoy 74, 80, 129, 171; Army Saloon Staff Car 87; motorcycles 61 MG record cars: Goldie Gardner's 122; Magic Midget 80 MGA 173 **MGTD 112**

MGTF 112 Micro Machines 176 Micro Models (Australia) 135 Micro Pet series 112 Micro-Racer series 132 Midgetoy 100 Mighty Metal 94 Mighty-Mites 94 Military Police vehicle 117 military vehicles 88, 89, 95; Ambulances 73; armoured 35, 75; Saloon Staff Car 87; Troop Transport 74 Miller-Ironside 102 Mini-Mod range 133 Minialuxe 132, 172 Minic 81, 87, 124, 130; Minic Motorways 125 Minichamps 175 minimodels, British 123 Minix 125 Mirako Peter motorbike 119 MLB 122 Model Pet 112, 148 Model Toys (Doepke) 102 models, shift to from toys 8, 171-3 Modern Motor Car (Bing) 25 Modern Toy (MT) 79 Modlwood 13 Mogul toys 152 Moline Pressed Steel Company 40 money-boxes: cast-iron 15, 22; Latil Bank Van 122; pot-metal 104 Montgomery Ward & Co 13, 15, 16, 17 Morestone 127 Morgan 173 Morris 8Z vans 129 Motor Bus (Carette) 28 Motor Car (Lehmann) 23, 24 Motor Car Figures (Bing) 26 Motor Cycle Cop 44 Motorcity 175-6 motorcycles, toy 46, 47, 61, 119, 167; Cop 44; Japanese 111; Mirako Peter; rider 7; Zündapp 119 Moyen Age models 156 Muller, Heinrich 63 Murray Manufacturing Company 108 Muscle Cars 165 music 175

N

Napier Railton Land Speed Record Car 122 Nascars 164, 168, 169 Nash Metropolitan Convertible 92 National pedal car 20 Neidermeier 119 New Deal 60 New York Toy Fair 40 New York World's Fair 45 Nicky 161 Nissan Gloria Hardtop 112 Noddy pedal car 126 Nomura 79, 110, 111; Cadillac Convertible 107: Cadillac Hardtop 107 Norev 131, 156, 167, 172 Novoexport / Saratov 161 Nuremburg Toy Fair 13 Nyberg, David 103 Nylint 102, 103, 139, 142, 174; Jaguar XK (120) 103; MG TD 103 NZG 158, 172

0

Odell, Jack 172 Ohlsson and Rice 104 Ohta Austin A50 Saloon *123* Old Jalopies 43, 96 Oldsmobile, Curved Dash 18–19 Olympics broadcast van 139, 142 Omnibuses, Clockwork 26 Opels 172 Open Touring Car 22 Oro (Orobr) 47 Osul 161

P

Packard 38, 109, 110; Straight (8) 46; Synchromatic Convertible 111
Palymobile 108
Panhard 130
Parker White Metal Co. 70
Paya 79
pedal cars 20, 31, 41, 81, 108, 125–6; Austin Junior Forty 120; dashboard toys 108; dumptruck 41; Kenworth 174; Mercedes 174; National 20; Noddy 126; Tri-ang 81
Pennytoys 6, 22, 31, 160
Petty, Richard 164, 165; STP Car 166 Peugeot models 78; (201) vans 53 Piccolo line 132 Pilen 154, 161, 173 Pinard Open Tourer 29 Pit Road 168 plastic 46, 94, 96, 97, 133-4, 155; Bakelite 46, 55; coloring 131; Polysteel 95; polythene 104, 105, 126; Tri-ang models 124 Playart 167 Playthings 68 Plymouth Sports Suburban 133 Pocher 160 Pocketoys 123 Polistil 173 Politoys 134, 160 Polysteel 95 polythene 104, 105, 126 Pontiac 165, 174 POOL Tanker 87 Porsches 117, 148, 172; (911) Carrera 173 Portugal 161, 173 pot-metal 70-1 Prämeta 132 Presley, Elvis 175 pressed-steel toys 20, 36-8, 40-1, 94 Pro Racing label 166 pull-along toys 13, 15

Q

Quaker Oats 100 Quiralu 131

R

racing cars 31, 80, 104, 155, 165–6, 168–9; Alfa (P2) 51–2, 55; electric set 88; Flying 19; Formula (1) 152, 155, 160, 161; Guidewhip 105; Hot Wheels 145; Japanese 111; Le Mans 155; Loop-the-Loop Set 144; Micro-Racer series 132; Scalex 123, 124–5
Racing Champions 168
Raging Bull 176
railway toys 75, 129; accessories 84–5, 133–4
Rainbow Rubber 74
Rami 132
Ranlite 55; Austin Saloon 56
Reach, Walter 103–4
Realistic 100
record cars 7, 38, 39, 80, 84, 122, 124 Red Devils (automotive) 22 Renault models 78, 119, 131; (750) 112, 119; Taxi 51 Renwal 104 replacement parts 147 reproductions 95 Republic Floor Toys 37 Rescue Hook 13 restoration 21 Revell 104, 168 Rico 79, 176 Riley Pathfinder 129 Rio 134, 160 Road Champs 167-8; Elgin Pelican Street Cleaner 167 Road Maniax 176 Roadster (Kilgore) 46 Rockets 152 'Roll-back' roof coupé 75 Rolls-Royce 132; pedal car 126; Silver Cloud 131 Roskopf 175 Rossignol, C. R. 31, 51, 78 Routieres-labelled beer-barrel truck 132 Rovex 125 rubber 71, 74, 93, 172-3 Runabout 22 RW-Ziss 158

S

Saab 173; (93) 112 Sablon 149, 160 Sabra cars 149, 161 Safir 155, 156 Sakura 150 Samtoys 134 Saurer vans 134 Scalex 123, 124 Scalextrix 124-5, 174 Scarab (Buddy L) 61 Schabak 172 Schieble Toy and Novelty Co. 17 Schoenhut 13 School Bus 94 Schuco 113, 116-17, 132, 156, 158, 172; motorbikes 119; Packard Synchromatic Convertible 111; Radio (5000) 116 Schwarz, F.A.O. 16, 40 Scootin' Tootin' Button Hot Rod 97

Scorcher pedal car 20 Sears Roebuck catalogue 16, 25, 34, 35, 36, 41 Shackleton trucks: Foden 127; FG Flat 125 Shell BP tankers 87, 130 Sheriff Sam and his Whoopee Car 96 Sherman tank 124 Shinsei 173 shops/stores 16, 174 Siegumfeldt 122 Siku 133, 158–9, 172, 175 Silver Bullet cars 50, 79, 84 Sit-'n'-Ride 124 Sky Roof Sedan 63 slush moulding 70-1, 147 Smith-Miller (Smitty) 102 Solido 88-9, 128, 131, 135, 148, 148, 154-5, 172, 175 Spain 131, 135, 154, 160-1, 173 Speedwell pedal car 20 Spot-On 130 SR (Simon & Rivollet) 22 Startex 123, 124 steel 15-6; pressed 20, 36-8, 40-1, 94 Steelcraft 41, 61 Stevenson 70-1 STP 165 Strauss, Ferdinand 20, 41-2; Reliable Mechanical Toys 34 Stripey the Magic Mini 151 Strombecker Corporation 93 Structo 36, 41, 61, 94; Auto Builder 36; Roadster 37 Studebaker trucks 130 Sturditoy 37 Sturdy Corporation 37 Stutz 44; Bearcat Roadster 36 Summer Metal Products 167 Sun Rubber 74 Sunbeam: Golden Arrow 39; 'slug' 39 Super Détail models 154 Supertoys 128

_

T

Taiseiya 112 Talk 'n' Go fire truck 174 Talking Police Car 104 tankers 65, 87, 87, 102, 130, 134, 146 tanks, armored 35, 124

Taunus vans 135 Taylor, Chicago 13 Taylor & Barrett (T&B) 84; Trolley Bus 80 TCO 74, 117 Technofix 119 Tekno 122, 128, 135, 156, 159-60 television vans 111 Terra town car 47 Thimbledrome 104 Thunderbirds, Ford's 111, 148, 166, 173 Timber Toter 102 Timpo 126 tinplate toys 15-16, 23, 31, 47, 50, 51, 75, 79, 112.118 Tintoys 167 Tipp & Co. (Tippco) 47, 50, 74, 75, 117; Army Ambulance 73; Army Troop Transport 74; Double Deck Bus 60; Fire brigade Turntable Ladder 70; Mercedes Benz 71; motorcycles 61, 119 Tomica 150, 167 Tomy 150, 173, 176 Tonka 103, 142-3, 176; Hydraulic Aerial Ladder 103; Quarry Dump Truck 153; Suburban Pumper 103; Tonka- Tote 143 Tootsietoy cars 8, 13, 22, 46, 67-9, 84, 92-3, 145; Buick Century 92-3; Classic Cars 903; Corvette Roadster 92; Hard Body 175; Hook and Ladder Truck 92; Hose Car 92; Jeepster 92; Jumbo series 92; Nash Metropolitan Convertible 92; Playtime Set (7500) 92; Torpedo series 92; Triumph TR3 93 Topper Toys 144 Torpedo series 92 Tour de Frances toys 132 toy fairs 13, 40, 45, 168, 176 Toy Manufacturers, USA 31 Toy Option 176 Toy Trader 174-5 Toyota 150; Celica 112; Corona 148; Sport (800) 148 Toys'R'Us 174 tractors 67,; BMC 108; climbing 44; Ertl 101; Fordson 44; Märklin 51; miniature 35 Traffic Jammers 175 trailers 34, 63, 67 Tri-ang 80-1, 85, 124, 151; Centurion pedal car

126; Ford Royal Mail; Minic models 81, 87, 117, 124 Triangtois 43 Trick Auto (Strauss) 34 Tricky Taxi 63 Tru-Scale International 102–3 Turboom vehicle 175 Turner, John C. 17 Tut-Tut car 24, 25 Tyco 176 tyres 71, 93, 147, 172–3

U

Ubilda 123 Ullmann, Philip 74, 80 Universal Toy Company of Hong Kong 167, 171 USA (America) 6, 7, 17–20, 21–2, 31, 34–46, 60–70, 92–108, 176 USSR 161

V

Vanguards 172 Vanwall 129 Verem 172 Viberti tankers 134 Victory 125 Vilmer 135 vintage car models 127, 132, 171–2 Vitesse 173 Volkswagen 118–19, 133; ADAC 133; Beetle 112, 118; Corgi *133*; Danish model vans 135; Minibuses 117

W

wagons, wooden 13 Wallwork 55 Wegenwacht 111 Wells, A., & Co. 53 Wells o' London 53, 79; Ambulances 78; Shell BP Petrol Tanker 87 Wells-Brimtoy 123 Welly range 167 Welsotoy 123 Wheelies 167 Whitanco 53; Open delivery truck 57 white metal 92 White trucks 146 Whitzwheels 152 Wiking 133, 134, 159, 175 Wildwheels 167 Wilkins Toy Company 19 Williams, A.C. 21–2, 44 Willys Jeep 161 windows 128 Winross 146–7 Wizard pedal car 20 Wolverine 42 Wondrie metal 167 Wood, Charles A. 71 wooden toys 12–13 World Famous Car Series 150 Wyandotte All Metal Products 60–1, 66

Y

Yatming toys 167; Ford Coupé 168 Yaxon 160 Yellow Cab 44, 45, 67 Yesteryears 127, 151, 171, 172 Yonezawa 110, 111, 112, 148, 149, 150; Atom Jet Futuristic Car 108, 111; Cadillac Pillarless Sedan 104; Indy car 111

Z

Zee 167; Turbo Trans Am 147 Ziss 158 zoo truck 138 Zylmex 167